T I L E

L E

JILL HERBERS

Photographs by ROY WRIGHT

ARTISAN *New York*

Text copyright ©1996 Jill Herbers
Photographs copyright ©1996 Roy Wright
Additional photo credits on page 188.

EDITOR: JENNIE BERNARD
DESIGNERS: JOEL AVIROM AND MEGHAN DAY HEALEY
DESIGN ASSISTANT: JASON SNYDER
PRODUCTION DIRECTOR: HOPE KOTURO

Published by Artisan
A Division of Workman Publishing Company, Inc.
708 Broadway
New York, NY 10003-9555
www.artisanbooks.com

Herbers, Jill.
Tile / Jill Herbers : photographs by Roy Wright.
 p. cm
Includes index.
ISBN 1-57965-209-3
1. Tiles. 2. Tiles in interior decoration. I. Title.
NK4670.H45 1996 96-21062
738.6–dc20 CIP

Printed in Singapore
10 9 8 7 6 5 4 3 2 1
First paperback edition, 2002

IN MEMORY OF DOUG,
WHO BELIEVED.
———

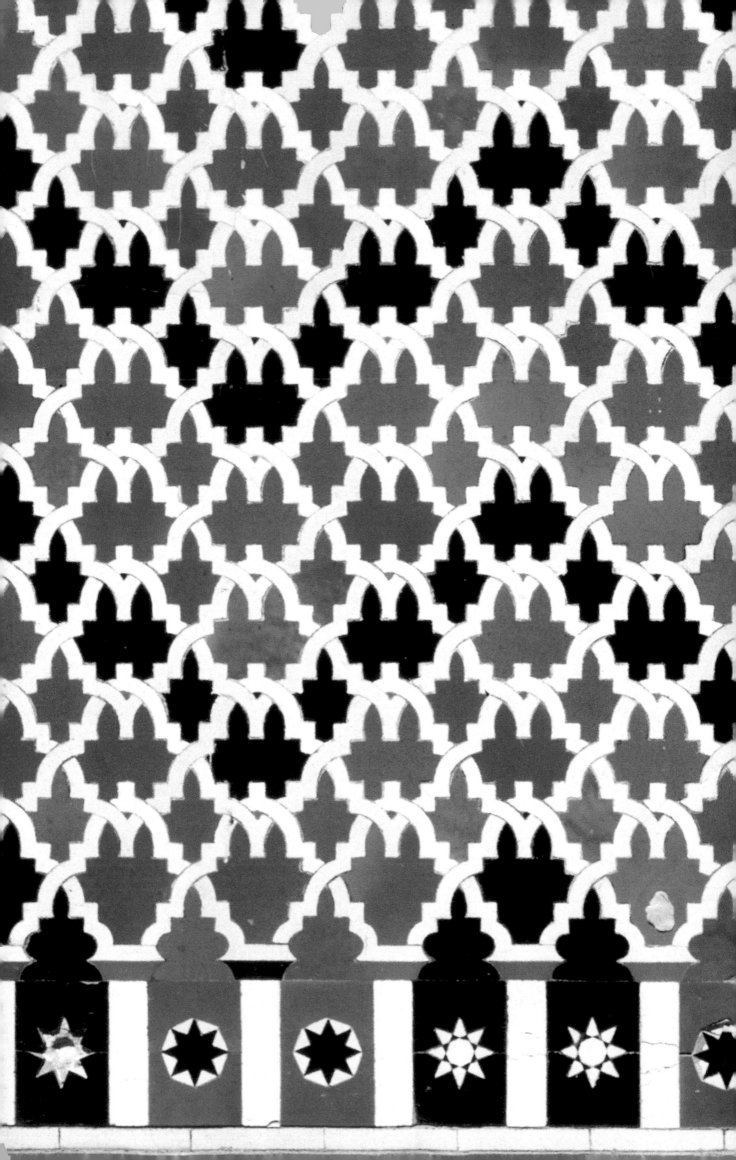

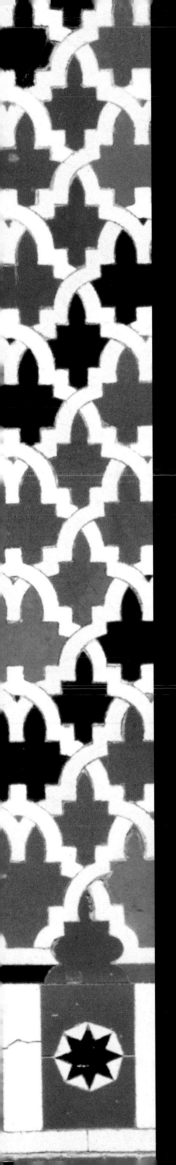
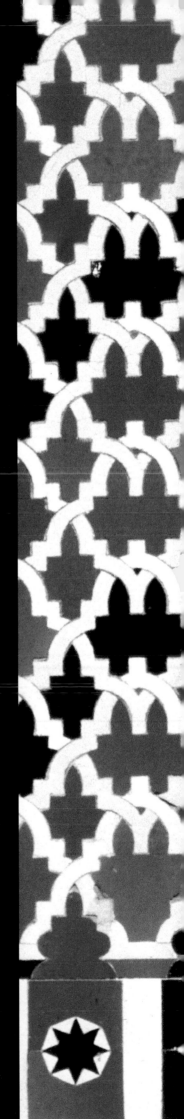

CONTENTS

ACKNOWLEDGMENTS

Usually, there are a dozen or so people who have been particularly helpful in creating a book. In the case of this book, however, there is someone to thank for nearly every day I worked on it. The people who are around tile—whether designing it, making it, selling it, building or living with it—share information and excitement with the same love, energy, openness, and inspiration with which they approach the material. It is rare to find people who are so pure in what they do. They gave me this book, and now I am giving it back to them.

There are almost as many other people outside the tile community who simply caught the enthusiasm for the subject, and stayed in touch with me about the book. It was an extraordinary experience to be going through my research and find articles and photographs from around the world sent by both close friends and family as well as by people I met for only an hour or so.

Many people close to me provided support, and were sometimes involved in the vision or details of the project. Randy Corcoran and Carol Schlitt were inspirational from the beginning, Susan DeMark and Helen Chin were not only supportive but also shared their considerable editorial and marketing skills, and Jolie Solomon will never be forgotten for her sharp eye and dining room table. Friends in Miami, Los Angeles, and Italy took me into their homes when I was traveling for the book. My family, as usual, was involved and supportive.

The Writer's Room, where I wrote most of this book, was invaluable, providing peace and strength through its very existence. The Tile Heritage Foundation was helpful throughout the project, providing information about tile on every level.

Finally, among the people at Artisan who made this book a beautiful reality are Leslie Stoker, who has a great excitement for ideas, and Joel Avirom, who translates them into wonderful and intelligent designs that capture the subject.

Thank you.

TILE

PART ONE
TILE CULTURE

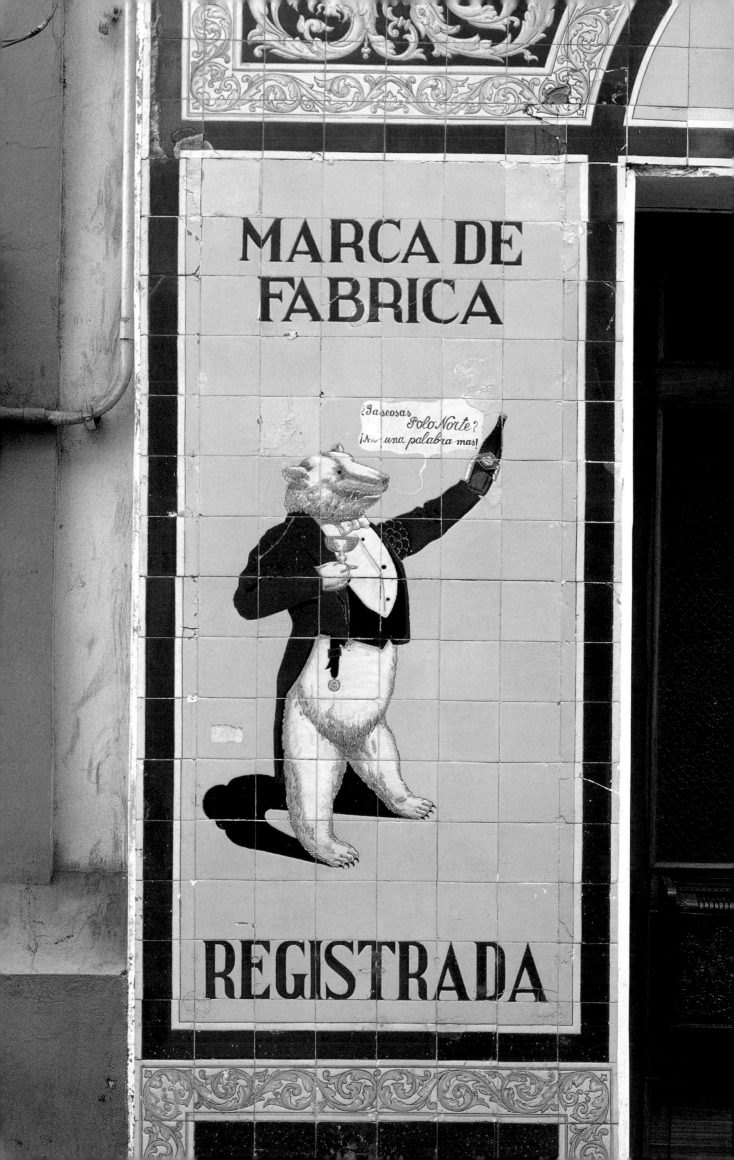

The Elements of Tile

The frost is over and done, the south wind laughs,
And to the very tiles of each red roof
A-smoke i' the sunshine, Rome lies gold and glad.

—ROBERT BROWNING, "THE RING AND THE BOOK"

Tile has made many centuries, civilizations, and buildings gold and glad—gold because of its inherent warmth; glad with its expressive joy. It is a material that has had many lives throughout the years and the world. Since it was invented by the Egyptians six thousand years ago, tile has covered entire civilizations, from the curved red tiles of their roofs to the large-squared floors of their marketplaces. It has lined tombs in China dating back to the third century B.C. with pictures and patterns. Tile has remained remarkably vibrant and expressive after centuries of being walked across in churches and cathedrals; danced across in palace ballrooms; splashed on in Mediterranean courtyard fountains. Ceramic tile covered the space shuttle when it was shot up into the heavens, and every kitchen floor that children of the

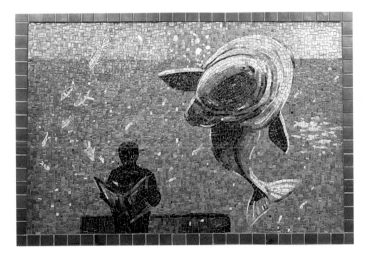

'50s grew up playing on. It was what the action in "Ben Hur" revolved around, when a roof tile from the family's house fell and killed a Roman general, causing them to be arrested. After decades, tile still spells out the water depths of pools. Bright pieces of it wash up on the beaches of Italy long after the buildings it once graced have disintegrated into the ocean. Tile used to be a measure of how well a farmer was

Tile is meant to be a shared experience. It brings buildings to life in Havana (PRECEDING PAGES) *and Old San Juan* (LEFT), *where a bear extols the virtues of the soda made within ("Polo Norte Soda? It's the last word!"). A contemporary mural of an underwater scene* (ABOVE), *by artist Deborah Brown, humorously reminds New York City subway passengers that they are in a subterranean environment.*

doing, because large, expensive cylinders of it were laid under the earth to take away excess water and make for a thriving crop. It is made of the four elements — fire, water, earth, and air — and for centuries it has been a part of homes enduring those elements: fire in the kitchen, water in the bath, earth in entryways and living areas, and air in yards.

With all that is new and striking about tile today, it is what is old about it — those properties that are enduring — that is loved. They are qualities that evoke a sense of humanity. The most basic is that tile is an organic material, of the earth, and the work of the hand is apparent in it. This makes it appeal to the eye, but it also means that there is a texture to tile. That texture varies with the millions of kinds of tiles that exist, whether raised, glazed, engraved, smooth, rough, or wavy. As Pedro Leitao of Solar Antique Tiles says, "It must be touched." At least this is the impulse — to place a hand on something made by another hand. Even by looking at it, everyone understands the tactile quality of tile — cool and reassuringly firm.

This temptation to touch invites us to be involved with the material. We are drawn in further by the fact that tile also has scale. There are many different sizes of tile, but the important thing is that there *is* a size. This makes everything, in architect Stanley Tigerman's words, "measurable, accessible for humans." The

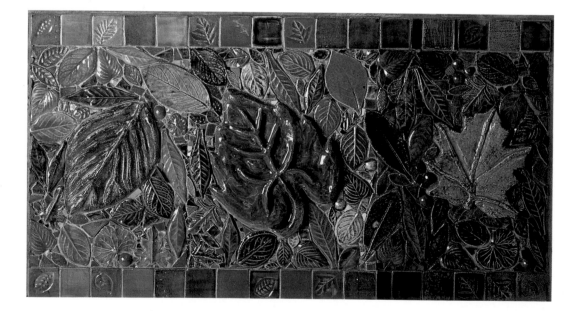

scale of tile provides something to relate to, whereas a material such as steel or aluminum can go on for expanses with no meaningful relation to the size of a room or of a person in it. Tiles laid side by side measure — a wall, a floor, a building — all the time the eye scans them. There is also a traditional shape to comprehend. The reliable square form of tile reaches back centuries, to exotic palace walls and ornate cathedral floors as well as to signs in old train stations and the space behind diner counters, to remain familiar today.

People also respond to color, and the magic of glaze creates a depth of color in tile that is impossible in materials that possess no such miracle. The range, subtlety, and richness of color produced by remarkable glaze recipes is comparable to the effects achieved in great oil paintings. The colors are so many and varied that they include an enormous array among black and white shades alone.

It is tile that provides the color in architecture. On ancient buildings in Spain architectural elements such as columns, floors, archways, and terraces are covered in tile, often in many shades to make one color when seen from a distance. These colors and others from the past have remained remarkably vibrant through the years, glowing after centuries of winds have beaten against walls and dusty feet have trampled over floors. Fourteenth-century tiles from the Alhambra palace in Granada are

LEFT: *"Brighton Clay Re-Leaf" murals were newly created by artist Susan Tunick for the New York City subway. The imaginatively colored leaves reflect the station's location at Prospect Park, one of New York's great natural settings.*

ABOVE: *Swimmers at New York's West Side YMCA call this the "Pompeian pool" for the lavish tile that surrounds and lines it. Though Italian in style, the tile was made in America in the 1920s.*

BELOW: *Using the phone or bathroom at the Marlin Hotel in Miami is an event, due to the bright mosaics and squares that announce them.*

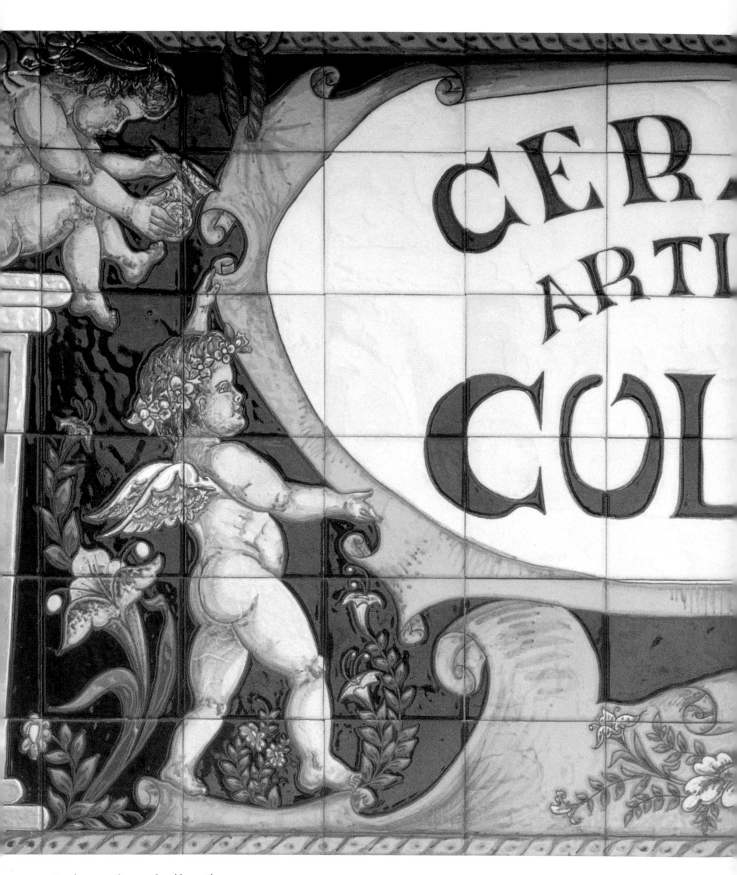

Angels seem to live comfortably on tile,
as they have graced it for centuries in
Europe. In this contemporary sign,
a band of artistic angels announces a
ceramics shop in Seville, one of many
that sells local handmade tile.

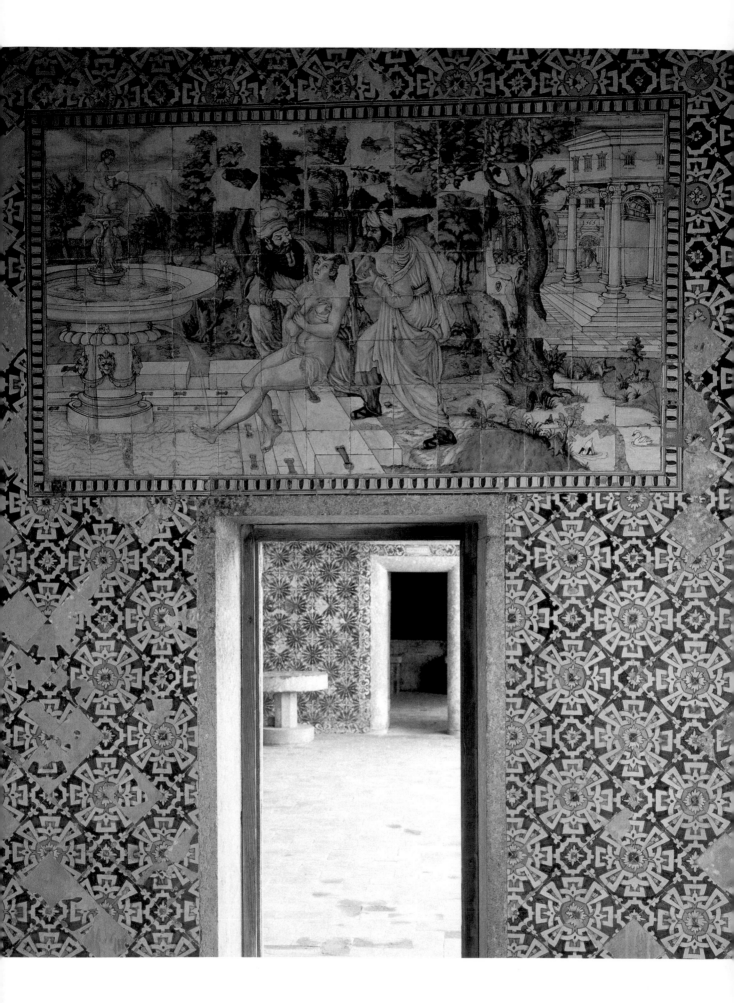

still unabashed proclamations of color—yellows, blues, and greens that fill flowers, leaves, and geometric shapes with life. The joy and exuberance of the color remains.

Today, architects are returning to the celebration of color in tile. The Samuel Goldwyn Children's Center in Los Angeles, for example, has been covered in large blocks of tile in bright primary colors that look like they came from a crayon box.

With color comes the opportunity for pattern. At the least, patterns can delight people, and at the most, they can express and fulfill psychological needs, like all good art. Tile allows for the most basic of patterns, such as a simple Greek key design, or the richest, like the elaborate leaves, flowers, and arabesques that are found in Persian carpets. In fact, the patterns of carpets and tile are often similar, with one historically borrowing the designs of the other.

Of course, each tile may have a beautiful and complex individual pattern. But patterns are also built. One tile is a single element of design. More than one starts a pattern. Even the simplest band of alternating black and white tiles laid end to end sets a pace when it runs across a wall or floor. With it, there is a delight in recognizing a simple pattern in play that is important to the human spirit.

ABOVE: *The United States Capitol is floored with Minton tile, a Victorian style from England. Installed in 1856, the intricate designs that lead Senators to their committees are the same that were worn by the feet of Lincoln, Roosevelt, and Kennedy. The corridors alone contain 1,000 different tile patterns.*

RIGHT: *Traditional Iznik tile instills reverence to the Mosque at the Islamic Center in Washington, D.C. Donated by Turkey in the 1960s, the tile is similar to that which lines ancient tombs there, with differences in the shades of red – a color so difficult to achieve that it varies with each century.*

OPPOSITE: *The oldest tile painting in Portugal (1565), "Suzanna and the Elders," is at the poolside pavilion of a salvaged country palace south of Lisbon, now owned by an American family.*

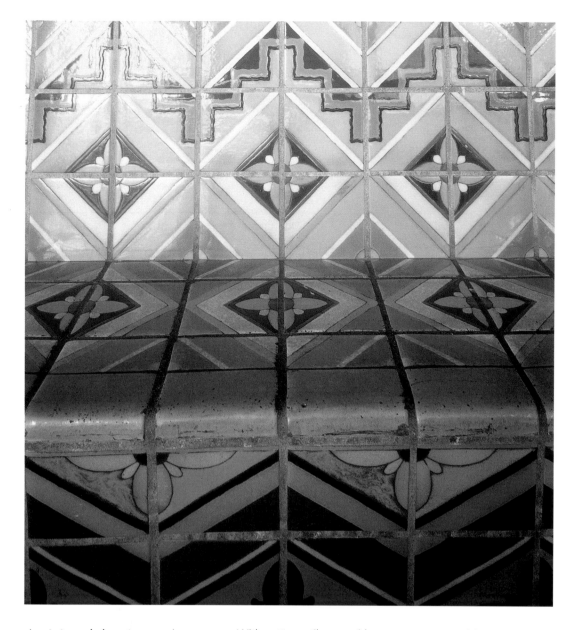

A train is worth the wait at Union Station in Los Angeles, if only to sit in the sun on one of its tile benches. The long, luxuriously tiled benches are bright with 1939 Gladding, McBean & Co. ceramics, custom-designed to enhance the Spanish Mission style of the last grand train station built in America.

With pattern, tiles are able to capture many things — a scene, a spirit, a portrait. They are even able to impart symbols, convey messages, and give information. The messages may be very direct, literally spelling things out in wonderfully patterned panels — showing where the downtown train can be caught, indicating the name of a street, or urging people to buy a certain brand of coffee or rum, as advertisements in Europe still do. Or they may be more hidden, such as the flowing forms on Moroccan tiles that look like graceful arching and falling designs but are actually Arabic letters that make up words such as "God Almighty." The tile friezes in New York City subway stations are messages for passengers who

know the code, with a many-colored wall standing for Wall Street, a proud ship signaling Columbus Avenue, and a sprightly beaver (the source of a fortune in pelts for the Astor family) indicating Astor Place. In Old San Juan, Puerto Rico, nuns dance joyfully and irreverently on tiles made as address signs to tell visitors they are on Nun Street.

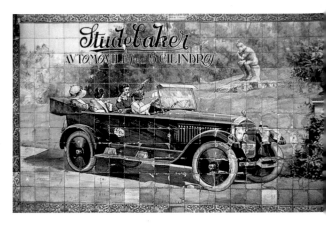

But the messages may also go much deeper. Tiles often tell stories, so their patterns are keys to a culture and clues to a people. They may have complex symbolism, such as the Iznik tiles of Turkey, which show pearls on the waves of the sea as a symbol of good fortune; they may reveal the everyday life of another time, as in delft tiles from Holland that depict dress and manners from another era in detail; or they may reflect the history of a place, as do the subway signs in New York City that are delicately bordered with tulips to represent the city's Dutch origins.

Whatever they show, these tiles speak from the past, having survived to tell history in a very human way. They are like living archeology.

ABOVE: *Tiled advertisements, such as this 1924 poster in Seville, are common throughout Europe. One of their charms is that the messages remain as reminders of a past culture long after the products are gone.* BELOW: *A ceramic plaque of Robert Fulton's steamship energetically indicates to New York subway riders that they are at Fulton Street. Made in 1905 by the renowned Rookwood Pottery, it bears out the vision of subway developers to make uplifting art an integral part of the ride.*

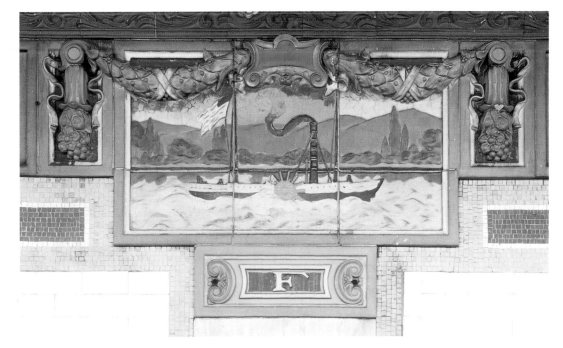

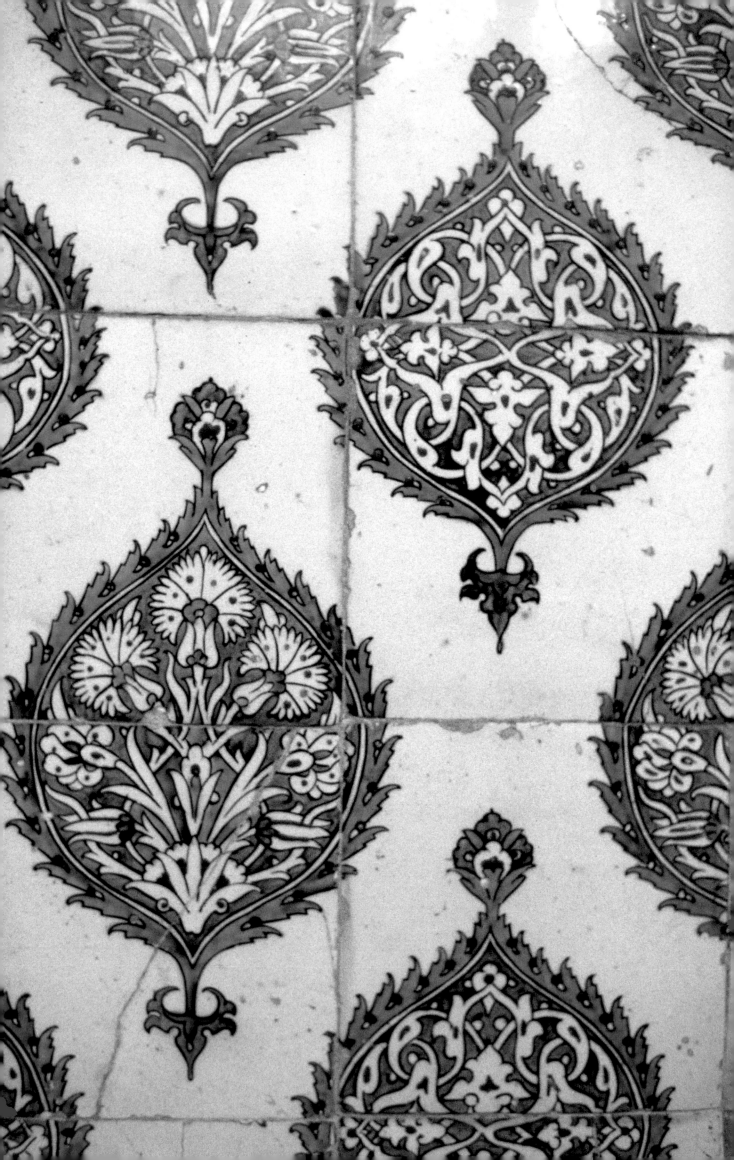

The soul of a culture is in its tile. This is certainly true in the villages of Mexico, where the landscape would be unimaginable without tile (and when, in plazas, tile often *is* the landscape); in the tile designs of Turkey, where the Islamic faith prohibited picturing anything resembling an icon so that even the spirit of flowers were stylized, with petals depicted as ornamental swirls and leaves as pointed geometrics; in the decorative tradition of England, which is preserved in vibrantly colored peacock tiles designed by William Morris and in the rich majolica-glazed tile that covers bars there; in the storytelling tiles of Portugal, where tile has been such a national form of expression that an entire life story may be shown on one wall; and in the pure beauty of persian tiles that are shaped like stars, bordered in bright blue, and centered with fine and still galloping horses. Even Americans have revealed their young culture in tile, with the opalescent tiles of Louis Tiffany and the many beautiful creations of late-nineteenth- and early-twentieth-century potteries that covered even ceilings of public spaces, such as train stations and restaurants, with striking handmade tile in a decorative reaction to the industrial revolution.

In public spaces tile evokes another type of human response because there it is a shared experience. Tile is public art, occurring in every kind of space, from banks and train stations to park benches and diners. When the New York City subway system was built around the turn of the century, its planners ordered it covered in tile because they knew the forms, colors, and designs of the material would relieve the impersonal nature of mass transit. They knew that with tile, art would be present. The passengers of the subway live with the

Only tile could convey the monumentality and splendor of the Ottoman Empire at the fifteenth-century Topkapi Palace in Turkey. The "Adobe of Felicity," where the harem assembled, was walled with Iznik-style tiles (LEFT), *adapted from Chinese motifs. The tiles are typically Turkish in pattern, stylized to avoid any representation of an icon. At the "Courtyard of the Black Eunuchs"* (BELOW) *the tile, still vibrant after five centuries, may have provided the only good association with the space.*

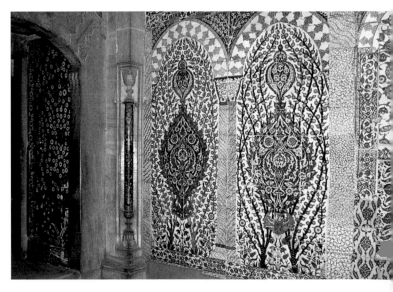

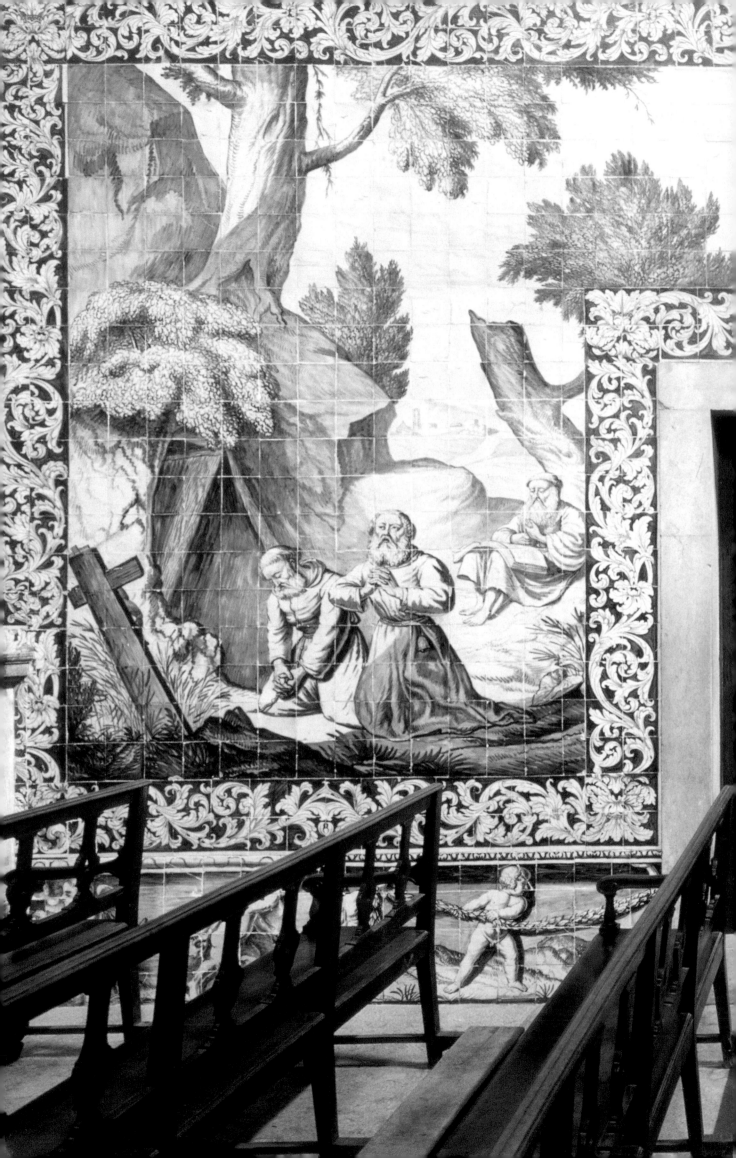

One of the purposes of Portuguese tile, called azulejos *for its blue tones, is to tell stories. At the Madre de Deus church in Lisbon* (LEFT), *eighteenth-century tiles commissioned by the Portuguese and made in Holland show thoughtful monks having discussions with God while mischievous angels below represent the senses. Real grass grows into a ceramic meadow of seventeenth-century Portuguese tile* (FOLLOWING PAGES) *in the gardens of the Palacio de Fronteira outside Lisbon. Following the artistic tendency of the day, animals are portrayed with much more character and life than people.*

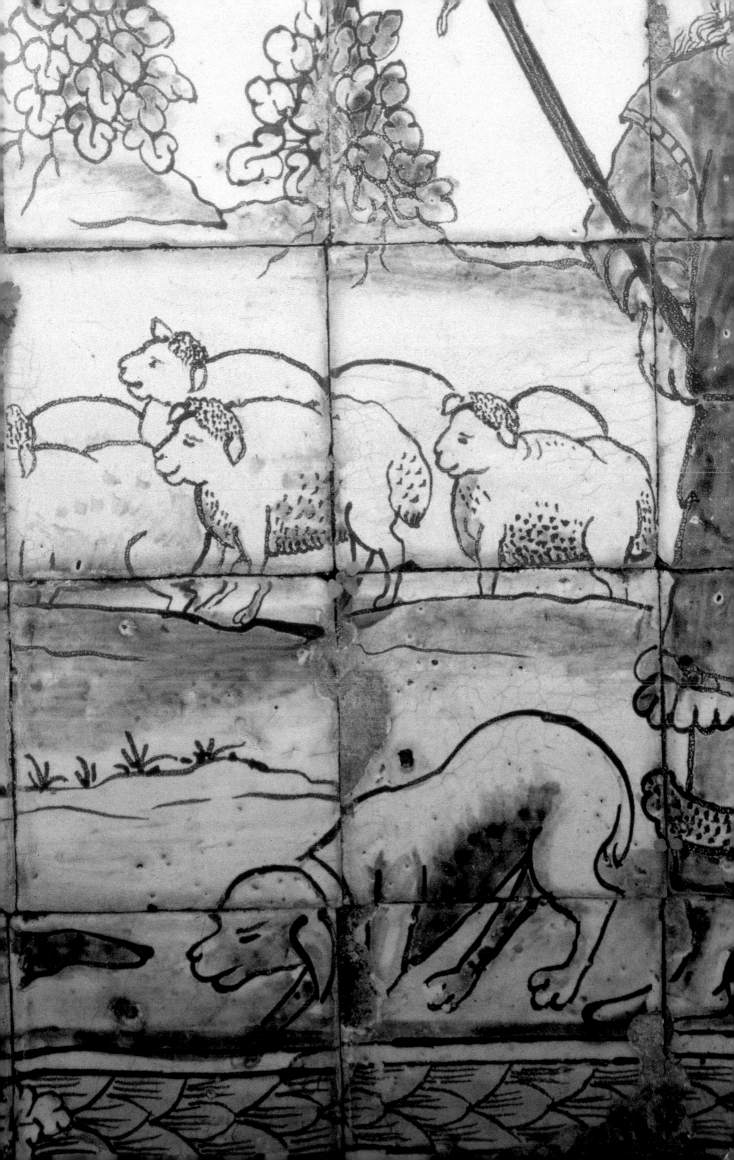

classic tile panels and many-colored signs that change shades as the trains travel outward—black, midnight blue, and light blue panels with white letters change to wonderfully unlikely colors like burnt orange, and then to shades of plum and blue as the stations get closer to Queens.

The underground train stations of other cities are also graced with tile, from Moscow's, which are covered from ceiling to platform in luscious blue, red, and white designs, to London's, panelled in white with colorful graphics, to Paris', stylized and artistic. Los Angeles has taken to tile in its new Metro, with designs depicting everything from movie scenes to the lives of various communities through which the trains run. By virtue of being public, the tile creates a community of all those who pass by it, walk over it, look at it, appreciate it, and touch it. By virtue of being beautiful and transforming the space, it is art.

Tile is also capable of being a compassionate material, respectfully resonating the spirit of whatever is around it. As the material of many church floors and mosque domes, it takes on a sense of the sacred, being knelt on and prayed under. At Friends in Deed, a center in New York City formed to support individuals with life-threatening diseases, designer Bob Patino laid the floors with paced squares of warm, dark gray tile. Running throughout the center, the tile has a healing, soothing effect and evokes a sense of kindness. At the Holocaust Memorial Museum in Washington, D.C., a wall of thirty-three hundred tiles created by children to express their feelings after studying the Holocaust is a testament to tile's ability to resonate spirit. One tile has a tulip drawn on it next

BELOW: *Generations of dinosaurs from classic films were let loose on the walls of the Los Angeles Metro. Created by artist Joyce Kozloff, the tiles run all along the walls like a film strip, showing hundreds of beloved movie scenes. Tile builds on itself, creating a whole when distinct units are used together.*

OPPOSITE TOP: *An entire chapel at the Sao Roque Church in Lisbon is tiled in a mural which dramatically tells the story of a plague. In one panel dating to 1584, a faithful dog brings bread to his master, who is struck with the disease. The tile, though Portuguese, draws on the colors and flowing patterns of Spanish tile.*

OPPOSITE BOTTOM: *Celebratory tile on the new Seattle Art Museum designed by Venturi, Scott Brown and Associates draws people into the building.*

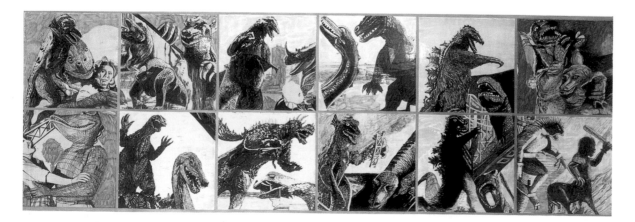

to the word "Hope." Since tile is a permanent material, the messages are eternal as well.

Because of its remarkable range, however, tile also has the ability to be fun and celebratory. Architects are responding to this potential in public buildings, brightening the urban landscape as they do so. They are building on examples of spaces where tile was used with a sense of humor and made the space special. Grocery stores in Puerto Rico picture the goods available all around the store in tile—all the cuts of meat diagrammed on tile animals, tile vegetables and fruits floating above the produce section. In Los Angeles, a man who worked for a tile showroom and brought home pieces of the material every day made a cultural icon by building towers 107 feet up into the air and applying tile to them, creating the strange and wonderful Watts Towers. Artist Friedensreich Hundertwasser revolutionized Vienna by going against the strict rules of the city's architecture, splashing the color and designs of tile across an apartment building, and then created the KunstHausWien, a museum with a floor of undulating tile delightfully and unevenly placed.

So today, architect Bernardo Ford-Brescia built his own tile floor in an office building in Miami by hiring artist Carlos Alves to create a mosaic of huge swimming fish and coral against a bright blue sea of tile. Architect Barton Myers covered the Cerritos Center for the Performing

RETILING DUBROVNIK

Dubrovnik is a city full of art, history, and outstanding architecture, but much of its culture can be understood by looking down on it from the air — at its rooftops. Classic rounded terra cotta tiles cover the tops of the buildings in the ancient Croatian city — the peaks of small shops, the chimneys of stone houses, the bell towers of baroque churches, the expanses of palace roofs. The long, half-cylinder tiles slightly overlap each other and run side by side on vast stretches of roof, telling a story of the deep history and rich culture of the city. Some tiles are newer and ruddy; others, near the Adriatic Sea, are bright red from the salt air and baking sun; many others bear an artfully weathered palette of blues and silvers and browns from their continuous presence on buildings dating back to the fourteenth century.

But after Dubrovnik was attacked by Serbian forces in the early 1990s, large pieces of the city's fabric were destroyed, with shells falling on more than half of the legendary roof tiles. The Buy-A-Tile program of the Rebuild Dubrovnik Fund allows citizens of the world to help rebuild the roofs tile by tile. For $10, anyone can purchase a tile that will be applied to one of the buildings of this medieval city to help restore the landscape of roofs that distinguishes it. The tile may end up on top of an ornate concert hall, a Renaissance palace, a local kindergarten, the library of the Franciscan monastery, a simple house or shop made of stone cut from the quarry on an island just across from Dubrovnik, or any number of other structures of the city that make up its life and contribute to its character as well as its charm.

The United Nations has estimated that 490,000 damaged tiles will need to be replaced with new tiles made just like those of the Old City — from rich clay formed into the traditional rounded shape and baked to a beautiful red-brown color. So far, about 18,000 tiles have been bought and put up on the roofs.

Tiles may be ordered as gifts, for holidays or any time of year, and a certificate will be sent to the recipient to inform him or her of the contribution. To buy a tile for Dubrovnik's roofs, or to receive more information, contact the Rebuild Dubrovnik Fund, 1804 Riggs Place, NW, Washington, DC 20009; 202-462-4883. All monies go directly and solely to rebuilding efforts.

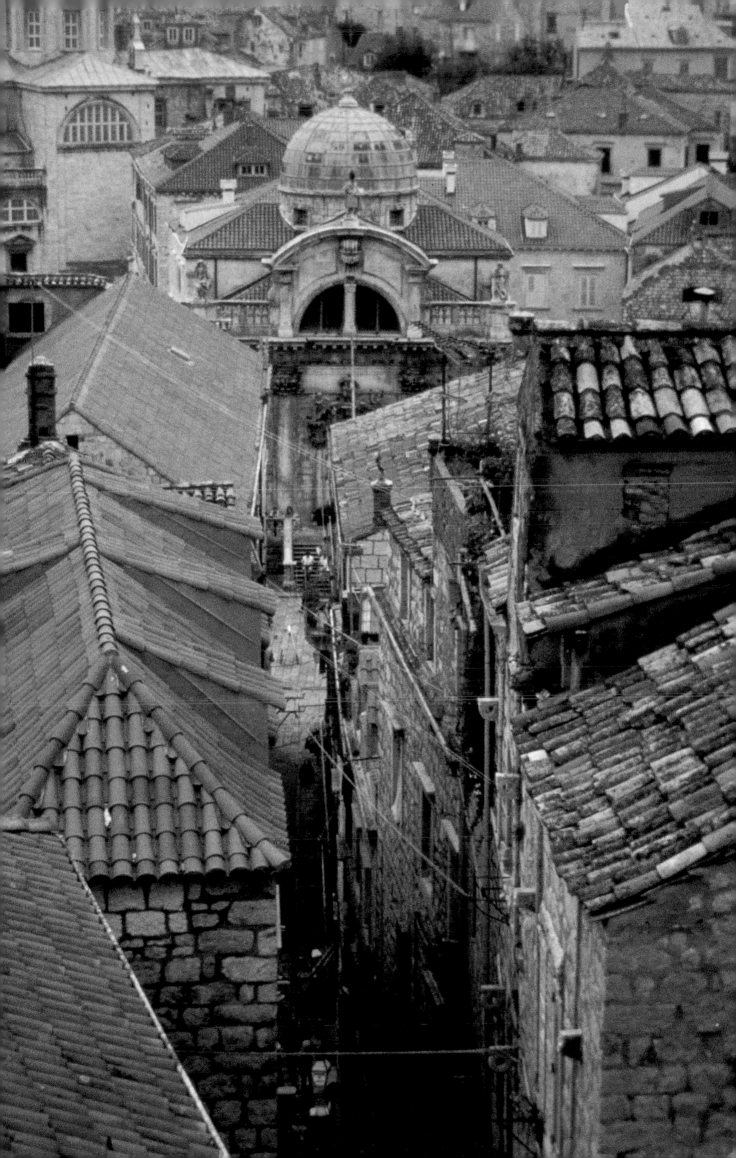

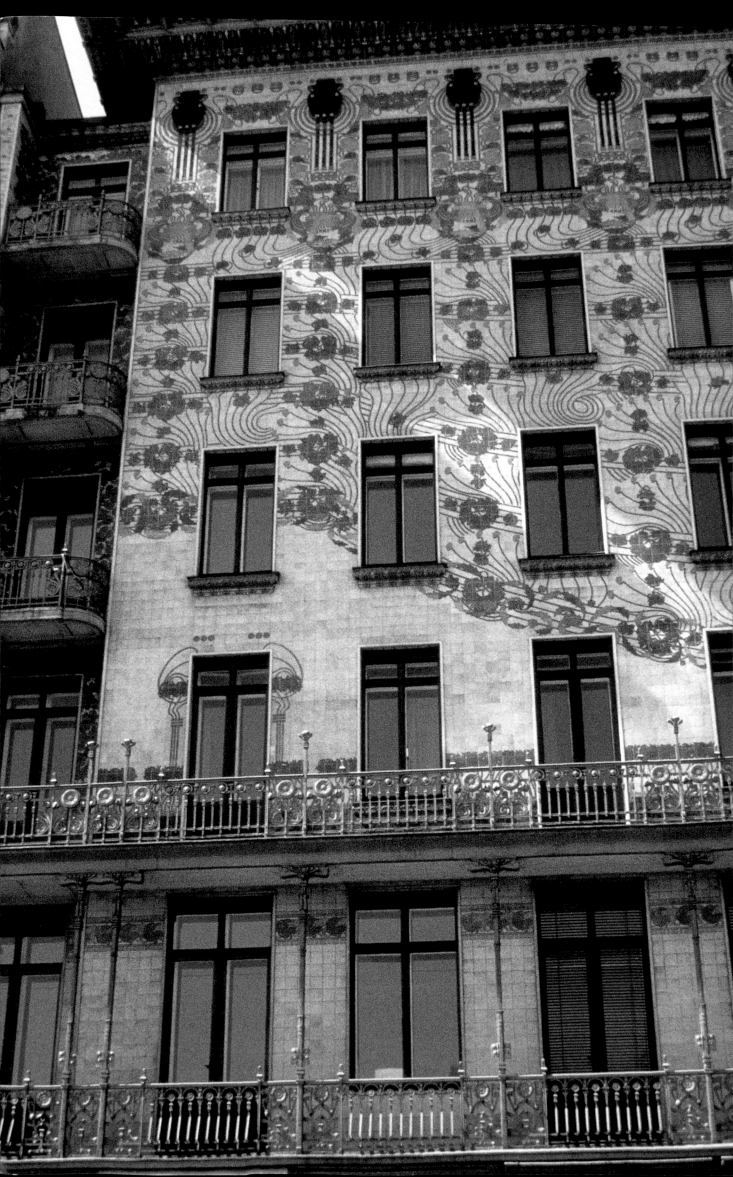

Arts in California with tile designs that were created by artist April Greiman with thirteen colors, two dozen design motifs, and a MacIntosh computer. "People go to the theater to be entertained, so this is a joyful, fun building," says Myers. "The celebration is built right into the graphics." And the Team Disney building in Orlando, Florida, was designed by architect Isosaki Arata to be a giant sundial, with tile measuring the days, hours, and minutes.

The bright colors and designs have another purpose, as well. They draw people into a building, piquing interest on the outside to get them inside. In fact, buildings with tile of any kind on them are not just more interesting, but are ceremonious. They are what architect Aldo Rossi calls "urban points of reference." A building with the ornament of tile on it, after all, is a building that looks like it matters. It must be loved to get such treatment. That is why official buildings for centuries have incorporated tile—to establish their place of importance in the community. On official buildings in Old San Juan, Puerto Rico, tile is a layered experience, appearing here and there at every view of the building, as people enter it and as they walk past it. Where the site and the building move uphill, the tile moves with it, measuring and ornamenting the building like a chair rail in a dining room.

All of these elements—the art, culture, and history of tile; its properties of color, pattern, and texture; and its ability to be interpreted in many different ways—are inherent in its rebirth today. As in so many areas of architecture, art, and design, a historical base has given an art form a new future.

LEFT. *The MajolicaHaus ("tile building")*
in Vienna is a testament to the Viennese
love of ornament in architecture. Building
dwellers can sit on their balconies sur-
rounded by enormous Art Nouveau flowers
that stretch out for a full story or two.
RIGHT: *In Seville, residents even tile the*
bottoms of their balconies. Anyone walking
by and looking up benefits from the
element of surprise that the Spanish are
famous for provoking with tile.
Here the architect signed his name in tile.

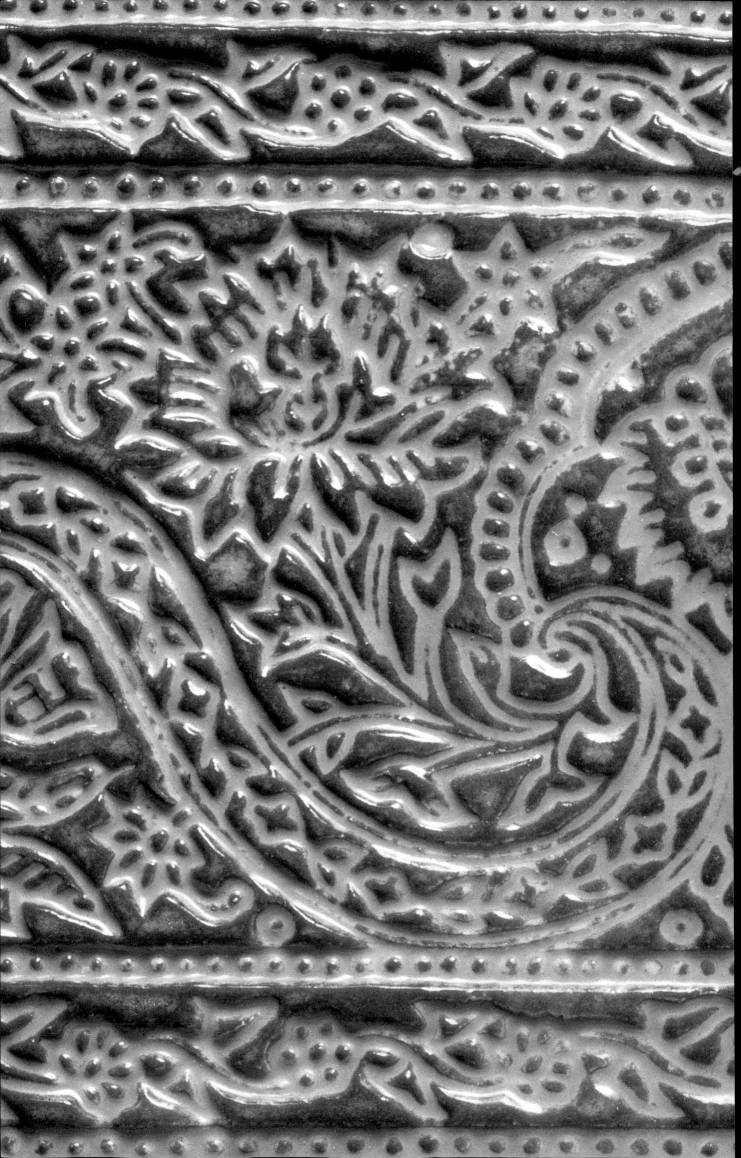

TILE TODAY

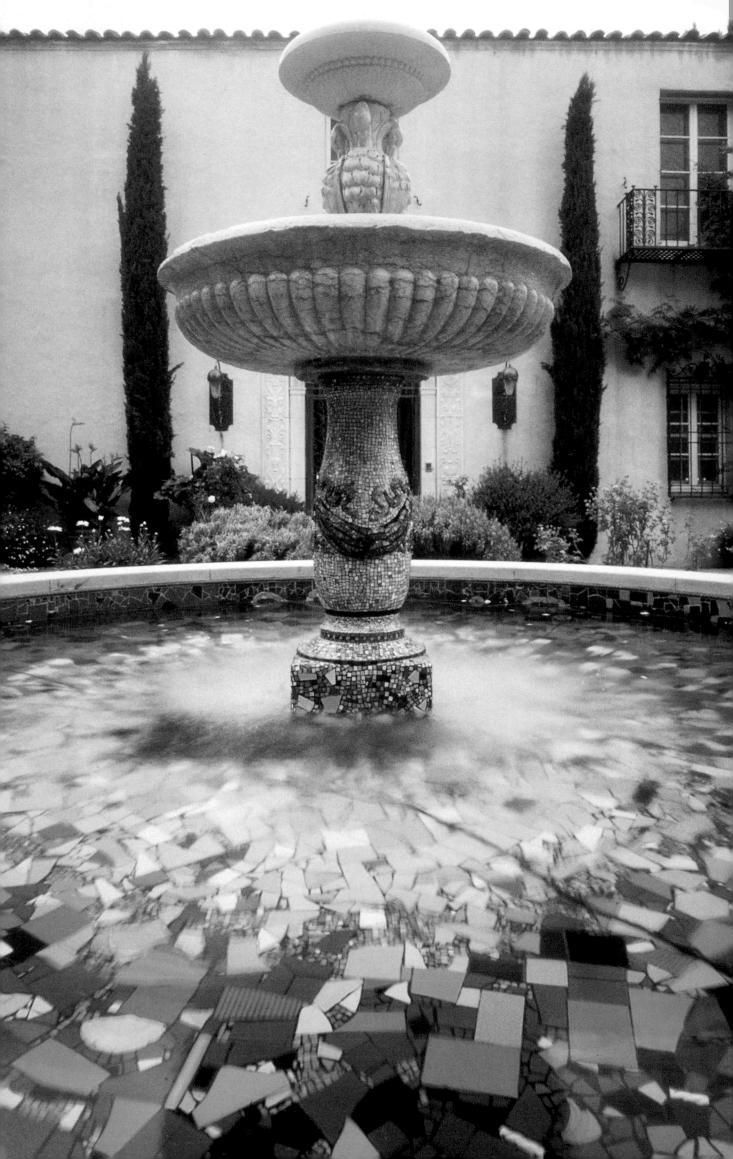

The Tile Universe

Dressed in style, brand new tile . . .

FROM THE 1911 SONG "ANY OLD IRON"

Despite its colorful history, brand new tile for the home has often meant rows and rows of shiny white squares. Though the appeal of the basic white square has never died, today every property of that form has been elaborated upon in literally countless ways. The colors, patterns, and designs of tile today are astonishingly diverse, beyond cataloging. Its surface may have any number of types of glazes, or no glaze at all, or it may feature different textures, or have relief designs on it or patterns carved into it. It may not even be a square anymore, but may take any number of shapes, in sizes from tiny to enormous. A tile is still a clay surfacing material that has been fired. Beyond that, it has endless manifestations. But because its character is so strong, it is always delightfully recognized as tile, no matter how many different ways it is interpreted.

Tile design is exploding today with such force it seems as if the material has just been invented. Instead it is being reinvented, again and again, in exuberant, stylish, smart ways that give testament to its flexibility. It is being explored to its fullest potential, although that potential seems to be limitless. Its possibilities are as varied as the visions each artist has for it, as numerous as the ways in which it has been interpreted throughout history, and as innovative as the technology and styles of today.

To make it easier to understand what's out there, today's tile has been categorized for this book into four groups: tiles of art, which are handmade or handpainted; tiles of culture, which refer to

There is a huge range of tile available today, with more types to choose from than ever before. Tile may be handmade art, like the one by artist Laura Shprentz (PRECEDING PAGES) that was inspired by medieval tapestry designs; or a mosaic, like in a fountain (LEFT) created by designer Nancy Kintisch for the front of a Beverly Hills home; or imported, as Tunisian tiles were (BELOW), by Metro Inter. Co. Many designs today mix these different types together.

imported tile or imported looks; tiles of style, which are manufactured by machine from clay dust, as opposed to being handmade from clay, in contemporary designs; and mosaics, an ancient art form that is being recreated today by artists and offered in pre-made pieces by companies. Tiles are not organized this way in showrooms, but these categories make it easy to understand them in terms of design. Designs today, of course, are not limited to any one of these groups of tiles. Instead, it is common for many types of tile to be used in one space.

TILES OF ART

Art tiles are probably the fastest growing and most diverse type of tiles today. They are now in the mainstream — suitable for many kinds of use, available in showrooms. The new enthusiasm for tile in general, and handmade or handpainted tile in particular, certainly is a reaction to the technological age. As more and more Americans' lives become run by technology, and as they spend an increasing number of their hours in cyberspace, they want the human touch that the decorative arts represent and the sensuality that tile exudes. As artist Frank Giorgini says, "People want something that someone has touched, something imperfect." With tile, they get the work of the hand. Few things could be more personal.

In other decades, tile has been art. Picasso painted tiles that were set around pools in Spain. (Most have been removed and sold.) Salvador Dali put his strange and fantastic visions on tile. Kenny Scharf splashed his vibrant primitive and urban expressions on tile.

Many of the artists making and selling tile today are fine artists who have worked in other media. They see tile as a canvas for their art. As with photography, tile provides a distinct space within which artists can frame an image. On this surface, they can create expressions in what artist Miriam Wosk calls their "vocabulary"—color and pattern, with a depth of color not available in any other material and a potential for pattern that is limitless. But beneath the surface, so to speak, there is art in the *making* of the tile body, so that the canvas itself becomes art.

Sophie Acheson etches designs into tiles for a sculptural effect, then glazes them. Acheson and other artists will design custom work; she used the same technique to create a field of ceramic sheep for a little girl's bath.

Some handpainted tile is just standard commercial tile with glaze brushed on and fired to hold the painting. The designs are as individual as the artists who make them, with whimsical faces, beautiful botanical forms that look like they're from an old textbook, variegated colors, and pastel sponged designs. There are blooming roses reminiscent of Georgia O'Keeffe, spreading wildflowers in Andrew Wyeth style, Matisse-like figures and bowls of fruit, and squares covered in a vibrancy of color and design that recall the Fauve artists. There are tiles with a sense of humor, featuring borders of dancing feet, animated household objects, and rows of colorful town houses and taxicabs. Subjects from everyday life are transferred wonderfully to tile, in patterns that look exactly like English chintz, in quilt designs interpreted in an altogether contemporary manner with bright colors and loose patterns, and in beautifully reproduced wine labels and seed packets. These and hundreds of other designs can be bought as they are or custom-designed.

Handmade tile, whether created by a couple in New Hampshire whose pottery is behind their house or by a company made up of dozens of artisans, is made in much the same way that it was in medieval days. In the current tile revolution, potteries and companies that make handmade tile of widely varying types have sprung up everywhere with a purely American style. With its honest forms, its irregular texture visible as the light falls on it, and its magical glazes, handmade tile is true art. No two handmade tiles are alike. Each, as artisan Ted Lowitz says, "has a story to tell."

ABOVE: *Handcarved borders, such as the "Family and Tree" designs from Trikeenan Tileworks, can be used to finish single-colored field tiles. The tiles' shimmering surface, created in this case with "galazy glaze," is only possible when the tile is handmade.*
RIGHT: *Falling leaves from Meredith Tile show the range of glazes available in handmade tile—high gloss, low-gloss, no-gloss, in one color, two colors, or colors placed on top of one another for a double glaze.*

Much of that story is in the glazes, which transform tile in a striking range, from matte glazes with flat color that let the natural character of tile show through to glossy glazes that are so lustrous they glow. There are glazes that are nothing less than active on the surface of tile—mirrored glazes reflect; iridescent "raku" glazes shimmer with uneven color like the ancient Chinese pottery from which they are adapted; metallic glazes shine with rich metals; "crackle" glazes seem to give off energy with the wandering lines that shoot across them. The look of one glaze may vary widely even from tile to tile. Some are so unpredictable in their colors that the same batch will produce several dramatically different shades, going from light to much darker. Put together, these form beautiful, undulating planes of color.

Many art tiles today have relief patterns that are so striking and singular they are often used in monochromatic designs—say all white, all ivory, or all green. The effect is that the subjects of the tile, whether they are M. E. Tiles' angels and architectural columns or Sonoma Tilemakers, fruits and elaborately designed borders, stand out like sculpture.

Other raised tiles, such as Talisman Handmade Tiles and Terra Designs' Firenze line, are patterned in white or light clay swirls designed to look like elaborately carved stone. The full patterns of the "carvings," however, come together only as individual tiles are placed next to one another, making for an intriguing look as the eye tries to comprehend tile that looks like stone and stone that looks like tile.

Handmade tiles are particularly appropriate for reflecting nature, even if they sometimes defy it. Ceramicist Susan Tunick creates bright, high-relief purple and blue leaves along with the more realistic red and yellow ones of fall. Surving Studios offers chameleons in relief tile with their tongues out trying to catch blue dragonflies two tiles away. Pine needles, falling leaves, ladybugs, and butterflies are caught in tiles with astonishing vibrancy. The arts and crafts style, which has always taken nature as its starting point, fits in beautifully with today's environmental themes. The many lines of this style available today are made up of finely carved and naturally colored plant and animal tiles, breathtakingly formed and proud in their handmade environments. Rough, natural looks are created with sandy glazes and irregular shapes. To show that their tile is handmade, Epro Tile has their artisans "sign" each clay body with a thumbprint, which becomes part of the design.

Handmade tiles may also be marked with etchings showing anything from petroglyphs that suggest cave walls to single artichokes, sunflowers, or a child making a snow angel, for example. "Cuenca" ("little valley") techniques

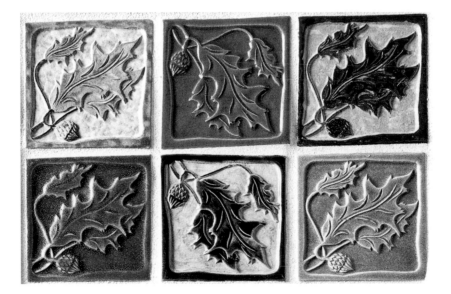

create etchings on the tile for glaze to fall into, separating glaze colors and thereby making the design that much more graphic. As many as sixteen different colors may be used in one tile to create vibrant patterns.

Shapes are very free in handmade tile. Four tiles may be pieced together to create a full image of a tree, a pitcher pouring milk, a vase of flowers. Round tiles, such as those originally created for architect Isosaki Arata's Team Disney building using a paper cup as a cutter, have become available—and are especially useful, partly because they fit on rounded or undulating walls. Tiles may also be shaped like falling leaves or jumping fish, as in Griffoul's line of happy ceramics.

Every design style is now being interpreted in clay. Art Nouveau willow trees weep on tiles from companies such as Meredith. Southwestern-style tiles such as those from Counterpoint Designs and Dunis Studios feature jackrabbits jumping across them; borders of running horses, rope, and barbed wire; and the dusty blues and pinks of the desert. Deco-style flowers made by artist Sue Burnett are framed with patterned borders. Designs in Tile faithfully recreates historic patterns from their large reference library in styles as diverse as Pennsylvania Dutch and Prairie.

In fact, reproductions of the fabulous tile from early-twentieth-century America are enormously popular today. The last tile revolution was in direct response to the industrial revolution—just as the current one is a reaction to the "information revolution." Some of the tile companies of that period, such as Pewabic in Detroit, famous for their iridescent glazes, and Moravian Tileworks in Doylestown, Pennsylvania, known for their flat glaze designs of figures and characters from literature and mythology, still produce tile from their original molds or historic techniques.

TOP RIGHT: *Squirrels and owls hold towels while a frog watches over the soap in arts and crafts–style tiles by Pratt & Larson. The husband-and-wife pottery team designed animals into their first tiles while living in a cabin in the Oregon woods. They use glazes that break to get the crackling lines that run across the tiles.*

BOTTOM RIGHT: *Carved relief tiles, such as these celestial ones by Sonoma Tilemakers, are architectural in style, so they work well on expanses of walls.*

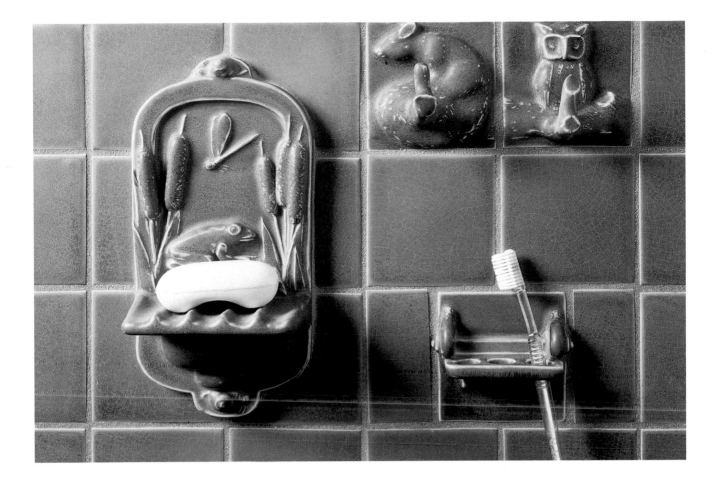

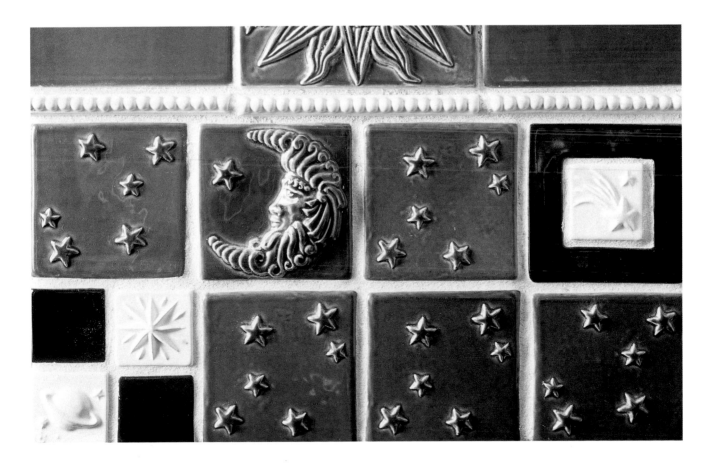

THE MAKING
OF A TILE

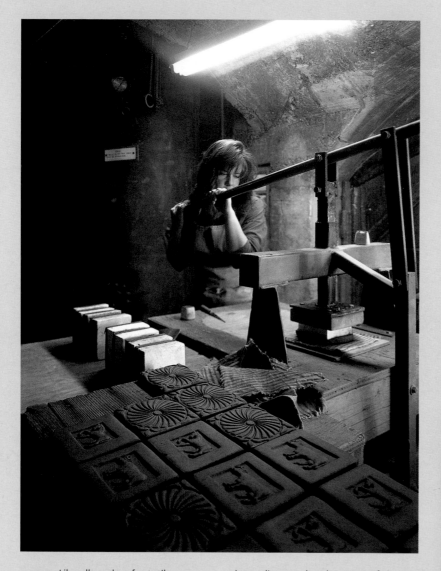

varying amount of flame and smoke. Different tones and textures are created by different kinds of firings. Tiles are fired at temperatures up to 2000 degrees Fahrenheit, sometimes for twenty-four hours or more. The temperature is increased gradually; tiles that are made to be especially strong are fired longest and at very high temperatures. During firing, the glaze becomes liquid glass, adhering to the tiles. When the kiln is turned down and the tiles cool, they become themselves — hard, strong, and expressive with color, shine, or texture.

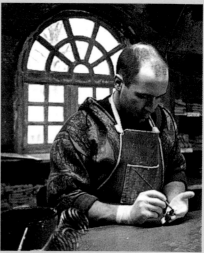

ABOVE: Like all works of art, tiles are created through a process. They may take days to complete. Many potteries, such as the Moravian Tileworks in Doylestown, Pennsylvania, shown here, grew up around areas with the richest clay. Moravian is a "living museum" that still makes tile with its 1930s mold designs. Clay is shaped by hand or, if there is a relief or imprint design, pressed by heavy weight with a mold that has been sanded to prevent sticking.

RIGHT TOP: Tiles have to dry completely before being glazed, sometimes for days or even weeks,

depending on the character of the clay. Then they are dipped, poured, or painted with glaze. The relief tiles at Moravian Tileworks are painted with a brush to produce different colors on various parts of the design. The glazes bear little resemblance to the magical surfaces they will become later; their colors are hardly distinguishable until they are fired.

RIGHT BOTTOM: Firing can make a huge difference in the character of the tiles produced. The kiln at Peace Valley Tile in Pennsylvania, shown here, is gas-fired, but some are fired with different types of wood, each of which emits a

Most other tileworks of that era are now closed, but today's artists are keeping their designs alive by reproducing them. Marie Tapp Glass makes tiles for the restoration of historic buildings and houses, such as those harmed by earthquakes in California, in the Batchelder style, with the intricate carvings and subtle glazes of that famed arts and crafts—era company. The lovely designs of old California potteries, with their bright colors offset by neutrals mirroring the California landscape, are being brought out again in reproductions. Many lines are available, but the most notable are Malibu and Catalina reproduction tiles, the flowering ceramics touched by lustrous glazes and exotic wildlife, interpreted today by tilemakers such as Richard Keit.

Art tile is available from showrooms and small potteries and artists around the country. Nationally, Country Floors showrooms carry art tile, but a broader range of it can be found at Ann Sacks Tile and Stone. It is also carried by a variety of smaller showrooms such as Tiles, A Refined Selection; Waterworks; Concept Studios; Ceramica Arnon; and Charles Tiles, to name just a few.

This section has offered just an overview of what is available in art tile, with examples to illustrate. It would be a mistake to believe these few pages could carry anything close to a complete description of what is available. Many fine tiles and tilemakers are part of today's movement, and the designs must be seen to be absorbed in their enormity. One tile company, for example, offers twenty-one different interpretations of the sun alone (Rising, Spring, Medieval, Festive, Goddess, etc.). It's a big world of tile. The only thing to do is explore it.

Whimsical designs are typical of art tile companies like Pull Cart. These raised patterns are in their collection, but for an hourly rate, you can paint your own tile or pottery in their studio.

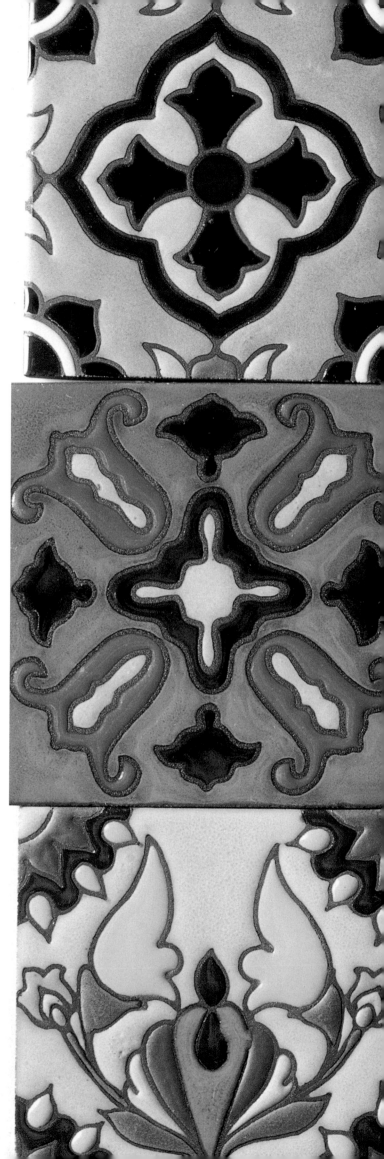

Malibu reproduction tile blooms with the flowers and colors of the California landscape. Replicas of the popular tile made in the 1920s and 30s, before a fire and the Depression closed the factory, are widely available; this is by Mary Reece, who also creates her own designs and distributes them through Venice Tile.

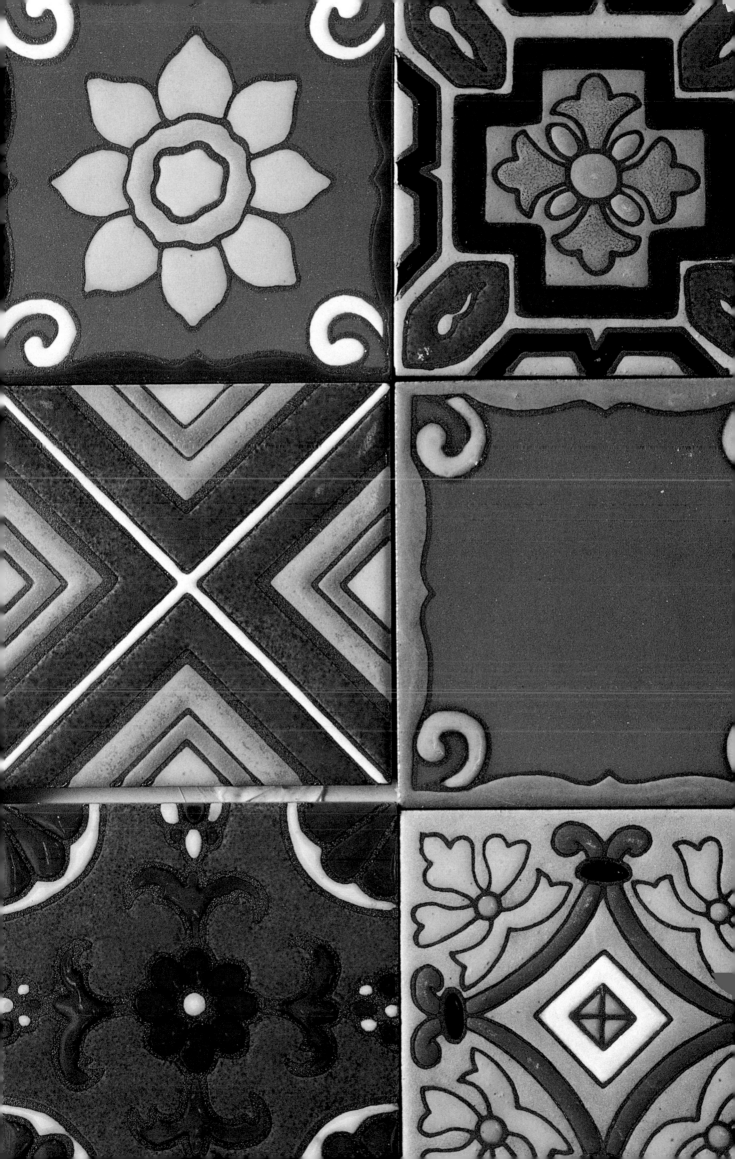

THE SECRET LIFE OF GLAZES

Tile in its simplest form is wonderfully honest: Unglazed terra cotta is earthy, tactile, and primitive, with the look of clay that has been burnished in the sun. This is the most basic appeal of tile, and what makes it so human.

But it is glaze that gives tile its magic. It is glaze that makes it shimmer and shine, that reflects light from the sun or from a subway platform, letting you know that a train is coming around the bend when the glow of its headlight hits the tile. It is glaze that gives it depth of color, rich hues in thousands and thousands of deeper and lighter shades. It is glaze that covers it with a smooth, glassy texture, tempting you to touch it. It is glaze that makes tile come vibrantly alive.

Since magic is involved, it is not surprising that the glazing process is complicated, veiled in secrecy, and often not completely understood, even by those who perform it. As much as tile is a human material, with glazes it acquires a touch of the divine. What happens when a tile is glazed can be explained chemically, but it is really something more like alchemy that produces the result.

Like a love affair, chemical reactions can cause unpredictable things to happen each time a glaze is applied. Because the elements used in glazing, such as heavy metals for color, are not completely stable, the results are often

joyously unexpected. A tilemaker may end up with a different look even when using the same glaze recipe because of the particular firing of the tile, or because of its placement in the kiln, or even because of the weather that day. This is one of the charms of glazes—that in a high-tech age there could be surprises and variations that delight every time you look at a row of handmade tiles in your home and see that each is different from another, like snowflakes, like people, like all things in the natural world. There may be graceful swirls of color on one, or areas of color on another so deep that the tile seems to glow like a jewel, or bright colors on another that fade across the tile gradually like a sunset.

Of course, there are recipes for this magic. Will Mead, who is always coming up with new glazes for Peace Valley Tile, his pottery in Pennsylvania, uses words like "juicy" and "alive" when discussing his most successful formulas. And glaze colors with names like "Elephant's Breath" and "Cat's-eye" from Fulper Pottery in New Jersey and "Waterfall" from Epro in Ohio are obviously highly individualistic. In fact, glaze formulas are considered so important to a pottery's success that historically they have been extremely closely guarded, like the best recipes of great chefs.

Tile may be an honest material, but the intrigue that exists where glaze formulas are concerned is almost unparalleled in any industry. Mary

Stratton of the historic Pewabic Potteries in Detroit was reported to have taken her recipes for Pewabic's famous iridescent glazes—colors with a metallic shine—with her to her grave in 1961. Later it was found that she had passed them on to a colleague who refuses to release them, forcing Pewabic to experiment again and again to try to replicate those fabulous effects of the past. And Fulper Pottery in New Jersey recently revived its tilemaking after the founder's granddaughters discovered the recipes for sixty-five of the original elaborate glazes hidden in the eaves of their grandfather's house, and put fifteen of those formulas back into production for the first time since the turn of the century.

No matter what the recipe, the entire glazing process is not only preindustrial, it is like something from medieval days. In fact, glazes were first developed in the ninth century in Baghdad. Today, as then, powdered metals are used to provide color—iron for red, cobalt for blue, copper for green, manganese for purple, among others. Various portions of the colored powders, with names like "chestnut," "royal purple," and "cossack vivid yellow," are mixed with one another to produce specific colors, including limitless possibilities for shades of black and white.

The triumph of color is never a small one, but with glazes it is particularly remarkable because metals determine the colors. Blue is the simplest

glaze color to achieve because cobalt is easy to work with. Red is very difficult because iron oxides that produce it have to be fired at temperatures so high that they often turn black. The result is a world in which there are many more blue tiles, and many fewer red ones, than any other colors. Today some of the difficulties of working with red glazes have been overcome, but in the past red was a very rare color in tile. Centuries ago in an area of Turkey, for example, only one man had the secret for red glaze. People from all over came to him with their pots and tiles, the designs glazed in every color except red, which was left for him to fill in. When he died, the secret died with him, and it was decades before the formula for red was reinvented.

The mysterious-looking powdered metals are mixed with silica, a substance like ground-up glass that provides the shine of high-gloss glazes. In small, poor villages in Iran, the shiny surface of the tile that covers the roofs of sacred tombs and the floors of mosques is achieved by using ordinary bottles from the trash that have been broken up and added to the glaze mixture.

The glaze is painted on or dipped into, but at this stage there is little

suggestion of the future color or sheen since glazes gain their brilliance only after they have been baptized by fire. It is in the kiln, at thousands of degrees for dozens of hours, that the chemicals react.

Then seemingly bizarre things may be done. In the centuries-old process of raku, the tiles are taken from the kiln and thrown into a pile of sawdust and straw. The straw bursts into flame around the tile, leaving a coating of carbon and ash. When the blackened tiles are cleaned off, a brilliant glaze that has crackled with beautiful wandering lines across the tile is unveiled. Pewabic Pottery is still performing this theatrical method today.

In a nineteenth-century technique called salt glazing, common rock salt is placed in the kiln at the high point of the firing. This creates a rich, creamy, bright glaze called majolica that was popular in England before it crossed the ocean and was applied to terra cotta, looking like icing on a cake. Potteries like L'Esperance Tile Works in Albany, New York, can match vintage glazes such as majolica and others that date back to the 1860s, using seemingly outdated methods. Being antiques, these glazes can result only from such primitive techniques.

Some contemporary methods seem equally archaic, strange, and charming. In one of the most popular, three or four different glazes are applied to produce variegated coloring, and then sand is thrown onto the tile. The tile is fired and may get another coat of glaze and handful of sand before it is fired again and topped with a heavy, protective, clear glaze. The result is the rough, natural look favored today, in dozens of colors from silver and cinnamon to emerald and blue.

The Ancient Sands series from Stellar Ceramics in California and the Sandstone Collection from Epro are two recent examples of this sandy style.

The tiles that are born from these firings glow with a range of glaze types. There are subdued matte glazes, less overpowering than reflective glazes, with their flat color and no-shine surface; gloss glazes, with a high shine; metallic glazes in burnished silvers, golds, and coppers; iridescent glazes that shimmer. Glazes may be applied once, so that the relief design of the tile shows through or so that the glazes break during firing to produce a multicolored effect, or many times, in order to produce layers of color or an extraordinary richness. The glazes may be designed to "craze"—crackle like the ice on trees after a winter storm—or to "smoke" with the wispy beauty of bonfire billows. They may be as translucent as glass or as layered and mysterious as the process that made them.

Speaking about the tile covering a performing arts theater in California that he designed, architect Barton Myers wonders at the power of glaze: "Every once in a while, the sun hits the tile and the black goes gold, like the mosques and other buildings of the desert, and the gold represents the desert sun." Such is the destiny of glazes—to transform tile into a magic material that transports the veiwer to another world. It's little wonder, then, that the methods to make them seem otherworldly as well.

TILES OF CULTURE

Americans have been learning from Europeans, Mexicans, Moroccans, and people of other cultures how much everyday life can be enhanced with tile. Now they are borrowing their designs in order to act on this knowledge. Buying imported tile with rich, exotic, or just different looks is a simple way to incorporate a foreign style into a home. People also seem to like imported tile just because it is beautiful and offers new options for design when mixed with other kinds of tile.

As foreign tile—and tile itself—has become more popular, American companies have increasingly copied foreign designs or incorporated them into their own. Whether you buy actual imported tile or American-made tile that evokes the same feeling may not really matter. The quality and authenticity of imported tile may make a difference, but the American designs are also of good quality and are usually cheaper.

Tiles of different cultures can be pulled together with similar colors. The top tile is a Victorian reproduction from Original Style in England. The one below, which carries the Moorish designs of Spain, is imported by Metro Inter. Co. from Tunisia.

Every culture has expressed itself in tile, and their characters are revealed through it just as they are revealed through their history. An area in England known as "the potteries," because it has been the center of the ceramic industry there for more than a century, offers classic Victorian-style tiles that have been recreated from original pattern books and from the designs of artists such as William Morris and William De Morgan. Paris Ceramics, based in London and with showrooms in New York and Connecticut, carries handmade tiles with the antique look of crackle glazes and designs such as the Old English signs of the zodiac, which resemble a Shakespearean play acted out in tile.

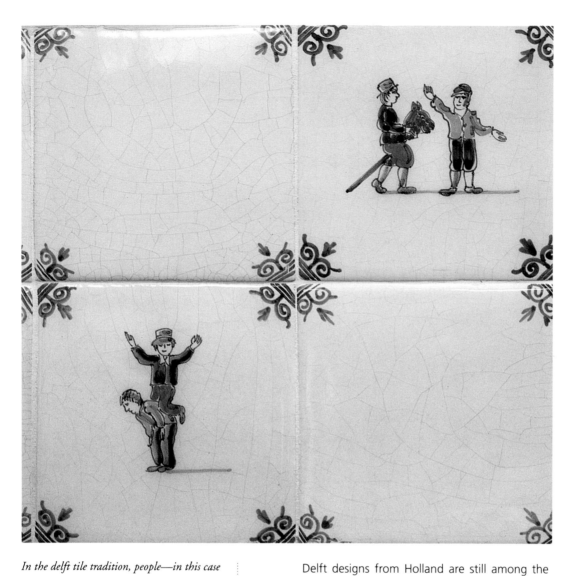

In the delft tile tradition, people—in this case small people—are shown doing their everyday activities. This tile line imported from Holland by Country Floors is called "Children's Games," but many other suppliers also carry delft from Holland.

Delft designs from Holland are still among the most popular of tiles, perhaps because they were one of the first in Europe. Today you can buy imported blue-and-white scenes of people and animals charmingly going about their days, or you can buy reproductions made by American companies like Designs in Tile. There are also lovely tulip panels from Holland, with the long flowers stretching and opening up along two or three tiles placed above one another.

Antique French terra cotta tiles that reflect their regions through their colors—from the yellows of Bordeaux to the roses of the southwest—are being salvaged from barns and 150-year-old buildings. Both Elon Tile and Paris Ceramics sell them today. Emaux de Briare offers a sleek line of small square and fan-shaped tiles in dozens of bright colors, available in America at Nemo Tile. The col-

ors and designs of southern France, including the Provençal blue-and-yellow look, are also widely available.

Perhaps the most celebrated looks in imported tile are from Spain. The ceremonial patterns, intricate geometrics, gleaming checkerboards, and striking copper metallic tiles are history brought to life. Metallic glazes also cover Italian tile in gold, silver, copper, and other minerals. There are also tiles that look like Italian silk scarf designs, in their patterns as well as their finish. The beautiful naive looks of the Vietri region of southern Italy (see page 138), in their traditional blues, greens, and yellows, are purely Italian in another way.

Portuguese tiles are adapted from the exteriors of buildings there that have, in every era, been covered in tile. Murals, classic blue-and-white designs, beautiful checkerboard tiles, elaborate patterns, and peasant-style paintings of meat and game hanging from hooks are all beautifully handpainted.

Original Moroccan tile, with its vibrant colors and patterns, is imported here along with tiles from Tunisia by Metro Inter. Co. Moroccan tiles are also reproduced in tile rug designs and in the many-pieced forms of stars, circles, and diamonds that are typically Moroccan, and are available form Country Floors.

Japan is not a country that usually comes to mind when thinking of tile, but its exports offer unexpected styles that can be used to build wonderful, ordered grid designs. There are unusual rectangular shapes, and a smart "1,2,3 Collection" that makes the same tiles available in 1-inch, 2-inch, or 3-inch sizes for interesting combinations. Cepac Tile supplies these in America.

American companies now replicate the golds, silvers, coppers, and other minerals of Spanish and Italian tile, as well as the greenish patinas that come with age. These particular borders are from Country Floors.

TERRA COTTA

Terra cotta translates literally from the Italian as "cooked earth." It is the most elemental form of tile, with no glaze and no color. It is, as it has been for centuries, rustic and ruddy and incredibly beautiful. Today, however, there are new breeds of terra cottas that take the basic form and add something strikingly new to it. These, together with the traditional terra cottas, offer a wide range of tiles that are so beautiful and varied, you could live with terra cottas alone.

Factories in the northern Italian village of Impruneta, from which most terra cotta still comes, are testament to the primitive nature of tile. They claim the clay is their secret; the prime material is right in their backyards since the factories are set on the land from which the tile is made. The high concentration of iron salts in this clay makes the tile harder and gives it great color, and it is no wonder. It is the same Tuscan clay that Della Robbia used to make his Renaissance tile medallions, the same earth that produces the grapes for Chianti wine and olives from undulating trees for olive oil, the same clay that the factories used at the turn of the

century to make enormous vessels that held the olive oil.

At the Sannini factory in Impruneta, tile is produced in quantity, but you could be anywhere but the twentieth century. You see tiles spread out on tables to dry in a room lit only by sunlight, or find a man reaching to sculpt leaf patterns onto the side of a six-foot urn that he can't get his arms around, or watch workers emerge from the kilns with clay baked onto their aprons. They get out before the tiles, which have to stay in the kiln for four days before they are ready. The results are as rich as the experience—deep red tiles that glow with the energy of the fire that baked them.

Though most terra cotta comes from Italy, Mexican terra cotta is also widely available. Called Saltillo tile for the region where it is made, it is a softer terra cotta but no less charming. After the tile is shaped, it is usually placed on hillsides to dry before firing. Since animals often wander in the area, it is not unusual to receive a tile bearing the paw print of a deer or dog. When the tile is fired, it takes on varying colors, depending on its placement in the kiln; those nearer to the fire are more yellow and the ones far-

ther away are more red. The appeal of the tiles is that they are very obviously handmade and create floors that, in the words of designer Leslie Fossler, "look like they've been somewhere."

Terra cotta floors naturally resemble the ground because of their earthy tones. And they age interestingly, with many of them taking on a patina like leather. When used on walls with other tiles, their honest look can keep colored and patterned tiles from being overwhelming.

The new terra cottas keep the integrity of the original material but add pictures and designs in colored glazes that are painted lightly on top of the tile or engraved into it, covering only a small portion of the overall tile. Or they have no glaze but are patterned with naive designs. The ancient Greek three-finger tile, which is marked with the simple design made when fingers are run on the clay surface of the tile before it is fired, is widely available again.

There are, of course, potteries in America that make terra cotta. Peace Valley Potteries' terra cotta tiles come out of the kiln looking like cookies—some burnt a little in places, others baked just right. Seen from a distance, these random marks form a beautiful pattern in a floor.

Terra cotta is probably the most widely available form of tile. Although all of the kinds discussed here might not be found in a tile showroom, every showroom will carry some kind of terra cotta.

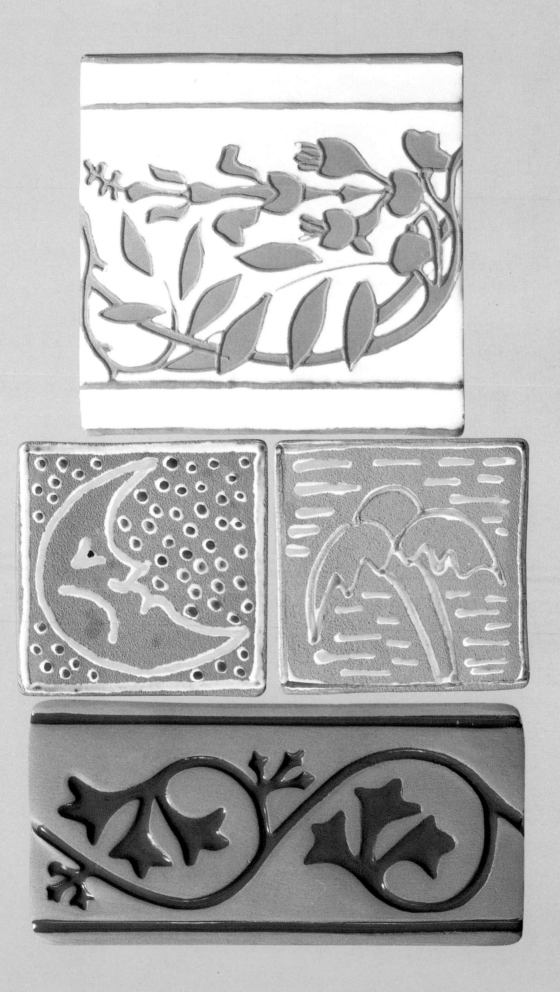

Ethnic looks, from dark-colored Indian patterns to primitive and vibrant Caribbean designs, are being splashed across tile. They are available from Antigua and Walker Zanger.

Country Floors carries the most imported tile of any national showroom and will have tile of all the cultures discussed here except the Japanese and ethnic looks. The bright, rough, floral tiles of Mexico are carried by Elon tile. English and Italian tile is available at Hastings Tile. French, Spanish, and Portuguese designs are carried by a number of large showrooms, including Walker Zanger, Ann Sacks Tile and Stone, and Elon Tile.

The exotic looks of Moroccan tile are being replicated by American companies; in many cases, it is hard to tell the two apart. Single tiles formed from smaller tile pieces (ABOVE) became a Moroccan-style mosaic. Traditional patterns that look like they were lifted from rugs (BELOW) come in many color combinations.

TILES OF STYLE

There are many ways in which the styles of today are being interpreted in commercial tile—that is, tile that is machine-made—with the help of technology and mass production. It is nothing less than impressive to see the sophistication of today's tastes and the enthusiasm for ceramics come together in commercial tile.

The selection of colors is remarkably wide, including beautifully subtle tones and the rustic shades of nature that are popular today. Glazes are wonderfully varied, from matte (flat finish) to different levels of glaze (lower to higher) to crystalline (lustrous). Commercial tile today also has all sorts of texture it never had before, such as sandy finishes, wavy and ribbed surfaces, and stone-like textures. Sizes and shapes are surprisingly diverse, including huge squares up to 24 inches wide, rectangles that are reminiscent of New York City subway tile, right and left parallelograms that haven't been seen since geometry class, and even tiles by Monarch that snap in half so that you can design with triangles.

With new technologies, as many as seven different colors of glazes may be placed on top of one another to give tile the look of stone.

By applying five or six glazes on top of one another, and using other technology, companies are now able to make ceramic tile that looks like stone, marble, granite, limestone, slate, and leather, in different colors and sizes. The look can be very impressive, and there is no scratching, no staining, and no need to seal this ceramic tile. In addition, it is waterproof.

Borders, trims, and edgings are remarkably varied, including raised rope designs and geometric patterns, metallic finishes, pencil-thin accents, jazzy patterns, and relief flowers and fruit.

Designs are also more sophisticated than ever. Florida Tile's "Confetti" line imitates art tile with its Memphis and harlequin designs. Imported tile looks are also emulated, with inexpensive but less-than-convincing versions of Mexican, French, delft, classic English, sleek Italian, and rustic Spanish designs. Commercial tile is also now available in design styles such as country, Victorian, southwestern, and deco. There is even a Laura Ashley ceramic tile collection out from American Olean. Laufen Tile offers an inexpensive system for customizing tile with decals in two hundred different designs. The decals are individually chosen and fired onto the tile, creating whatever style or look is desired.

Computers are creating other miracles for commercial tile. Imagine Design can take photographs or graphics of anything — leaves, flowers, herbs, tomatoes — and transfer them to durable tile. Computers determine the exact glaze shades and tones needed to translate the images. The result is tiles with photorealistic images or extremely accurate graphic interpretations. For example, their leaf tiles look like a real photograph of leaves, in any color or tint desired. These tiles are custom-designed and more expensive than most commercial tile.

Of course, you can still have tiles custom-painted by some commercial companies, such as Summitville. They can be designed to match wallpaper, fabric, china, or anything else, and can be made into not only backsplashes and counter-tops but switchplates, address signs, and drawer pulls, for example. It costs from about $50 to $200 a square foot to have a tiled scene painted.

Yet another design option exists in the new range of grout colors offered today. Countless shades of white are available, so you don't have to live with stark white grout lines anymore, but surprising colors like red, black, cobalt blue, dark brown, and lavender are also made today. You can get just about any shade in between, as well. Simply changing a grout color can change an entire design, so companies like American Olean are offering coordinating tile and grout designs to suggest good combinations. They, along with Dal-Tile and Florida Tile, also offer complete lines of coordinating floor, wall, and accent tile and give suggestions on how to use them in their brochures.

LEFT: *Commercial tile today is diverse and sophisticated. It comes in sizes and shapes not seen in tile before, from tiny octagons to thick borders; in finishes from metallic to granite-like; in pencil-thin edgings for trimming; with numbers for address signs, words for fun, and cows diagrammed in the European tradition.*
RIGHT: *Classical themes are again popular in contemporary tile. Celestial suns, moons, stars, angels, and the elements of architecture are all showing up on ceramic. The sun and archway tiles shown here are made with decals affixed to the tile and are available at Hastings.*

SHOWROOM SURVIVAL

Walking into a tile showroom these days is like entering a candy store. There are so many luscious colors, delightful motifs, and beautiful patterns all around that you are going to want everything.

Since tile is, after all, an architectural ceramic, it is a major material and no small thing to understand. First, you have to be able to narrow down your choices from thousands to a tile or tiles that not only make you happy but also really make sense for your home. Then you need to figure out how to make them work in a design and in a room.

It is definitely a time to get help. Even if you are working with an architect or interior designer — and especially if you aren't — showroom representatives can be invaluable in your tile ventures. These people work exclusively with tile, so they know it intimately. They also love tile, and they will guide you through the process with the kind of care that they would give to their own projects. During the exhilarating but confusing time of remodeling or even re-tiling, they will seem like tile angels.

Since tile is a very specialized material to be working with, the showroom people will likely know more about it than either you or your architect. But only you know what you like. Walk around the showroom and try to

get a feel for what's there. You can — and probably will — come back several times before making a decision, so just try to take it in on the first visit.

Look at the displays that are set up in showrooms to get an idea of how individual tiles work when put in larger areas. There may be partial kitchens, or a fireplace, steps, single countertops, or just floors with different samples shown every few feet or so. It's a good way to find things out. The flowers that you thought were sweet on a single tile may become saccharine to you when used in numbers, or the colors or designs that struck you as unusual when you first saw them on a tile may seem loud when put in groups. And other tiles that you didn't even stop to consider for long may appear wonderful when installed in a sample setting.

Always, always go into the bathroom when you are visiting a showroom. At the very least, they are great fun to see. At the most, the fully tiled rooms are marvelous displays of striking tile and ways it can be used. They can give you a feeling for certain looks or ideas for combining tile and putting it in the right place.

Smaller displays on chalkboard-size panels, such as the ones shown here in Concept Studios in California, match tile with various borders and show how it looks all lined up in a design and grouted. These are like a little piece of the real thing. You just need to multiply them visually several times to get an idea of what a wall or

floor of the tile might look like. Boards are particularly great for suggesting — and showing — what can go with what. Different tile combinations, tile accents within a larger field, and the use and placement of tile trims can all be picked up from them.

You may want to take along a Polaroid camera to record the looks you especially like. Use the photos to see how the tile might look in your home, and to compare it to other tile.

When you have some idea of what you like, get some idea of what is realistic by talking to a showroom representative. These are salespeople, but not in the sense you may think. They're not as interested in price as they are in design, because that is the fun part of their job. They can help you narrow down possibilities, on the one hand, or give you new ideas for looks you may not have considered, on the other. They know how to isolate certain tiles from among the legions to get the look you want, and how to put those tiles together for the best design. They know what goes with what, and what doesn't. They know how to substitute or improvise when you want to stay on a budget. They know how to keep ornate tile from being overwhelming by cutting its richness with complementary tiles, and they know how to keep a simple tile from being predictable by adding decorative motifs. And they are endlessly patient with your changes of mind or heart.

These people are often the forces behind the looks you see in new bathrooms or kitchens, or other places in the house where tile lives, though they usually don't get credit for it. Many people consider these representatives their best consultants throughout a tile project. They often have the kind of design acumen and people skills that make customers say they couldn't have done their houses without them.

But there are salespeople that have just the opposite attitude. The investment you're making is a big one, usually not only in money but in commitment to a look. Tile lasts, and you probably will be living with what you choose for a long time. So if a showroom salesperson tries to force his or her taste upon you, or isn't willing to spend reasonable time with you, or treats your budget like something that isn't to be bothered with, find a new salesperson — or a new showroom. Most of them are very good at their jobs, and very friendly. There is no reason to work with those who aren't.

The salesperson will follow through with you on your project, helping you if you need to solve problems or add to your tile design.

Some showrooms have annexes or "seconds" rooms where you can find tile that is deeply discounted because stock has run out or there are minor imperfections in the ceramic. Ask about them when you are in a showroom, because they are often in basements or back rooms and not readily visible.

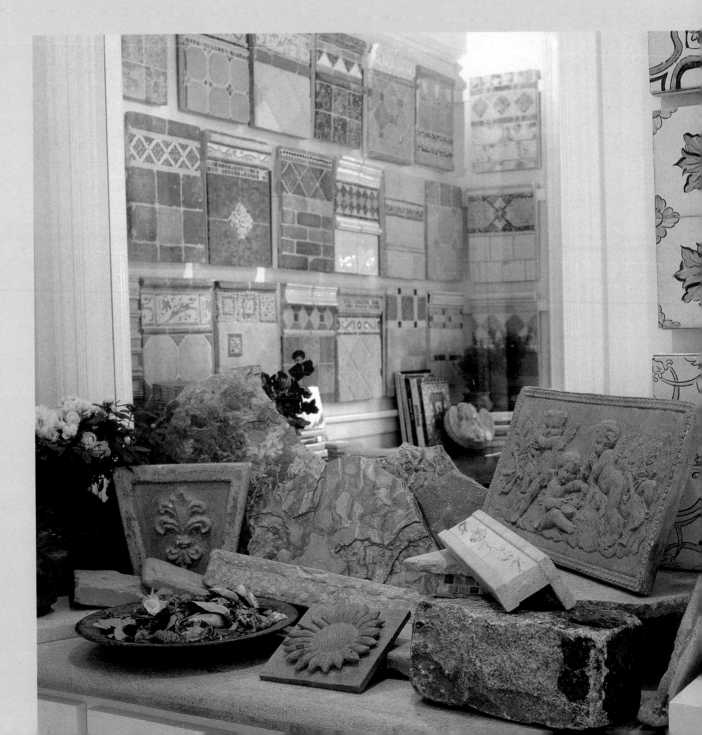

MOSAICS

A fascination with mosaics has been building along with today's increasing interest in tile. Of course, the compelling idea of thousands of gleaming shards forming a grand and expressive design has captivated since Pompeii, where mosaic gods and goddesses spill across the floors. Today, however, people are doing something unprecedented by bringing mosaics everywhere into their homes, either by hiring an artist, creating mosaics themselves, or using the pre-made designs that tile companies now offer.

One of the appeals of regular tile is its order, the grid it creates when lined up side by side. But the attraction of mosaics is in their freedom from order, their ability to spread all over a surface in different designs, shapes, forms, and colors — yet still be tile. The freedom is in the broken shards, a liberation from the distinct square shape of tile. But then there is also a triumph in having pieced together something that is broken into a new, intricate, and elegant image. The idea with mosaics is that if rules are made to be broken, mosaics are broken to be made.

For artists, mosaics make a painterly style possible in tile. They involve, as artist Linda Benswanger describes it, simply translating the color and pattern of canvases onto a "harder material." Julian Schnabel may have started the

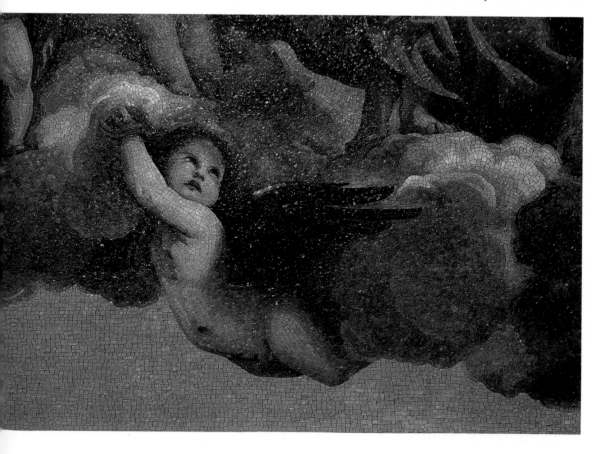

resurgence more than a decade ago when he startled the art world by covering his canvases with broken crockery. But the tradition that artists are building on is ancient, so part of the appeal of mosaics is that they are inextricably tied up with centuries of art and history.

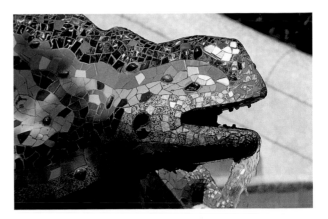

LEFT: An angel flies across the clouds in a mosaic at the National Shrine of the Immaculate Conception in Washington, D.C. The dimple on his arm alone is made up of a half-dozen pieces of tile.
ABOVE: *A fountain at the entryway to the famous Parque Guell in Barcelona was covered with colorful broken tile designs, like the rest of the park, by architect Antonio Gaudi.*

The Romans are closely associated with mosaics, since they spread them across the surfaces of their own civilization, and others as well. These ancient mosaics were more likely to be stone, or a mixture of ceramic and stone. Roman mosaic floors have been found centuries after they were created—still intricate, intact, and breathtakingly beautiful—by farmers in England. The Romans also landed in Byzantium, where they created mosaics carrying powerful messages of Christianity. In Sicily, the mosaics are like ground covers, spreading across large areas of pavement and land in huge designs. In Venice, they take on the most sacred forms, still resonating spirit around the windows and on the floors of St. Mark's Church after years of incense, dust, and tears.

Aztec civilizations dating back to 300 A.D. covered ceremonial masks with vibrantly colorful and expressive mosaic designs. In Jericho, ancient synagogue floors picture religious symbols and writing in subtle shades in thousands of pieces. In Morocco, tiles were made with mosaics, instead of the other way around, by chipping out stars, triangles, and other geometric shapes from stones. Each person formed one type of shape, and the different shapes of all the people were put together to make a complete tile. Much of the tile in Morocco is still made this way today.

In modern times, the Spanish architect Antonio Gaudi, known for inventing "abstract impressionism," covered benches in the Parque Guell and much of the rest of Barcelona in bright ceramic tile. The benches have become famous and beloved worldwide for their textured, swirling mosaic designs.

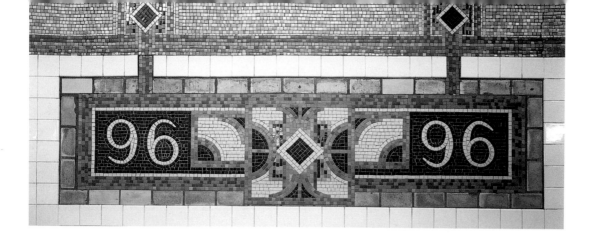

Thousands of pieces of tile form the numbered signs of the New York City subway. This one was reinvented by artist Laura Bradley to replace damaged tile. The old style was kept, with a contemporary design added in the center.

Residents and school kids in New York City transformed the benches around Grant's Tomb, an area in need of restoration, with mosaic taxis, animals, visions of love and music, and other expressions under the guidance of artist Pedro Silva. The scene is now inviting rather than forbidding, made friendly with the warmth of mosaics. The same principle applies in the New York City subway system, which is famous for its century-old mosaics that, like impressionist paintings, are made up of dozens of colors that together create one color on signs announcing the stations. There are also mosaics that create symbolic pictures, such as an historic scene from the area of the station stop. The design is always delightful to make out; depending on the scale of the sign, a piece of tile may represent the wing of a bird or an entire hilltop. More recently, mosaics have been used to make restaurants, bars, and jazz clubs like Iridium in New York City shimmer. Architect Jordan Mozer designed the club to convey music visually, and the floors flow with thousands of pieces of colored tile rising, falling, and coming together up and down the stairs and around the bar like notes on a musical score.

Artists today are creating mosaics in homes for the same reasons that they have been created throughout history. Mosaics have a wonderful rough texture, the light shimmers and plays off the various angles of their colored pieces, and their designs create motion and energy for a space.

Mosaics can create a sense of formality and grandeur or a completely different feeling of fun and irreverence, depending on the design and the artist. Artists work with homeowners to determine what kind of colors, subjects, and overall feeling will work for a space, be it a fireplace surround, such as the one designer Nancy

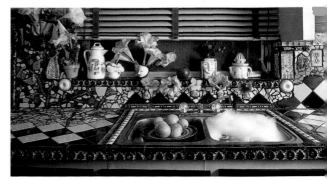

Kintisch created in a Los Angeles home using the original tile that had been found cracked outside; or a birdcage, such as the one artist Kim Rizio covered in a colorful mosaic jungle outside a home in Miami; or a window seat, like the one that designer David Cohn made to glimmer in the sun in a San Diego home. Mosaics are showing up everywhere. Bathroom walls may be graced with classical scenes, like the Pan with pipes that George Fishman created for a Miami bath, or garden walls may shimmer with colored mosaics, or outdoor chairs may even be covered with them. Many artists use a mixture of materials when making mosaics, such as broken dishes, stones, marbles, and pieces of mirrors. "I'll use anything," says Nancy Kintisch, who has been known to smash antiques In order to reassemble the pieces into an exquisite mosaic. This approach, called "debrism," is used to cover furniture and objects as well.

Designers and artists can also create mosaics from the very small square tiles that are sold today. One intricate mosaic scene made from squares was even laid out first on computer, because the graphics of squares were compatible to those of computers. The layout first determined how the design would work visually and then served as a guide to the installation. Though the prices charged by tile artists vary greatly, a general estimate for any mosaic design is about $500 per square foot.

In addition to the small squares designed for making mosaics, there are pre-made mosaics available in classic and contemporary patterns. These come ready to install, like regular tiles and borders, or attached to a square-shaped net so that you can grout it yourself in whatever color you like. Companies like American Olean and Emaux de Briare and showrooms like Hastings Tile carry these. (See page 110 for more on pre-made mosaics.)

ABOVE: *Artist Carlos Alves used everything but the kitchen sink to create a tile environment for a Miami kitchen, including antique tile borders and small ceramic pots for holding flowers.*

BELOW: *When square tiles are mixed with mosaics, a certain artistry and balance results, as in this mural on the outside wall of a Miami house.*

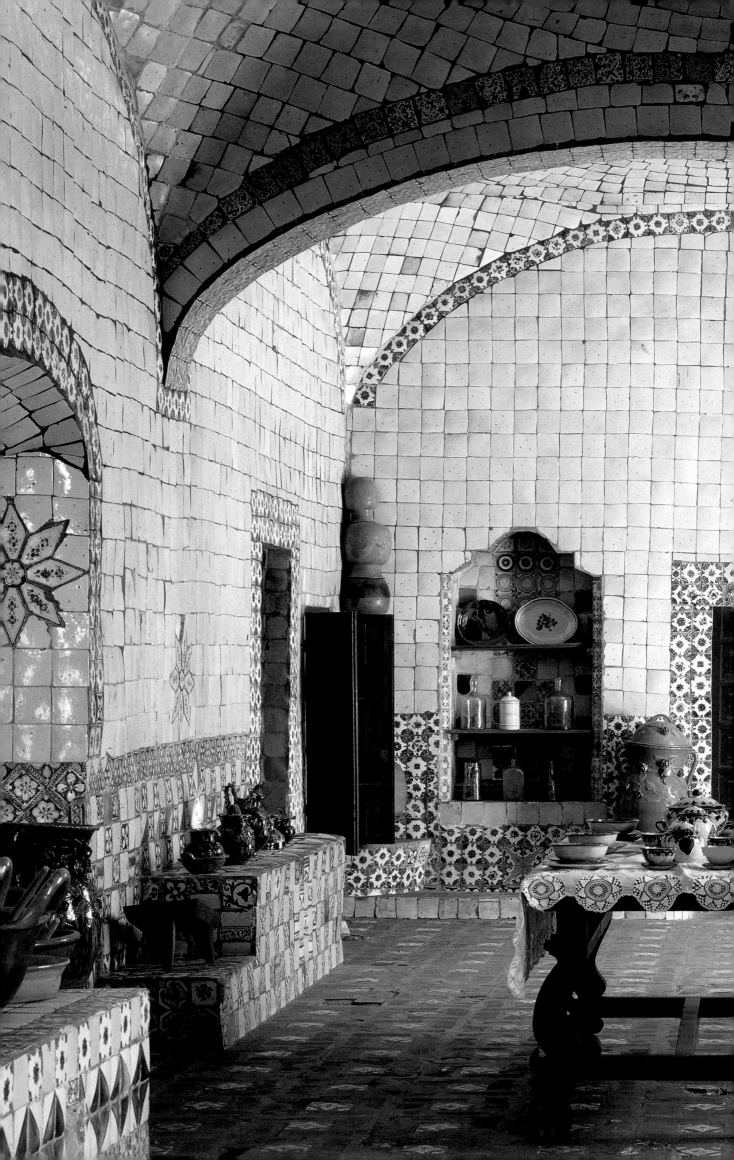

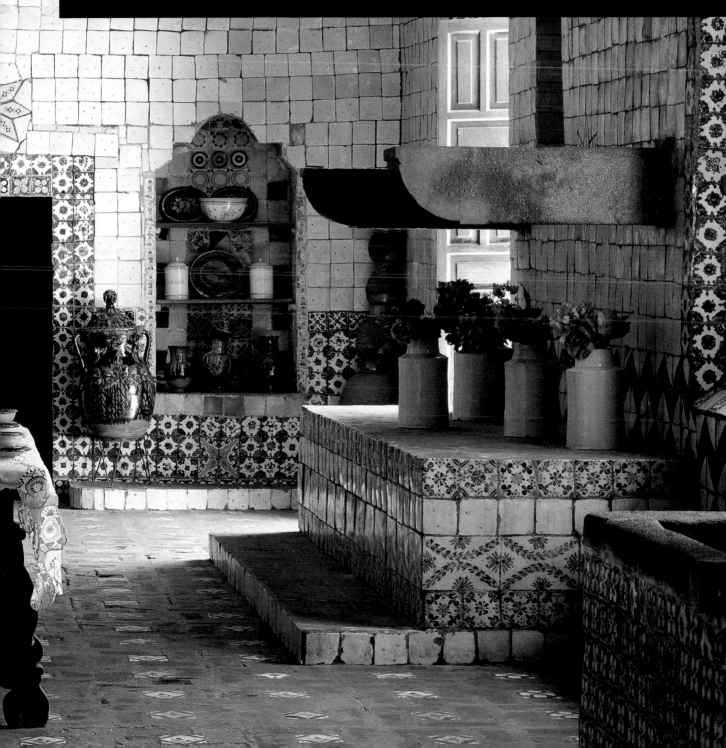

PART THREE
LIVING WITH TILE

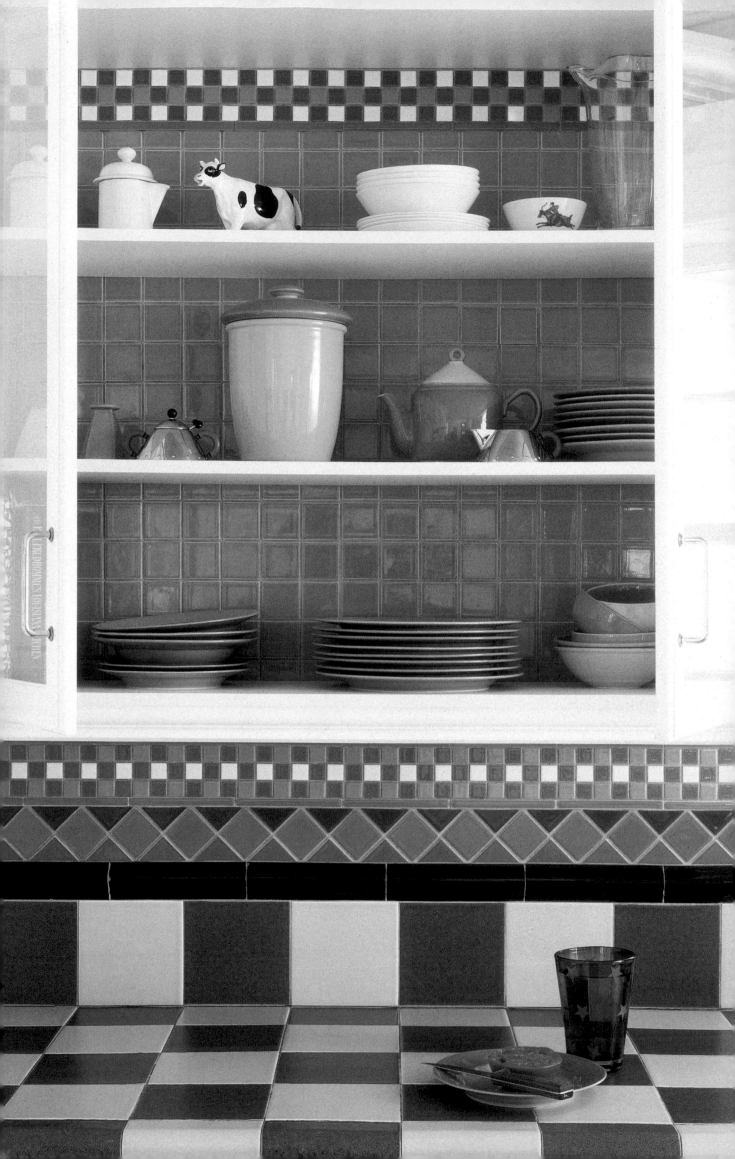

Kitchens

From the entrance door to the kitchen, the floor was covered with black and white checkerboard tiles, a fact often attributed to Dr. Urbino's ruling passion without taking into account that this was a weakness common to the Catalonian craftsmen who built this district for the nouveaux riches at the beginning of the century.

—GABRIEL GARCÍA MÁRQUEZ, *LOVE IN THE TIME OF CHOLERA*

Obviously, you don't have to become part of the nouveaux riches or employ Catalonian craftsmen to make tile a part of your life in the kitchen, but with the artful designs available today that flow luxuriously across kitchen floors, pantries, walls, and countertops, you can feel as though you have done both. Tile in the kitchen has come far from its mundane role as a merely convenient material, from the dull little turquoise or white squares of the '50s and '60s. It is once again—as it was in much earlier days and in more elaborate cultures—not just functional but celebratory.

Tile has been used for centuries in settings that involve food for a number of reasons. It is clean, it stands up to water and to heat, and it is an easy surface on which to work. In these settings, the tile becomes something of an event, part of the fun and drama of the space. Butcher shops in small European towns are lined with tile, spreading from the front counter, where meat is ordered and placed in front of customers, to the cutting blocks where it is chopped, and onto the walls and floors. Huge pizza ovens in Italy, which were replicated in old cities of America by immigrant sons and grandsons who carried on the family restau-

When kitchens are covered in tile, they become like outdoor plazas, whether they are historic (PRECEDING PAGES), such as the seventeenth-century kitchen of a former convent in Mexico, or contemporary (LEFT AND ABOVE), such as one in Washington, D.C. Designer Skip Sroka used standard American Olean tile but made the space remarkable by building patterns with different sizes and colors, using sky blues and dusty pinks to further the feeling of the outdoors.

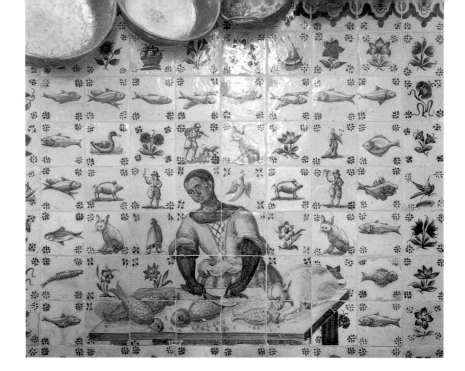

The mischievous animals of Portuguese tile animate the back wall of a kitchen in Lisbon. These seventeenth-century tiles give a glimpse of art history by showing how animals were characterized.

rants, are surrounded in enormous squares of tile to keep the heat in and the pizza hot. The elaborate rows of gourmet food counters at the legendary Harrod's in London are tiled from top to bottom, giving the feeling of village cheese and meat shops. Individually, they have the intimacy of the marketplace, but seen end to end as you walk in the door, they impart a sense of grandeur that makes the entire space special.

Today, tile has the same wonderful practicality for the kitchen with all of the decorative potential for making the room special. The number of varieties of art, imported, and commercial tile available is so vast that your kitchen can be as lavish as the tapas bars of Spain, where rich metallics and geometric ceramic shapes cover the walls, floors, and eating counters, or as straightforward as the American diner, with simple colored squares of tile wonderfully paced in patterns across the room.

In fact, tile's recent transformation from sanitary surface to a material of decorative expression allows styles into the kitchen that would barely have been possible before. You can have an arts and crafts—style kitchen with handcrafted tile spreading behind the stove or sink in the classic colors and designs of nature, or a deco kitchen with silver metallic borders shooting through a field of white tiles, or a Swedish country kitchen with expanses of the same simple, rough gray ceramic across both the floors and walls creating a spare beauty. Of course, you

can now have any other style as well, including more common ones, but you don't have to rely on tiled bouquets of flowers or bowls of fruit anymore to cover your kitchen walls. Tile, as architect Raul Rodriguez says, "is a one-quarter-inch thick opportunity to express individuality in a pre-built home." The opportunities today are greater than ever.

Whatever the style, tile puts freshness, energy, and interest into a kitchen. Tile makes it come alive. "When you take away the tile, you take away the interest," says Florence Perchuk, a designer who specializes in kitchens and believes in the power of tile to give a room character. No cabinet, she points out, is as interesting as tile. It is the dynamism and charm of tile atop or behind counters that can make an ordinary cabinet special, and it is tile on a wall or behind a sink that can make chopping vegetables or washing dishes an experience. With tile, there is ambience.

For centuries, tile has created an environment in the kitchens of Mediterranean homes, which are like the outdoor tiled plazas brought indoors. Peasant kitchens were covered in eight or nine vastly different patterns of tile. There might be solid yellows and blues on shelves, small black-and-white checkerboard borders edging countertops, butterfly and flower insets in blue-edged

A homeowner in Connecticut placed antique delft tile from Holland behind her sink. Her grandfather found the tile at the World's Fair and passed it down to her. The blue-and-white color scheme is particularly appropriate in tile, because it is like the colors of porcelain pottery.

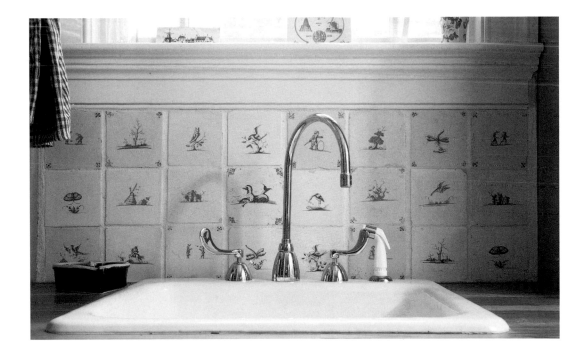

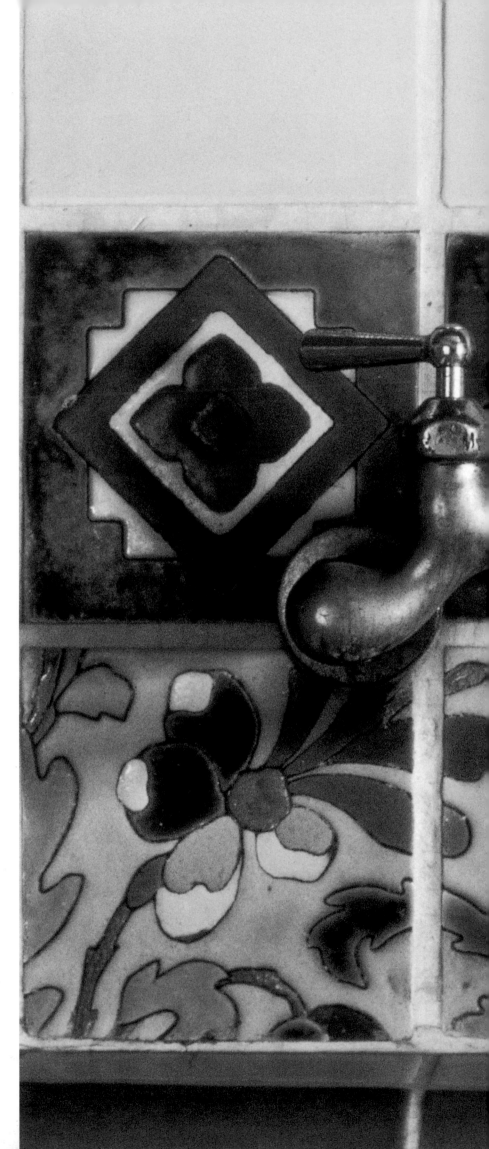

It doesn't take many Malibu tiles to transform a sink space into a flowering environment, bright with the golden tones and optimistic colors of California. This original Malibu tile is in the factory owner's 1929 Malibu mansion, but reproductions are widely available today.

THE TILE DESIGNER

If the showroom salesperson is your best friend during the tiling stage of your remodeling, the tile designer is your kitchen's or bathroom's best friend. He or she makes your general choices work very specifically and beautifully in a particular place in your house, designing the room or space to the last detail so that it becomes a little masterpiece. Tile designers are not nearly as common or necessary to the process as salespeople; in fact, there are not many of them right now except in major cities. But they are well worth seeking out. Whether you are working with an architect or doing the tiled part of your house yourself, a tile designer can make the process easier, less expensive, and create a project that is an exquisitely finished whole.

Some architects like to create a home down to the last detail and are very good at it. Like Frank Lloyd Wright, these architects believe that every detail of the home relates to every other and to its larger themes, so they make every decision themselves. But more often, architects like to focus on the bigger theme of the entire home and leave the finishing of kitchens and bathrooms to a tile designer, knowing that this person has complete knowledge of the field, both aesthetically and technically. To many architects, tile design has become, like lighting design, a subfield of interior design. It is so specific, complicated, and important that it benefits from the services of a specialist. The tile designer can create something unique and complete in each room, in keeping with the architect's theme for the house.

Because the tile designer works exclusively in this medium, he or she can be very detailed and specific about a design. Michael Golden, a New York tile designer, draws out designs on a computer like the one shown below. Golden says the drawings "are very close to reality, so the client can make a quick and confident decision" about a kitchen, bathroom, sunroom, entryway, backsplash, shower stall, or any other area.

Since the drawings are so accurate, there is no guesswork, and you will know exactly what the room or space will look like. If you don't like what you see or want another option, it takes only a second to make adjustments on the computer, changing the size of things, taking out or putting in borders or certain design elements, moving things around. Golden has a "tile library" to refer to — designs and motifs that have worked in the past — so you have any number of elements from which to choose.

You will also know exactly what the project will cost, since the drawings make it possible to order just the amount of tile needed. Otherwise, extra tile is ordered because it is safer to have more than less in case a tile goes out of stock or a later batch doesn't match because of glaze variations. So people end up with lots of extra tile, and extra costs.

A tile designer can also save you money on labor, since the specific drawings are very easy for a tile installer to understand, often making that stage of the process shorter. In addition, the tile designer anticipates potential problems and troubleshoots long before the tile goes up, cutting down on time, money, and headaches.

The results are spaces that are like little jewels, perfectly balanced and shining with detail and delightful motifs, such as the backsplash shown at right.

A tile designer's fee is usually eight to fifteen percent of the cost of the tile and installation, but using a tile designer should save you more than half the amount of the fee. To find a tile designer, ask for recommendations from your architect or at showrooms.

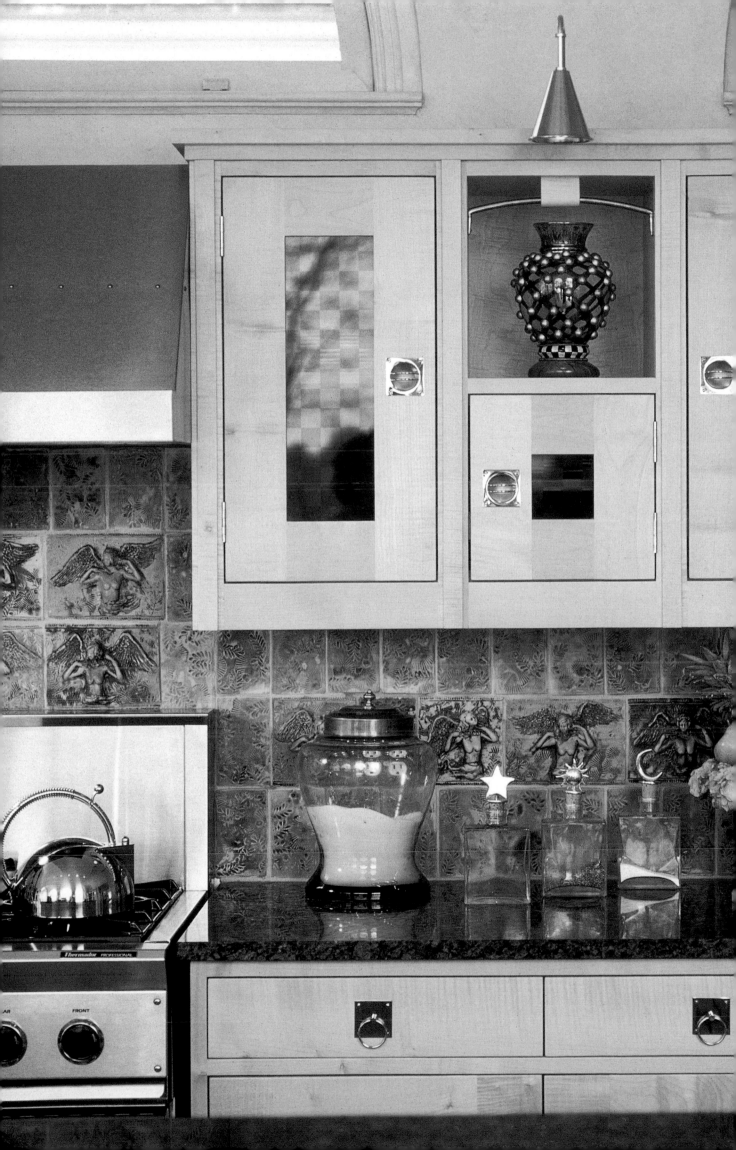

white tile spreading to the ceiling across walls, and large terra cotta octagons on the floor. It is speculated that this incredible mix of tile resulted from the fact that there wasn't enough money to buy one complete pattern for the kitchen, so whatever tile was left over from the rest of the house or was salvaged in the village was placed on a surface in the kitchen. Then the use of many kinds of unmatched tile became a desired look, rather than a neccessity.

RIGHT: *A kitchen in Cuerna Vaca, Mexico, was remodeled to feature Mexican tiles from the turn of the century. In the Mexican way, the owners did not stop at tiled backsplashes, but let the tile run free so that it lines shelves, frames windows, and covers entire elements like this hearth.*

BELOW: *For an apartment in New York, designer Llana used six kinds of tile from several countries to give the kitchen the fresh feeling of the outdoors and open up the small room. Moroccan-style tile rugs grace walls and floors, just as real rugs in Morocco do.*

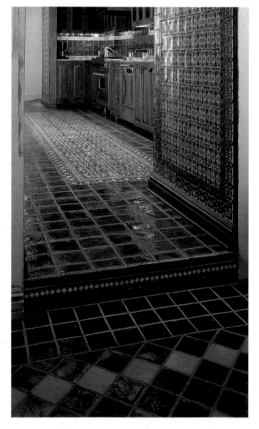

The wonderfully festive look of these old Mediterranean kitchens can be achieved today by actually covering the room with tile—putting different colors and patterns on every shelf, wall, storage niche, and counter; using trims to run tile up to the ceilings and down to the floors, which are themselves spread with tile. The mismatched patterns and colors that created a certain unpredictable charm in the peasant's kitchens is one option, but for a more finished look, unify the kitchen by using a theme of designs, patterns, or colors throughout the room. You can still use different colors and designs, but be sure that they are paced throughout the room, repeating so that they tie it together.

If however, like the European peasants, the only way you could possibly afford to tile the entire room is if you found the tile somewhere, there are other ways to get that outdoor Mediterranean feeling. You can cover one entire wall with tile, breaking the tile design only to accomodate windows, stoves, or sinks. Tiling right up to and around a window or cabinet, as the people in Mexico and Spain do in their kitchens, gives the feeling that a space has been covered entirely, even if only one wall is tiled. Or you can, as designer Skip Sroka did, tile the inside of the cabinets so that the tile shows through glass doors.

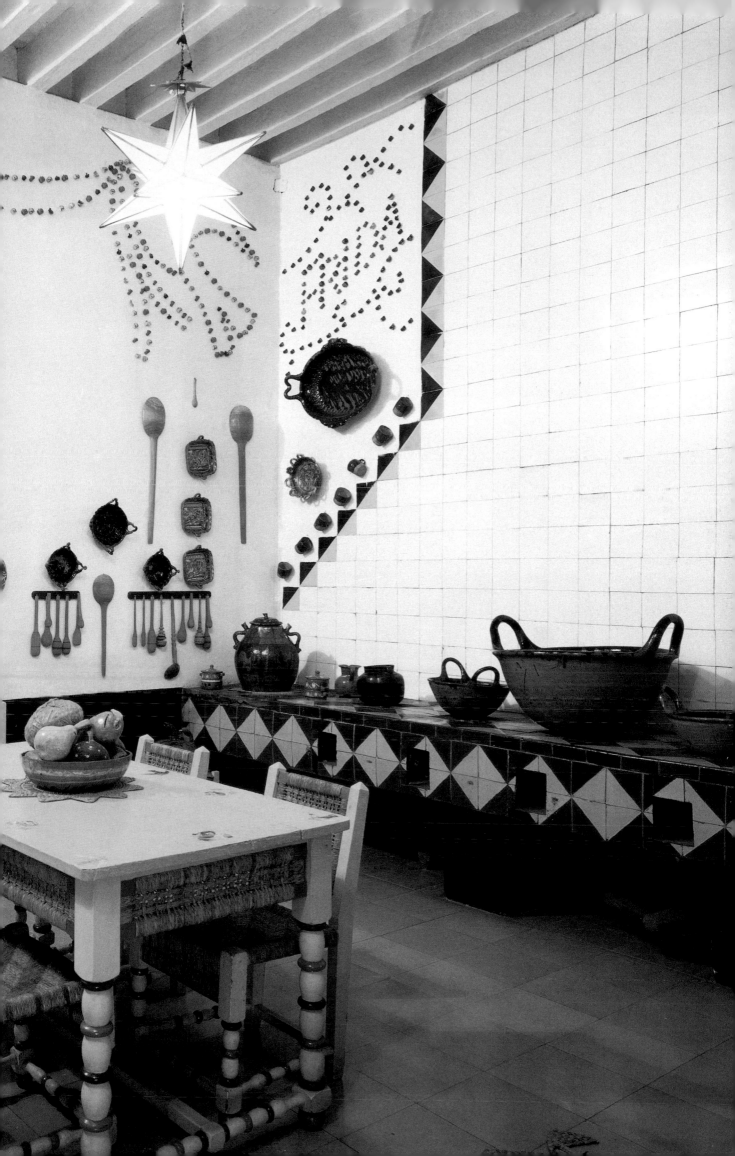

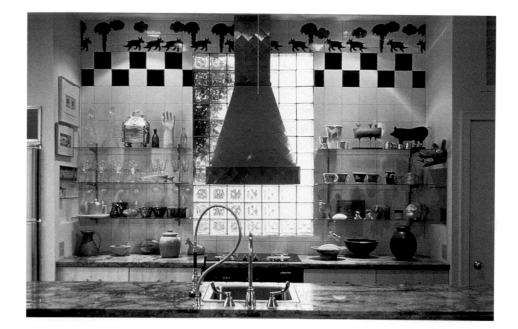

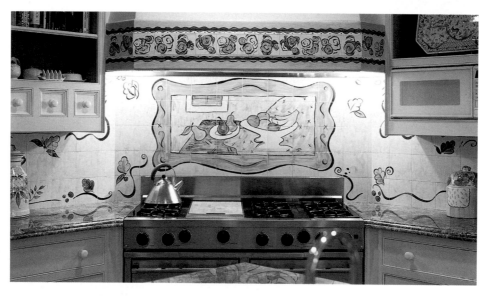

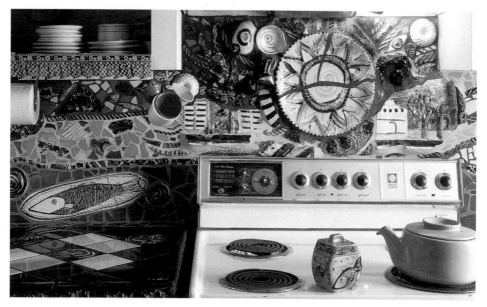

Covering large elements with tile is another approach. When an entire kitchen island, hearth, column, or even range hood is tiled, the effect of all that tile in one space is to make it seem as though the whole kitchen is about tile. Even tile in smaller settings can have great impact. Putting tile together in one place will give it more power. Tile your countertops right up to the walls, and then tile the walls behind them up a foot or so, with either the same tile or different kinds for a more sophisticated look. Tiling the counters and walls together will create a look reminiscent of small shops in European villages, where meat and cheese is slapped down on tiled counters for customers. Put tile on windowsills and you won't have to worry when watering plants. Put it on countertops above ovens, and you can place hot pans right on them. Keep the tile going around all the walls of the room, running it just a short way up, and the Mediterranean feeling will still be there because the tile is covering one whole space, not just appearing here and there about the room.

Of course, putting small areas of tile around the room is another approach with a separate charm. It is like the difference between the fullness of a garden with many flowers or the singular beauty of a row of them. Each has its effect. You can repeat a motif, say ivy, from the center wall onto the trim near the ceiling, on the tops of counters, at the bottoms of cabinets, and on small inserts in the floor tile. You can even carry the theme onto a hutch with a tile border on top or around its counter.

A common way to use tile in kitchens has been to create a focal point in the room, usually a backsplash behind the sink or a landscape of tile behind the stove depicting a nature scene or a still life. These can be custom-made by a commercial company such as Summitville or designed originally by an artist. The area behind one family's stove, for instance, features their summer house in tile. Another,

PAGES 78-79: *Frida Kahlo decorated her kitchen at Casa Azul in the style of Mexican rural kitchens, with ceramics everywhere. A tiled banquette running below an entire wall of tile holds pottery, and tiny pots spell out her name.*

TOP LEFT: *When designing a kitchen in Connecticut, architect Steven Harris let the black dogs that were painted on tile by the owner run around near the ceiling like a Greek frieze, with the intention of drawing the eye upward toward a soaring ceiling above.*

CENTER LEFT: *Artist Cristina Acosta painted a Matisse-like mural in tile for a Los Angeles kitchen, following the owner's request to make things "a little off-balance," so a pear nearly topples playfully off the table. Roses on the range hood and vines on the walls enhance the mural.*

BOTTOM LEFT: *A mosaic by artist Carlos Alves transforms a Miami kitchen.*

A LITTLE TILE

At the fourteenth-century Alhambra palace in Granada, Spain, Moorish kings covered the walls, floors, steps, columns, seats, fountains, and pathways in tile. Given the lusciousness and variety of tile today, you may be tempted to do the same. But the reality may be that even if you want to tile an entire kitchen or bath, you can't afford it, or you're not ready to remodel, or you're living in a place you know you won't be in long enough to justify investing in something as long-lasting as tile.

But you can still find ways to live with tile by bringing it into your home in smaller installations that give expression to the material and to the home itself. By doing so, you can use rarer, more expensive tile — art tile or imported tile — because you will be buying relatively little.

The effect will be different than if you covered whole rooms with the material. But it will also be more personal, more surprising, more endearing because of its small scale. When a large expanse of tile is used, the effect is in its power; when a small amount is used, the delight is in the discovery. It is like the difference between large canvases on the walls of a room and a small sculpture or framed photograph in a corner of it. Both have an impact, but in separate ways.

This cappuccino corner is a charming example of how to live with a little tile. Tile is a strong, graphic

material, so a small amount of it makes a big impression. The design should be tight and well-planned, using the material to its fullest potential. Here, solid-colored tile complements the richness of ornately patterned borders, and rows of small tiles run next to larger ones so that they balance and set off one another. Three different kinds of tile are used in one small space to successfully create a little haven of tile.

Any countertop — in the bathroom, the kitchen, the laundry room — is a good place to put a little tile. Tile a kitchen island and it becomes the focal point of the room, as well as a practical surface for working in the kitchen. A striking array of trims, borders, and thin liners available today can beautifully finish small spaces like these.

Backsplashes are often created using tiles that people love but don't know how to fit into their homes.

Often, a family of art tiles or antique tiles are placed on a wall behind a counter or sink because they are too fragile for countertops or floors, and not many are needed to make an impact. Even a row of tiles—six or seven or eight running side by side—behind a sink can add something special to a kitchen, as well as keeping the area behind the sink dry.

Any of the beautiful border tiles out there today—from arts and crafts pine needles to heavens full of angels to bright, classic Italian and Spanish patterns—can be run around doors, windows, or archways, showing them off and also framing the architectural elements they border. This doesn't have to be done in a way that reminds you of a Mexican restaurant; smallish, sophisticated tiles paced well can result in an elegant look. Or they can be used in the European tradition, in rows replacing baseboards, ceiling molding, or chair rails for an element of surprise. Run them along the dead space beneath the kitchen cabinets near the floor and you'll be reminded of the small markets in Europe where cheese and meat and eggs are sold among rows of tiles.

Even if you can't live like the kings did at the Alhambra, you can get the effect of its charm every day by putting a little tile in your home, and in your life.

ABOVE: *Picasso-like figures turn the space behind a San Diego sink into a gallery of portraits. The Italian tile from Desimone is quite expensive, so designer Janet Sperber placed just a row of it in a field of Mexican-made purple tile that was much less costly.*

OPPOSITE: *Designer Terri Katz got the inspiration for this Miami kitchen from a book on British porcelain. The tile from Sunny McLean & Co. is handmade, with the bowl in the central fruit panel rendered from a picture in the book.*

behind a sink, pictures the four seasons of the garden that is seen outside the kitchen window. Often people are drawn to elaborate scenes they see in showrooms, but even when the tile is not custom-made, these designs can cost quite a lot. If a particular scene makes you happy, it may be worth it. But there are other, less predictable ways to invest your money in tile that can be far more interesting.

Custom-designed tile or mosaics created by artists can wander across the kitchen, spreading the tile around rather than making it a focus. If you have the money, cover the entire room with custom-made tile. One kitchen in California features tile cows wandering around pastures behind the dishwasher, above the stove, next to the coffeepot.

But with so much incredible tile available in stores today, you don't need custom-made designs to create interesting effects in the kitchen. The beauty of handmade art tile behind a sink or on a countertop alone can make a kitchen special. And trims are outstanding enough to become the central design feature. Thick, dark green rope trim, for example, was run around a kitchen of white field tile — on counter edgings, on walls, and around arches. Designed by Linda Dorr, the look is simple but intriguing, and the trim unifies the whole space.

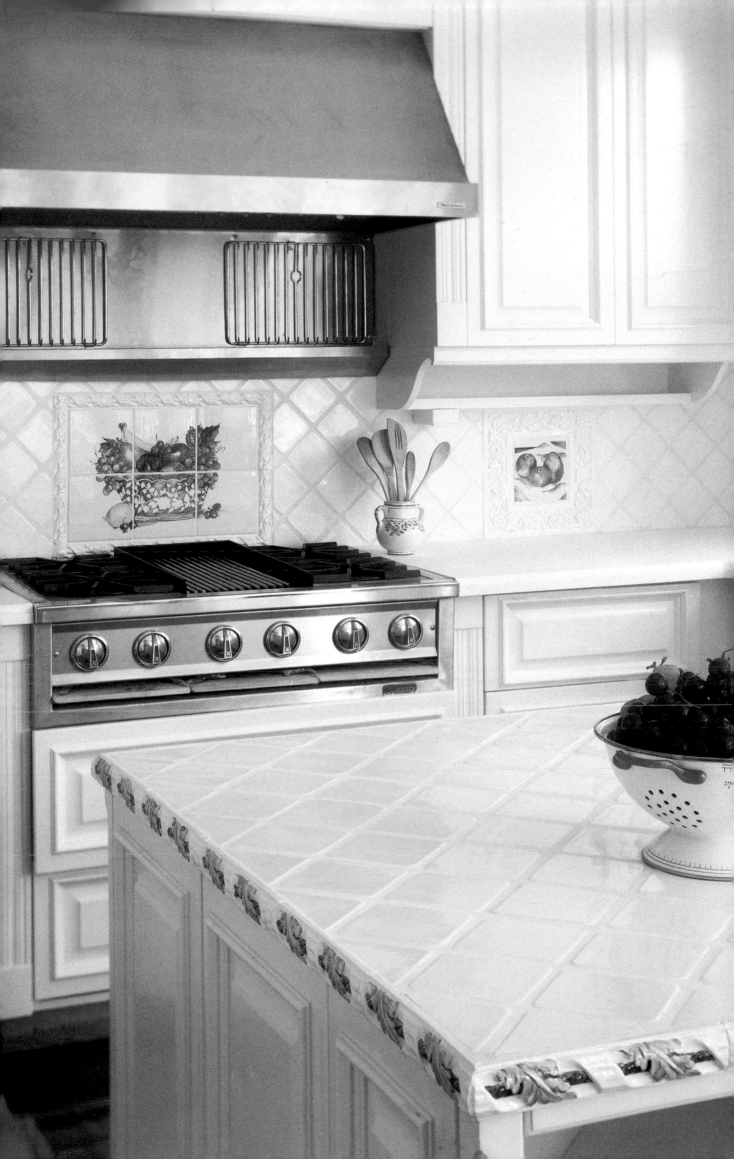

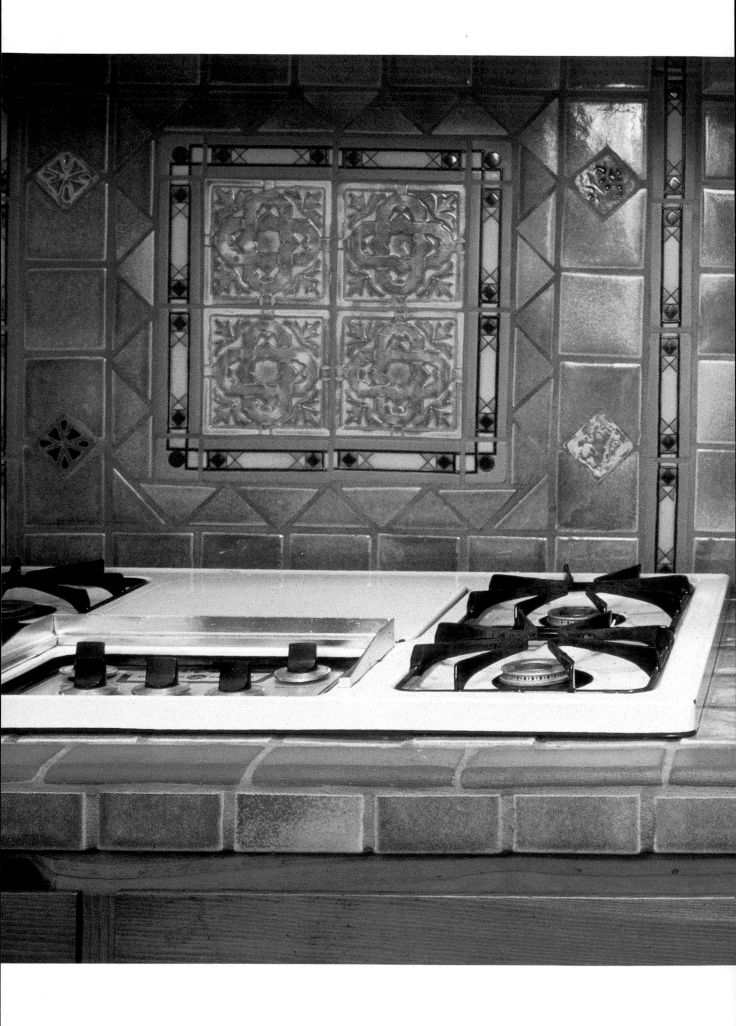

In fact, any element that runs all around the room can make it interesting and unify it at the same time. Borders of commercial tile squares set in alternating colors against a field of white give a wonderful pace to walls and an energy to the room. Any size squares can be used, and any colors—perhaps a theme in one color, like different shades of blue, or several different colors together. The squares can be run near the sink and repeated up near the ceiling for more interest.

You can place tiles with decorative designs in a vertical row going up the wall like a column against a field of plain-colored tiles. Or run a row of decorative tile that matches the edging of the countertops around the floor. Using different sizes of commercial tiles in one color, you can create a lot of pattern in a small space or make larger patterns that repeat across the room.

In fact, several different colors of tile can be used randomly, instead of in patterns, to create great effects across the walls. The colors have to jump around in just the right way to make the look work, however, and you should probably consult a designer to avoid getting, in the words of ceramicist Susan Tunick, "a Pizza Hut." One woman who was remodeling her Manhattan apartment consulted a friend who is a designer for Ralph Lauren and ended up with a wall she loves in a pattern reminiscent of a very sophisticated plaid shirt.

You can also create a pattern by alternating tiles of the same color in different finishes, such as high-glaze and matte, suggests architect Marlys Hann. Or, a really good-looking tile can be used in different sizes for floor and coun-

LEFT: *A Los Angeles kitchen was lit up by tile made in the California craftsman style. Designer Lori Erenberg cut square tiles on the diagonal to form a border of triangles framing the central panel. The two-by-six and two-by-two craftsman deco and corner pieces were designed and manufactured by Mary Reece, Venice Tile.*

ABOVE: *The space behind a stove looks like a lesson in the alphabet with handmade tiles imported from England by Paris Ceramics. The surrounding white tiles feature a crackle glaze.*

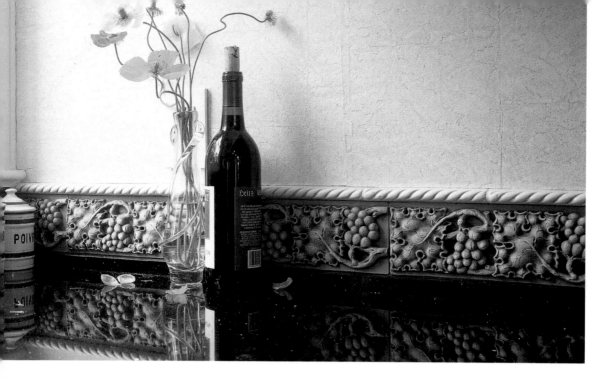

ters, say a 12-inch square for floors and a 6-inch version of the same tile for counters. The look is unified, but the echo of floor tile in miniature on the counter is intriguing.

Be aware of the influence of borders. A finishing border on a counter can be important in establishing a look. You may want to use a border in a different texture than that of the counters, such as a terra cotta and a glaze, for interest. Borders can be used to create a theme themselves, tying the space together. They can also be useful in a secondary role, separating different patterns and designs of tile from one another. Tile can be great combined with all the wood grains available today, and edging a counter or island with it will soften the room.

Creating floors is another opportunity for great design in kitchens. Floor tiles come in very large sizes today—24 inches square, and sometimes bigger. Like wall tiles, some are made to look like marble, stone, and granite so that you can have the look of these materials but with the simplicity of ceramic. Today they come in many more shapes than the traditional square—octagons, rectangles, hexagons.

ABOVE: *Handmade tile by David Ellis makes a kitchen counter in Connecticut look like it was touched by Renaissance artistry. The tile has a high relief and a low glaze so that it looks sculpted, almost like stone. When architect Mark Demerly, who designed the kitchen, used this border he knew that it would decorate the area almost by itself.*

BELOW: *When the right tile is set into wood, striking kitchen floors are created. Handmade tile, like this from Pewabic Pottery, lives comfortably with wood because they are both natural materials.*

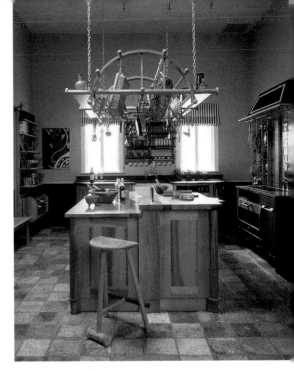

With the new shapes available, the potential for pattern on floors is greater than ever. There are so many possibilities, in fact, that manufacturers and showrooms often provide sketched pattern ideas and planners to fill in along with their brochures and catalogs. Designer Florence Perchuk uses floor tiles in one color and shape but orients them differently—placing some squares straight on and some tilted to form diamonds, for example. This tactic, she says, "both gives the room motion and makes it feel bigger." She also uses a straight border tile at the edges of the kitchen and places a pattern of tiles, perhaps squares set on the diagonal, in the center. The effect is that of a carpet.

Antique terra cotta tiles are salvaged from barns in France and sold here by tile companies like Paris Ceramics. Because of their past lives, the tiles have a rustic and outdoorsy, yet warm, feeling.

When choosing colors for floors, Perchuk advises asking yourself whether you want your eye to go to the floor or the walls in the kitchen. A darker floor will draw your eye there. Whatever you decide, she says, the floor and backsplash tile should integrate, not fight with one another.

Designer Susan Hutchings put a sky blue tile floor in a Manhattan kitchen with white wall tile decorated in flowers. The floor brings the room a great light and freshness and works wonderfully with the walls, being an equal partner to them in the room.

You may want to alternate colors of floor tiles, using classic black and white, a softer peach and ivory, or an even subtler mix of dark and light shades of off-white.

To enhance the gridded effect of tiles, you can use grout in a color that contrasts with the floor tiles. Designer Eric Bernard put cobalt blue grout between black floor tiles for a really striking look. A more subtle one could be achieved with off-white tile and light blue grout.

Today's kitchen is where everyone in the house tends to end up, so make it a place everyone will enjoy by using tile to make it comfortable, alive, and stylish.

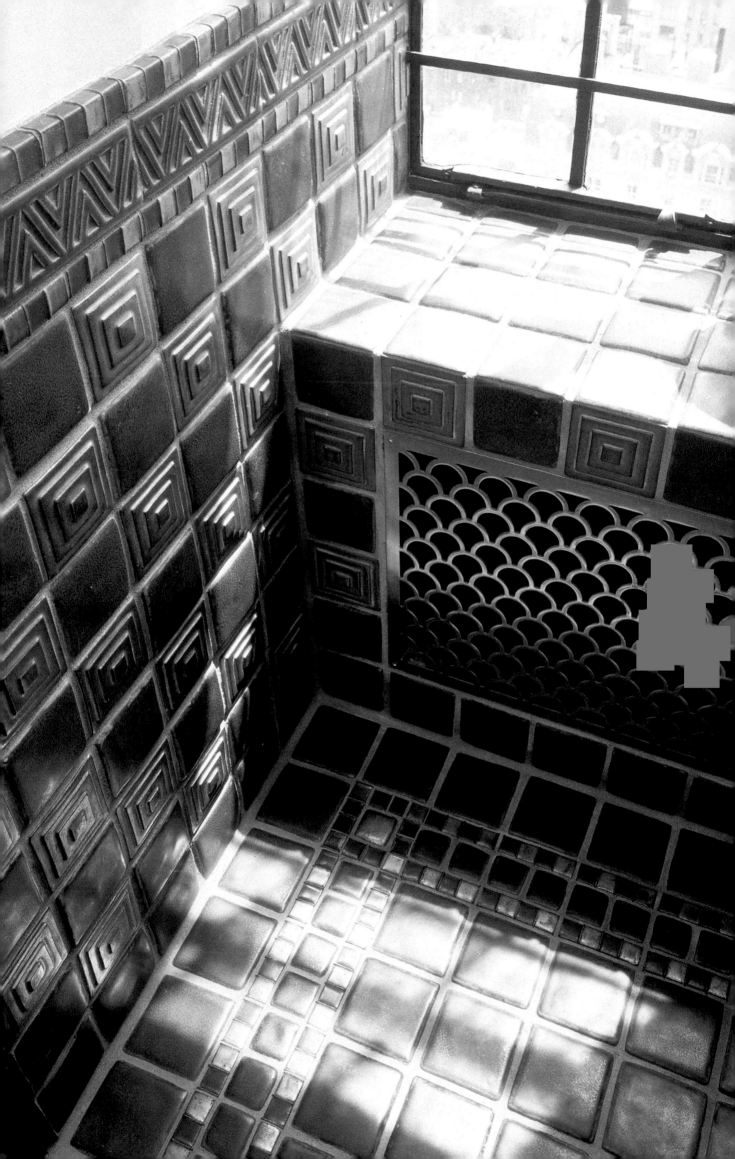

Baths

The two half-moon pools are separated by a sea-blue tiled walk. The water
laps gently under a high vault, also tiled. [The women] sometimes talk to
one another in the water, but their exchanges are not secrets. Conversations
do echo in the ceramic chamber, so gossip has to be restrained.

—Edith Pearlman, reporting on Budapest baths in
The New York Times, 1995

Aside from its restraining effect on gossip, tile is the ultimate material for baths. Just as with ancient baths, it can resonate the sense of grandeur and the sacredness of the bath. At the same time, it is an intimate and human material capable of conveying a sense of privacy and putting bodies at ease. An architect once said that a successful bathroom is one in which people feel comfortable being nude. Partly because it is such an old material, tile gives that sense of security. And, of course, tile is destined to be with water. It works for the bathroom. So it is practical and luxurious at the same time.

LEFT: *Designer Jed Johnson created Aztec-like designs to complement the art deco detailing on the outside of a historic Manhattan building. The tile was handmade by Pewabic Pottery.*
ABOVE: *Using Stonecraft tile in panels and borders, designer Lori Erenberg evokes the exotic feeling of a Mesopotamian spa in a Los Angeles bath.*

Today, tile has the power to make what are usually the smallest and most overlooked rooms in the house places with real presence. It is great for small spaces because it is interesting and offers so much to see that it causes rooms to seem bigger.

Just as in other rooms, you can create any style you want with today's tile. You can have arts and crafts–style animals wandering around you in ceramic while you're taking a bath or brushing your teeth, or the landscapes of the Southwest in the shower with tiles in dusty roses and sky blues, or elegant William de Morgan birds stretching across walls. Tile is wonderful for historic houses because it can make the style of the bathroom true to the house, say Victorian or mission.

ABOVE: *For the shower of a girl's bathroom in Connecticut, architect Mark Demerly simply combined angel borders with white squares to get a striking look, turning the squares at an angle near the bottom to create diamond shapes. Angels dance above in a terra cotta frieze from Country Floors.*
RIGHT: *Brazilian designer Arthur de Mattos Casas created a spa effect with glass tiles from Vidrotil. Glass tiles are now widely available, and can be used alone or mixed with ceramic.*

But beyond these specific styles are striking approaches to baths that are often more interesting. If you cover the room in tile with traditional squares in white or off-white, you'll get the feeling of every spa throughout the centuries. Since the age of the ancient Roman baths, where people gathered in huge rooms to luxuriate and steam and wade in the waters, tile has lined spas from top to bottom as if it were an element of their healing power. At the 10th Street Russian and Turkish baths in New York City, tile has existed at two extremes of temperature since 1892. Rows of shiny white tile run across the benches and walls of the rooms that pour forth steam when their doors are opened. In the narrow tiled pool that bathers dive into after taking a sauna, ice cold water splashes against rows of tulip-shaped blue tile below a wall of bright, flowered mosaics. There is a sense of abandon and also of ceremony in the space—that this is a place to relax but also to regard the body—which the tile evokes. In the baths at Hot Springs, Arkansas, to which people came from miles around in the 1920s to find cures, squares of tile line the sunken tubs, the showers that spritz water from several directions, and the shallow pools where 140-degree mineral water bubbles in directly from natural mountain springs through the original aqueducts. A ceramic portrait of Ponce de León in the middle of an indoor fountain, where the mineral water is offered to drink, is a tile reminder of renewal. These tile-lined rooms are all places where people feel comfortable, and in each, neat rows of tile have brought a sense of healthful order to the space.

Today, these paced squares of tile can spill out across the floor, up the walls, and even onto the ceiling of a bathroom, continuing along the counters, splashing across the shower, and surrounding the tub like water flowing over its

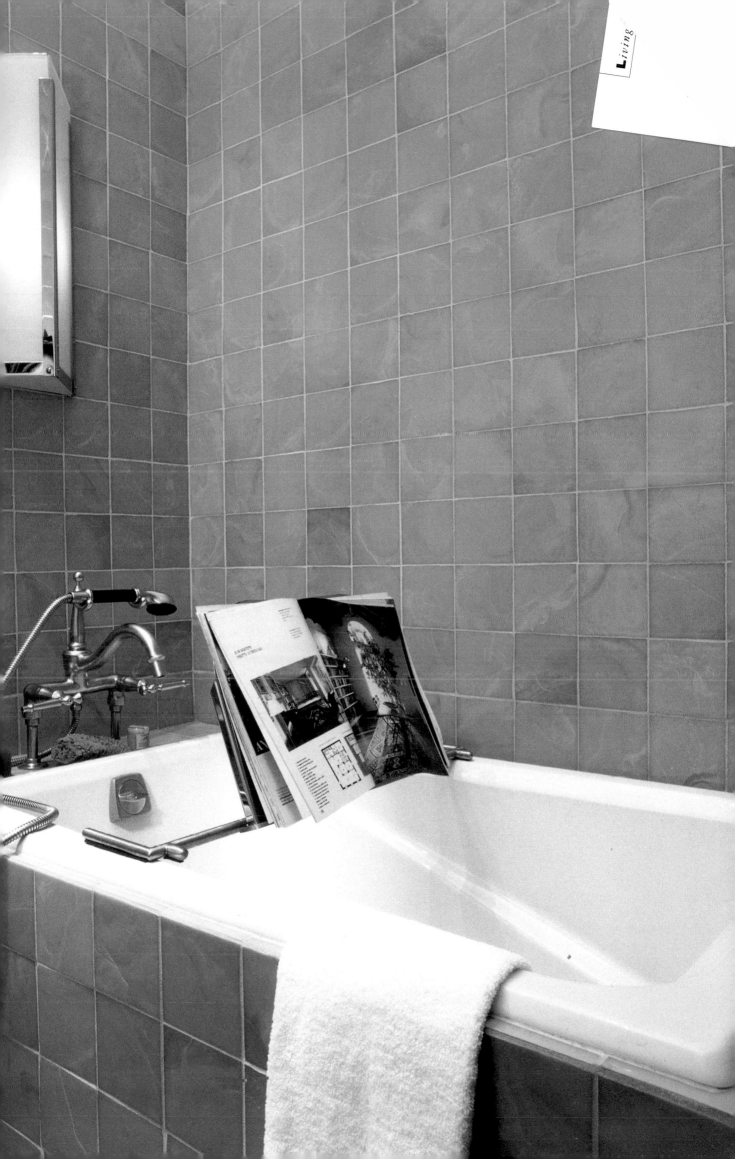

edge. Tile can even fill the tub. It can also go inside storage shelves or frame the windows, mirrors, and doors of the room. A medicine cabinet can be replaced by a tiled niche with glass shelves running across it, and tiled shampoo shelves can be built into the shower. For variation, you can use different sizes of the same tile, say 1-inch and 2-inch squares, as architect Duo Dickinson did in a bathroom that is tiled from window seat to columns to tub surround in pure white squares.

These "planes of tile," as architect Margaret Helfand calls them, are a great example of the classic grid design—tiles set side by side in row after row. The reliable grid carries with it, as architect Stanley Tigerman says, "the power of repetition." Even with all the innovations in tile that are being celebrated today, it is the basic grid that anyone who loves tile loved in it from the start.

A very different kind of historic bath was the elegant, opulent one that was a wonderful haven for hedonism and revival. Those from Arabian cultures were floored with intricate mosaics from which bathing fountains sprang, and surrounded by ornate patterns of tile that gleamed with droplets of water.

Tile designer Michael Golden mixed tile with marble mosaics to give architectural grandeur to a Long Island master bath. The Italian tile from Hastings comes in panels to build columns like these. Thin gold trims were used lightly for accents.

Tile can give baths today an elegance in many different ways. Mosaics made from small squares of tile, rather than broken tile, are reminiscent of the monumental ancient mosaics that drew portraits or patterns in tile. The many pieces put together can give a magnificence to the entire room or to just a part of it, where it creates a little environment, such as the wall behind a tub.

Certain kinds of tile make bathrooms immediately elegant with their presence. Tile with super high glaze shines and

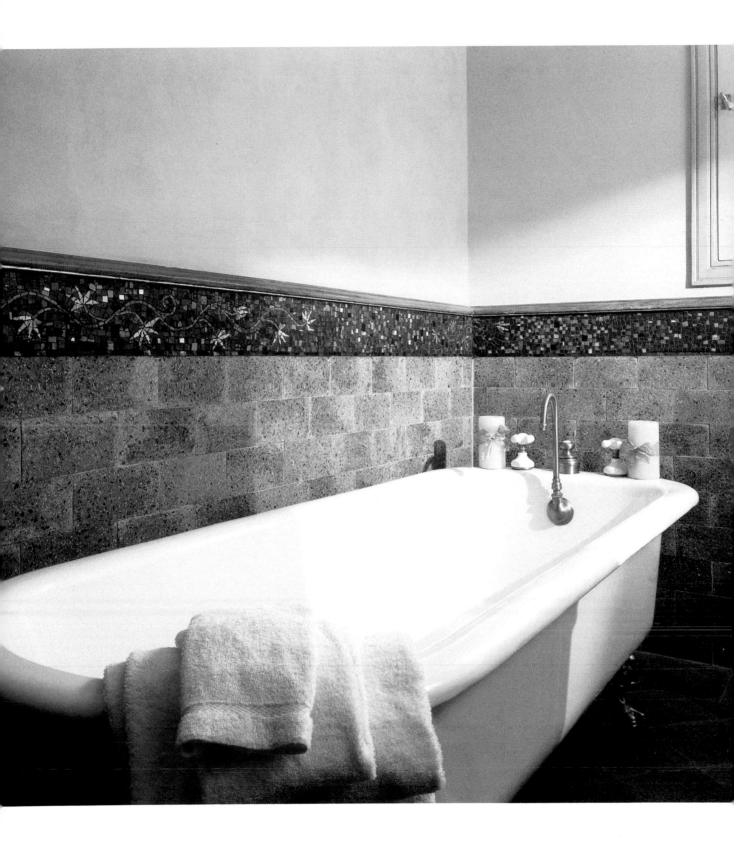

A mosaic vine flowers around the bathroom of a Beverly Hills home in a border created by designer Nancy Kintisch. Changing colors as it grows, the blooming mosaic elegantly offsets the stone walls and adds color and warmth to the room.

TILING ON A BUDGET

"I like for the design to evoke a mood, for it to be alive, experimental, different—and not too safe." Designer Lori Erenberg is talking about her goals when using tile; they are big ones that make it sound as if her plans are quite grand. But the surprising fact is that Erenberg is referring to projects she does for people whose budgets are not so big, and the specific designs she is talking about can cost under $3 per square foot.

The qualities of tile that make it loved and useful, that give it the potential for true artfulness—brilliant and diverse color, engaging texture, an enduring earthiness—are found in the most basic types of tile as well as in those that are elaborate or exquisitely crafted. In this sense, tile is a democratic material. There is no reason that using it creatively in the home cannot be completely affordable.

Erenberg uses Dal-Tile for her least expensive projects. It doesn't have the intricate beauty of many of today's art tiles or the human touch of hand-crafted tile, but it does have the potential for a great design. That potential comes in sixty-seven shades of earth tones, sixty-three gray tones,

forty-five blue tones, fifty-two rose tones, and twenty-one accent shades in bright primary colors. There are flat, semi-gloss, glossy, or high-gloss textures; sparkly crystal, speckled, or marble-like looks; different shapes to use as accents; and various sizes such as long, thin strips for borders or small squares to use in mosaics.

In creating a design, Erenberg first considers the character of the space. If it is small, she will use smaller scale designs and colors; if it is more spacious, she can be bolder. She then thinks about how people want to feel using the space—perhaps serene in the shower, for instance, or uplifted at the kitchen counter. She picks her colors from there, giving her clients different combinations from which to choose.

She then lays it all out on the floor, making patterns and changing the composition around until it seems right, using quarter-inch liners and small, 2-inch tiles to border and accent the larger ones. "It's like a big puzzle," she says, "and you move the pieces around depending on where you want the eye to go."

The shower shown at right was designed according to the same principles but with a tile that offers subtler color variations and textures—for

more money. This space cost about $11 a square foot using McIntyre tile. McIntyre is an old California company that revived its line recently after being out of business for decades. Like many companies that have started up again after seeing a new demand for tile today, they are making reproductions in the old colors. McIntyre manages to make theirs affordable because the tile is quite simple, but it has the handcrafted look of tile that is usually more expensive. McIntyre tile is suited for more rarified environments than the standard contemporary home—for special settings like the craftsman-style house in which this shower is found.

Finding a way around high costs is easier with tile than with most materials because of the huge variations in its offerings today. Whatever design you wish to create, there's a tile out there to use in it. It may not have the ripples, richness, and depth of glaze color that handmade tile does, but it could be the kind of tile you can use to build a great design.

Dal-Tile can be found in showrooms across the country. McIntyre tile is sold, among other places, at Walker Zanger showrooms on the West Coast and Tiles, A Refined Selection on the East Coast.

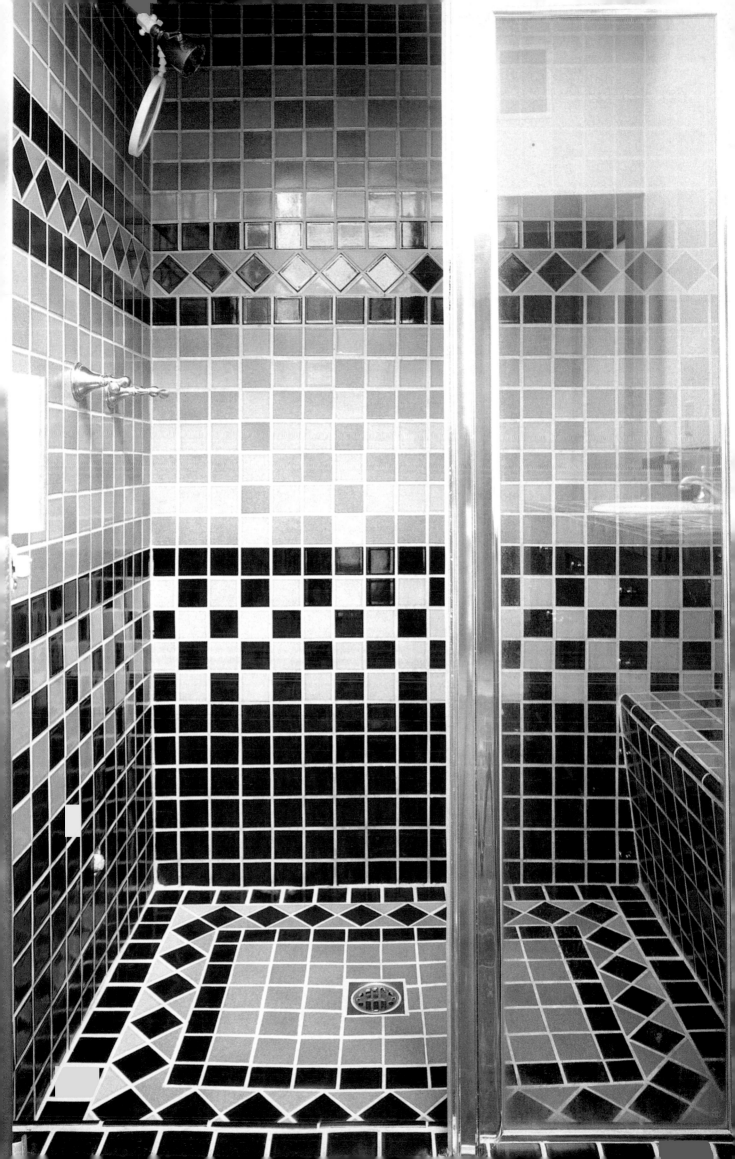

ABOVE: *Tiles fired with a raku glaze have complex finishes—some crackled, some shimmering metallic, others deep in color. Designer Ian Athfield used the "Fire and Earth" series from Ann Sacks Tile & Stone to open up a small bath.*
RIGHT: *The slick and primitive qualities of tile are unified in a Miami bath. The French tile near the ceiling is triple-glazed, giving it deep gloss, intense color, and a rich elegance. Below, terra cotta tile contrasts with a roughness that was enhanced by designer Dennis Jenkins installing it back side out.*
BELOW: *"Funtime" tiles handmade by La Luz Canyon Studios wrap a bathroom in Santa Fe with celebratory color.*

shimmers like the water that consistently runs through baths. Its deep luster gives richness to even a small space, such as that behind the sink. Copper-glazed tiles imported from Spain will literally glow on your walls as the light catches them. To keep them from being overwhelming, use borders, rather than whole tiles, or do as the Spanish have done for centuries and place rows of blue and white tiles above and below them.

Using more ordinary tile can result in elegance when it is done innovatively. Architect Donato Savoie has put nine different shades of white or seven different shades of red, for example, in baths to keep them from looking flat or opaque. And designer Eric Bernard has used tiles like jewels, inlaying bright colors into fields of white. The effects can be stunning.

Another approach, different from both the healthful spa look and the hedonistic elegant one, is the humorous one. The bathroom often seems to be where the fun is in today's houses. For some reason, perhaps because baths are the places that are least likely to be seen by visitors, people like to be charmingly irreverent with them, splashing color and playful designs around the room.

Custom-designed tile often captures this spirit. Designer Barbara Hauben-Ross recreated a Miró painting in tile that covers all six surfaces of the room with the vibrant colors and shapes of his designs. When you close the door, the painting becomes complete. For his house in Coral Gables, Miami architect Bernardo Ford-Brescia took a collection of postcards portraying old Florida and had them affixed to white tile and glazed with a clear finish. Each

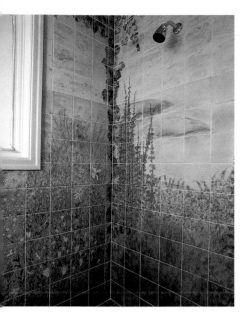

ABOVE: *Artist Martine Vermeulen created a tiled sea garden that resembles the landscape surrounding this Nova Scotia bathroom. She uses tile like a canvas, incorporating the homeowners' lives into her work; a tub may be painted with nudes, a child's book left open may be portrayed on a kitchen counter.*

BELOW: *Surving Studios' handmade amphibians are so mischievous they are best used sparingly, with plain field tiles to separate them.*

bathroom is covered in white tile with a white border running around the center of the room on which, occasionally, instead of a tile, there appears a postcard of a woman in a bathing suit feeding porpoises or of palm trees swaying in 1940s Miami Beach.

Broken-tile mosaics, with their free shapes and wide color range, are perfect for giving exuberance to bathroom surfaces. Artist Robert Stout covered a floor in Santa Fe with shimmering stars in blue, red, silver, and black tile, for example, and artist Judy Robertson placed impossible elements together, like a cat and the sea, in a buoyant and many-shaded blue, green, and white tile mural on the wall behind a hot tub in a Manhattan bathroom.

Tile doesn't have to be custom-designed, however, to be fun. Some tiles just lend themselves to it. With Blue Slide Art Tiles, you can put a border of elephants around the room or a bath surround, marching trunk to tail. One homeowner used Surving Studios' exquisite portraits of nature to create a spider bathroom. Jazzy borders, zigzag trims, and rows of colored tile from Pratt and Larson transformed a small bathroom in Portland, Oregon. "It's fun to stand in the shower and see all the pattern and color

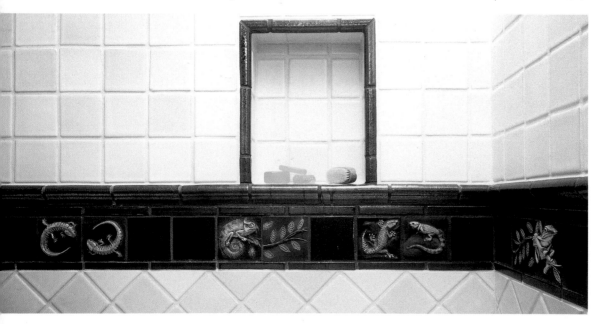

reflected in the mirror," says architect Carol Edelman of this room that she and her husband, Albert, also an architect, remodeled for their house. Designer Skip Sroka creates his own fun in bathrooms, using standard tile to make huge versions of the classic diamond-and-square patterns of 1950s bathrooms.

Any of these designs would be wonderful for children's baths — the only place in the home, aside from their bedrooms, that they can feel is theirs. Architect Mark Demerly created two children's baths for a home in Connecticut. The little boy's is based on the colors and patterns of an Indian bead belt, with vibrant yellow, red, green, and orange triangles set in designs around the mirror and in borders around the room. A row of bright squares set in white tile runs along the sink

countertop, looking like a lesson in colors. The little girl's bathroom is filled with ceramic angels that are singing in bands from the space near the ceiling, by the floor, next to the sink, and in the shower.

Llana of the design firm Lemeau and Llana feels that the joy of tile is in this quality of surprise, humor, and vibrancy. She encourages people not to be afraid of the thousands of components available but to have fun, and play with them. But she warns that you need to keep things compatible, "in the same family," to make it work. Use themes like color or texture to be sure the tile harmonizes, and to unify the room.

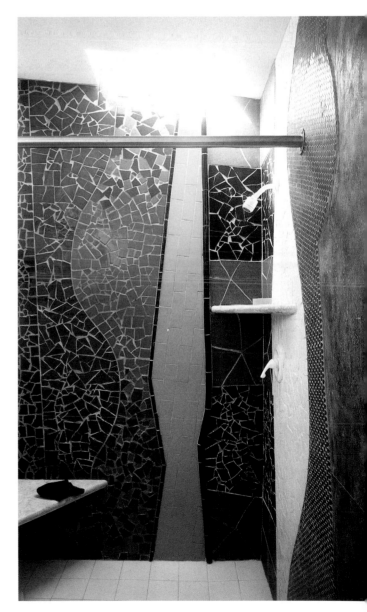

Artist Debra Yates created a mosaic for a Miami shower that is reminiscent of a jungle in its primitive spirit and adventurous colors. In Florida fashion, the feeling of the outdoors has been brought inside, so this seems like an outdoor shower.

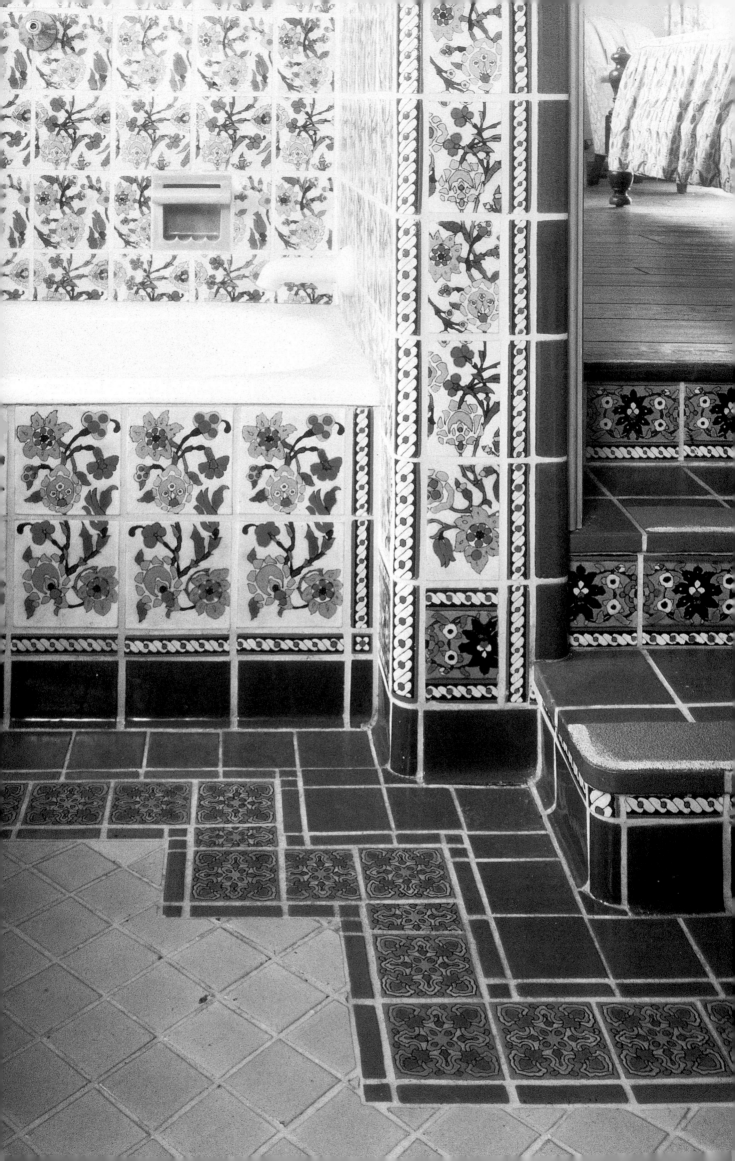

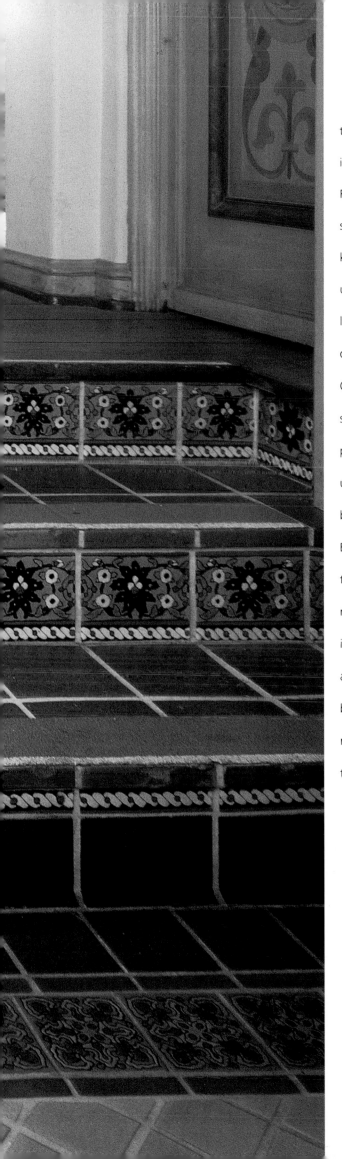

The incredible array of borders and trims available today are making bathrooms into spaces that are wonderfully alive. Rochelle Cohen of Shelley Tile in New York says, "Five years ago people would use one kind of tile per room. Today, however, they're using more like ten kinds per room, putting lots of designs together." In a bathroom designed by the architectural firm of Robert Orr & Associates, seven different trims — some raised, some thick and corniced, some pencil-thin, but all in blue or white — were used one above the other to create one large border running around a room of white tile. Borders and trims are great for adding architectural interest to what are often blank rooms. They can take the place of wainscoting when used at the ceiling, or of chair rails and crowns at the middle of the room, or of baseboard molding near the floor. If you run regular 4-inch-square tiles in a border near the floor, an idea taken from New York City

LEFT: *A bathroom at the historic Adamson House flowers with seven different types of Malibu tile. The room is accented with a distinctive border edged by a thin red liner, and stair risers feature varying tiles and trims.*

RIGHT: *The shower is the focal point of a Long Island bath designed by Michael Golden, with an Italian tile panel by Grazia that resembles art nouveau stained glass, and a floor bordered with three different shades of blue tile.*

VICTORIAN-STYLE TILES

If you love Victoriana and get even a glimpse of the tiles currently being reproduced from that era and sold in showrooms, you could be in trouble. There is a beautiful array of designs available that, like the Victorian style itself, are rich, ornate, and possibly overwhelming, with the threat of taking over a room. But like Victorian design, they can also be charming, artistic, and distinctive. As with the cupolas, trims, and garden gates on Victorian houses, their effect is all in how you use them.

Certainly the striking range of Victorian tile designs available today would tempt anyone who is drawn to the style to use them freely. There are intricate portraits of blue poppies, windflowers, apple blossoms, sweetbriers, peaches, plums, and pears; classically inspired figures dancing with harps; urns holding expressive flowers and sheaves of wheat; chubby cherubs mischievously riding dolphins and making music that attracts butterflies; small, sweet birds singing among rushes and water lilies on ceramic ponds as well as fantastically ornate peacocks, storks, and other exotic birds whose every feather is a stroke of magnificence;

ladies with flowing hair and gowns gazing in nineteenth-century reveries; grand Viking ships sailing across wavy blue ceramic oceans; repeating patterns of pomegranates, bluebirds, and floral trellises twined with laurel and ivy; stylized designs of waves, ropes, love knots, and the traditional egg-and-dart and Greek key patterns for borders. They are taken from artists' works and designers' patterns found in museums, galleries, antique shops, libraries, and private collections. Some are reproductions of the creations of masters like William De Morgan, who made specific renderings and developed his own glazes just for tiles. There are also designs intended for china patterns that have been translated to tile, and the original designs of tilemakers of the time have been carefully reproduced.

Each tile, each pattern or scene, is a world unto itself — rich, ornate, and intricate, sometimes with as many as twenty-two glaze colors to illustrate it. Even by Victorian standards, using more than a few of these designs would create not depth but chaos, and the patterns and scenes — and charm — would be lost.

The secret is to use Victorian-style tiles sparingly and keep the design simple. Put tiles in places where not many are required but where they will be seen, like a fireplace surround. You can also keep some of the more complex designs

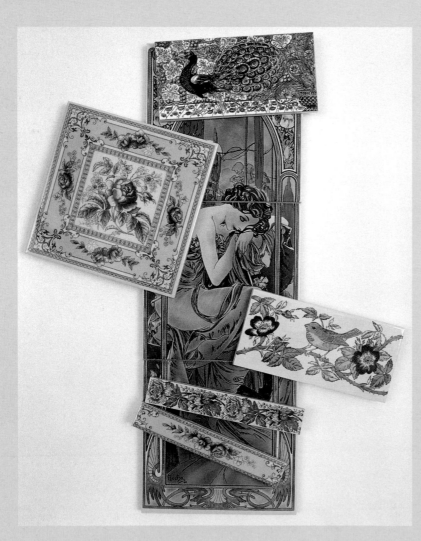

calmed down by placing them in a field of solid-colored tile. The same design may be picked up lightly in borders running across the tops or bottoms of bathroom walls, or around a shower door, for example. When the tiles are used simply and sparingly like this, they become special and appreciated—something that distinguishes and delights every time the room is used.

Victorian tile panels or murals should be treated like stained-glass windows in a church, with reverence. They should be given lots of room, set off to themselves in a place where they can be admired, and there should be few of them. In the bathroom pictured here, a panel of tiled flowers was placed on the bottom half of the wall to keep it separate and self-contained. It could also have succeeded in places like a shower stall, on the wall behind a tub, or on a kitchen backsplash.

Manufacturers have made choosing Victorian tile easier by offering it in sets that include border and corner tiles that coordinate with and frame panels and murals. They can also echo the panel or mural when used in other places throughout the room. There are also coordinated designs that put same-color relief and pictorial tile patterns together, from Jet Black and Imperial Ivory to Lilac and Royal Blue. Solid-colored field tiles are specially made

by many companies to match exactly the color tones and gloss levels of the patterned tiles. "Quarter" tiles with designs echoing those of full-sized tiles are available for creating borders that run at the floor, ceiling, or center of the walls of a room.

Just like Victorian style itself, many of today's Victorian tiles come from England. Many of these are produced by a company called Original

Style and sold in several American showrooms, such as Hastings. Designs in Tile in California offers a line of Victorian tiles and can even custom-color the glazes or refer to specific patterns from their design reference library. Laufen Tile in Oklahoma has a line of commercially made Victorian designs in their "Personal Touches" collection, available in showrooms throughout the country.

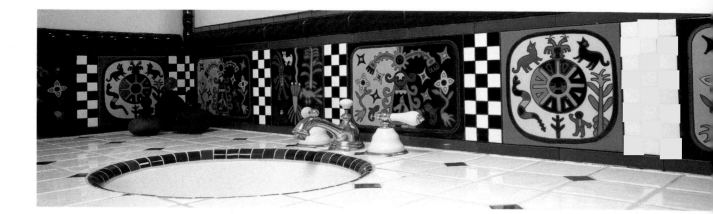

subway walls, you'll finish the space and put that detail into it that makes it both architectural and special.

Since bathrooms are often small spaces, tile for them should be carefully thought out. If you use identical tile on the walls and floors, it will make the room look bigger. Putting large tiles or large designs into a small bath will also make it appear larger. To keep a rich tile design from becoming overwhelming in a room, dilute it by placing it in a field of white tile or fading it out gradually. Graham Barr, manager of the Elon tile showroom in New York, did this in a bathroom he designed by using the flowered tile the client wanted near the bottom of the room and then, as the tile climbed toward the ceiling, using tiles with fewer and fewer flowers on them so that it looked as though the flowers were blowing away. This cut the richness of the design and also kept costs down, since the tiles with fewer flower designs were less expensive.

Floors in today's bathrooms are as important as they were in the old spas, meaning they must be comfortable, safe, and striking. Art tile that is strong enough to use on floors can be both beautiful and practical because handmade tiles often have a waviness to them that offers some traction. Some, such as the Sandstone collection from Epro, are made with substances such as sand that make them gritty and textured. But even commercial tiles come in raised, ribbed, or incised patterns that keep them from being slippery. Designer Florence

Perchuk recommends using small tiles for bathroom floors because smaller tile requires more grout, making for a less slippery floor. She advises using 4-inch tiles, going no larger than 6-inch.

Designer Michael Golden makes the floors darker than the walls in the bathrooms he creates, with the space getting lighter toward the ceiling, just as colors in nature lighten toward the sky. This approach gives rooms a strong presence. Another idea is to create "tile rugs" which take on the character of bathmats, laid out across the floor in long stretches of pattern bordered by a tile trim.

If you get overwhelmed by all the choices available, you can always turn to the coordinated designs offered by companies like American Olean, Florida Tile, and Dal-Tile. These designs show you floor, wall, trim, border, and accent tile that go together for a complete room, and offer different suggestions on how to use them. Creating tile designs for a bath, after all, should be as fun, beautiful, and restorative as the tiles themselves.

PRE-MADE MOSAICS

Mosaics are so popular today that companies are producing little miracles—pre-made mosaics that you can use like regular tiles. The many ceramic pieces that make up a mosaic design are already adhered to a single net shaped like a tile. When you grout it, you get the look of a free-form artistic mosaic, but since it is self-contained it is easy to fit and install into an overall design. It is like having a little piece of Pompeii with which to work.

At Pompeii, however, you won't find shining celestial symbols like suns, moons, and stars made up of bits of yellow, blue, and white tile; rain forest animals whose beaks and tusks and horns are shaped from different colored shards; bright daisies spilling across green fields of broken ceramic; cow spots made of classic black and white tile pieces; numbers and letters of the alphabet spelled out across bands of tile like a ceramic wall of graffiti; tiny apples, pears, grapes, oranges, and cherries in a fruit ensemble of broken tile. But you will find these in showrooms across the country today, along with pre-made mosaics that form not scenes or designs but instead glorious swirls in rich detail,

deep colors, and glazes ranging from matte to metallic. There are also pre-made mosaics bearing parts of patterns that, when placed next to companion tiles, join to make a larger pattern. So half-moons, angles, and open rectangles on one tile become circles, triangles, and squares when placed next to corresponding tiles. On a single tile, the mosaic works as an abstract pattern; on more than one, a geometric design begins to take form.

The way you use pre-made mosaics is often as important as the way you hang or place art, because they are singular and eye-catching. It requires some thought and some consideration of their uniqueness. In the bathroom shown at right, tile designer Michael Golden put the larger mosaics at exactly the same height—about eye level—around the room. This gives an order to the design and the room, and allows the mosaics to be showcased without being overwhelming or chaotic. That order anchored the room, so he had some fun with the remaining, smaller mosaics, placing them around in a random manner, like "magnets on a refrigerator," as Golden puts it. Then he set moon and star mosaics on the ceiling of midnight blue tile above the tub to create a starry night for whoever is bathing below.

In another design, Golden placed mosaics at paced intervals around a bathroom and framed each with a tile edge so that they look like little pictures placed around the walls of the room.

Golden also likes to use pre-made mosaics on shower floors. Aside from the fun of looking down and seeing a tiled bouquet of flowers or stars at your feet, this idea is great for practical reasons. Because mosaics naturally have more grout in them due to the spaces between the tile pieces, they offer more traction, making the shower safer.

Pre-made mosaics can go anywhere, even places ordinary tile won't go, such as around columns or on other rounded surfaces, because they are flexible on the net until grouted. And they can often be custom-designed. Smashing Tiles, one of the companies specializing in pre-made mosaics, has worked from swatches of fabric to match glaze colors to pieces of furniture in the room. They glaze their own tiles before breaking them up for the mosaic.

You can further customize the look of a pre-made mosaic because you grout it yourself, and using any of the lively grout colors available today will change the look of a mosaic. Black can be particularly beautiful and dramatic in the right settings, bringing the mosaic designs forward and making the colors come alive.

Most pre-made mosaics, whether they are from a major company like Epro or a smaller one like Decoratta, are designed in quarter-inch thicknesses so that they will be compatible with standard field tiles from commercial tile companies. Pre-made mosaics are available at showrooms nationwide.

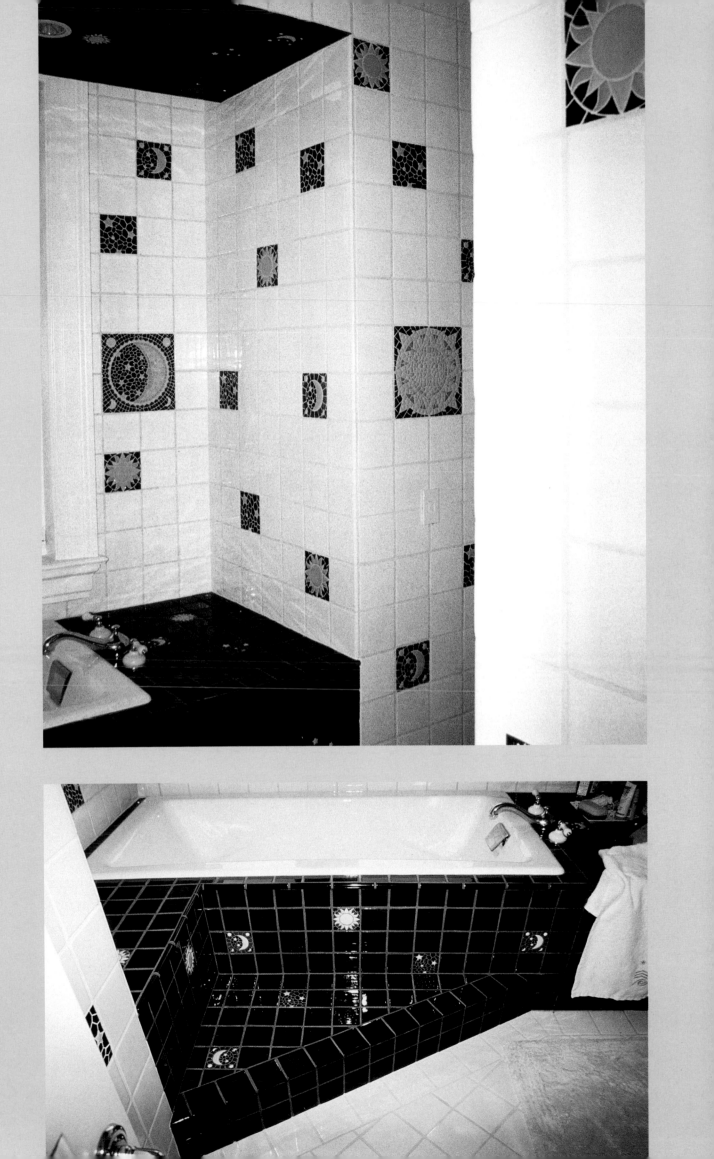

Iconoclastic Rooms

"There's nothing like tile for the tango."

—FROM *SUNSET BOULEVARD*

Though the tile floors that spill across entryways, living areas, hallways, and other rooms in the home today may not have been intended for dancing, the expanses of tile that are alive with pattern and design may very well inspire that impulse. It is wonderful to see tile flowing across the floors of rooms where it is not expected to be. Unfortunately, American homes have rarely given anyone reason to think of dancing. But today Americans are often approaching tile in the same way that Europeans have for years, as an element that continues inside quite naturally from the outdoors, almost like a plant that spreads and keeps growing indoors. This wonderful sense of abandon with tile has meant that Europeans have used it far beyond the kitchen and bath, running it part way up walls; on columns, stairs, and built-in benches; and across the floors of most, if not all, rooms. The Pope's bedroom floor, from fourteenth-century Avignon, France, was tiled in squares of rich solid colors alternating with blue-and-white random patterns.

In Cuba and Mexico, the outdoors and indoors are not just related, but often barely distinguishable. In parts of Havana, the backs of small connected houses are tiled halfway up, and the alley between the two rows of them is lined with a runner of tile. You might think you are in a long, splendid room until you look up and see the sky. Dining rooms and living rooms surround you with tile, used in scenes on the walls and patterns on the floors. The feeling is so much like that of the outdoors that here you are tempted to look up to

LEFT: *A living room made of tile sets the tone of a Manhattan apartment, following the philosophy of the arts and crafts movement that materials should be both natural and functional. The handmade tile and checkerboard border are from Country Floors.* BELOW: *Tiled door panels and a long entryway of terra cotta floors were originally built into a 1927 Los Angeles house.*

see if the sky *is* above you. The hotel room in which Hemingway lived and wrote in Havana is floored in vibrantly patterned Cuban tile, the designs of which he must have looked down at many times from his chair and typewriter.

Sleeping porches in old mansions of San Antonio, Texas, such as the McNay house (now a museum), have tiled floors that stayed cool during hot Texas nights.

This wonderful confusion between the outdoors and in is part of the attraction of using tile throughout the house. It brings the same sort of feeling to spaces that plants do.

The most dramatic way to use tile in rooms other than the kitchen and bath is to put it on floors, where it will have a great impact on the space. Designer Melvin Dwork has designed houses with all the floors covered with tile, sometimes with terra cotta, sometimes with dark green tile, sometimes with large, 12-inch squares of variegated shading. No matter what kind of tile he has used, the effect is like that of a landscape. There is a continuity and tranquility, with rooms flowing one into the other.

Putting tile on the floor of individual rooms can have more singular effects. Tile the bedroom floor with terra cotta, and you will feel like you are in

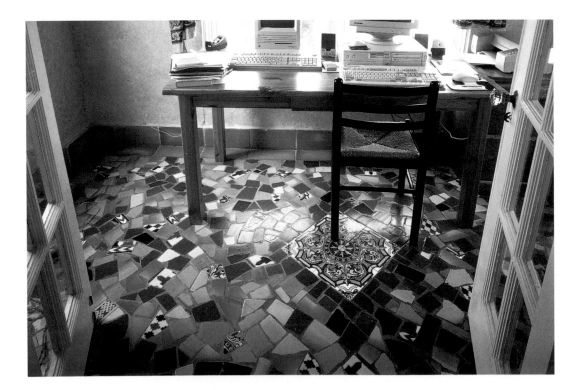

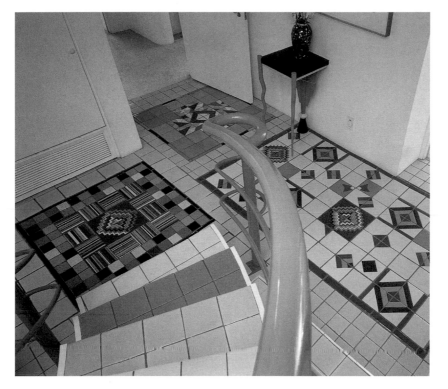

the missions of California and Texas. A tiled floor in the living room gives the impression of a big carpet spread out across the space. The living room floor offers a great opportunity to show off hand-made tile, because its striking form and glaze can really be seen there. Tiling an office floor creates an open, comfortable environment for working. A sunroom floor can be tiled in terra cotta and be reminiscent of a courtyard, or in handmade bright-colored squares for a warm, informal feeling evoking the styles in the south of France.

Tiles for floors are being commercially made specifically to bring color and pattern to rooms other than the kitchen and bath. They are striking or subtle or elegant in strong blue, green, and red tones; in cool greens and pale roses; or in copper, leather, stone, and slate looks, in beautifully varying shades. Dozens of different geometric patterns are offered in single-color tile, including those inspired by American quilt and Navajo rug designs. Tiles based on original Victorian designs are lively with colored geometric patterns to give a different look to hallways. Classic black and white tile can either be tradi-

LEFT: *Cuban tile flows through a 1938 house in the Little Havana section of Miami. The original mosaics are wonderful for an office floor, where work can be uplifted by the freshness and life of the colorful ceramic.*
ABOVE: *Artist Miriam Wosk splashed tile rugs across a Los Angeles entryway as well as on steps like runners. The yellows and blues were inspired by the nearby dome of the Beverly Hills City Hall, which gleams in the sun with tile patterns. The tile rugs have a welcoming quality and feel great to bare feet.*

TILE RUGS

In old villas throughout Sicily, the floors are intricately patterned rugs and carpets—made of tile. Aside from the fact that much of Italy is made of tile, the rugs were designed this way because they make sense; they are cooler and cheaper than wool or fabric and easier to maintain. Dirt from outdoors can blow over them, rain can spill in. It all seems quite natural, since tile itself is made of earth and water. And after centuries and centuries, the tile rugs still haven't worn out.

When May Rindge, who started the acclaimed Malibu Potteries, built her house by the California sea in 1929 she borrowed the Italian idea, spreading tile rugs across the floors of what is now known as the Adamson House. She was building in much the same environment as Sicily—sun, sand, salt water—but also in the same kind of "tile culture" that considers the material a natural part of everyday life. Her striking tile rugs, one of which is shown below, were made in the Malibu factories with the bright,

jewel-like glazes for which the company was known. The rugs were made to look just like real Persian ones in pattern and design, down to the fringe on the edges.

More than sixty years later, Peace Valley Tile has created an altogether contemporary version of the tile rug, shown at right. It couldn't be more different from the Adamson House rug, but the principle is the same. Like all good rugs, both of these give a sense of ceremony to the houses while at the same time making them into homes because of their comforting presence. And they are an invitation—to enter the house, to come into a room.

Tile naturally makes great patterns, and, when outlined in one of the incredibly large selection of borders available, a tile rug is easy to create. All these factors have made tile rugs newly popular today. As part of the architecture, they are not merely on the floor, but *are* the floor. This makes them witty but also functional. They are being used everywhere that textile rugs go. In the dining room, the floor under the table may be tiled a solid color and outlined with a different color, creating the look of an area rug and making cleaning up after a meal easy. In the bathroom, tiled "bath mats" can be designed next to tubs for both fun and function. In the foyer, a tiled rug is a surprise that introduces the home and also takes dirt well. In the family room, a space

that benefits practically from tile perhaps more than any other because of the traffic and wear it takes, an entire floor of natural terra cotta tiles can be lined on the outer edges with colorful borders to create a tile carpet. Or separate tile rugs can define different spaces in the room, such as the eating area, the play area, or the living area, with a tile rug spread in front of the fireplace, for instance.

Companies today have made it easy to create tile rugs by carrying lines of tile designed specifically for this purpose. Country Floors offers tile that has the rich patterns, deep colors, and even the fringe of Moroccan carpets. These have become popular for the wall, too, echoing the Turkish and Moroccan tradition of displaying rugs across the walls of a home. In a completely different spirit, Crossville Ceramics has twenty-three geometric patterns in tile, six free-form patterns adapted from traditional quilt designs, and seven patterns of geometric borders to make quilt designs for floors.

tional or serve as a background for vibrant color and design elsewhere in the room. With computer-generated designs based on photographs, you can create floors that make you feel like you're walking through a real bed of leaves or a field of flowers.

If you use terra cotta tiles, they will fit with every style — country, traditional, funky. Oriental rugs go as well with them as leather furniture. Rugs of all kinds live beautifully on tile floors, though they are not necessary. Contrary to rumor, tile floors are not any harder on feet than floors made of wood, for example. And tile floors are not cold; they respond directly to the temperature in the room. They'll be warm if the room is warm and cool if it is cool.

The same renewed enthusiasm for the decorative arts that has made tile so popular today has also made stone and marble widely available in a similarly diverse array of designs. Granite, slate, bluestone, limestone, small pieces of precious stone, classic marble in shimmering white squares and colorful slabs with dark veins, and "tumbled marble" — a beautifully weathered and smoothed form of the material — are now often side by side with tile in stores. They are certainly side by side with tile in today's designs, particularly in entryways. They harken back to ancient designs, such as the entryway to Michelangelo's house in Florence, where marble was set amidst expanses of terra cotta tile. When the earthiness of tile is placed against the luxuriance of stone or marble, a layered look is created, and the materials set off one another. Stone and marble are rich, literally as well as visually. So when ceramic tile is used with them, the cost is much less than if they had been used alone, and the overall effect is elegant without being overwhelming.

Since other rooms and spaces so often flow from kitchens today, tile often carries over into them. It can be used to unify spaces, such as family rooms that combine cooking, dining, and sitting areas. Terra cotta floors are popular for spreading across family rooms, but there are also many other options today. Showroom owner Ann Sacks carried the clean-lined white tile from her kitchen to the wall below the wainscoting in the adjoining dining room. Above the wain-

scoting, she used larger rectangular white tile that echoes the white-painted bricks on the fireplace in the dining room. The same white floor tile runs throughout both the kitchen and dining room. The space ended up feeling like one big, bright area.

Tile can also be used to do the opposite, setting spaces apart. If the same floor tile is laid in the cooking area of the kitchen in one pattern and the eating area in another pattern, the two spaces will seem separate. A breakfast room can be distinguished by using tile on the floors and covering the wall near it with that same tile. An office in the kitchen can be tiled with the same design as the kitchen walls, but with distinctive trims at its edges to set it off. Designer Florence Perchuk used small tiles on the floor of a family room to create checkerboard borders that define elements of the room such as the eating area, the entertainment area, and the office. They also form a traffic path that guides the family through it all.

Entire rooms in the house can be tiled, just as the kitchen and bath have been. A sunroom or greenhouse can have planters and shelves tiled to match the floor. Counters, tables, and platforms can also be tiled to resist water, and the tile will soak up the heat of the sun to warm the plants. An exercise room built by architects Brock Arms and Associates was completely covered in tile, with mosaic designs on the walls for the homeowners to look at while exercising. Designer Bob Patino tiled an entire beach house, from countertops and cabinets to doors and walls. Each room in the house can be tiled in a different style, so that every room evokes a different culture.

It is not necessary to use a lot of tile, though, to make an impact. Tile can instead be featured in particular places of importance throughout the house, as it has been in cultures around the world and throughout history. This way, the ordinary is made

LEFT: *An entryway floor can be the best place to show off beautiful tile. Architect Alan Wanzenberg and designer Jed Johnson used handmade terra cotta from Peace Valley Tile to make an impression at the front door of this Manhattan apartment.*
BELOW: *In an oceanside house in Newport Beach, California, a vibrantly tiled bar creates a celebratory environment.*

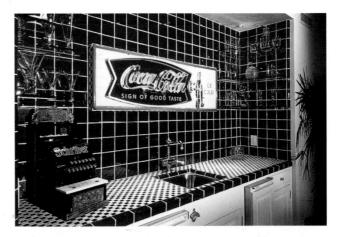

Portuguese tile panels in the Chinese style are the centerpiece for the entirely tiled living room of a seaside house in Southampton, New York. Denning/Fourcade Design found the panels, which date to 1870. Imported antique tile can also be bought through Solar Antique Tile in New York City.

ceremonial. The tile marks the daily events of entering the house, moving up the stairs, or walking down a hallway.

Entryways can have expansive sweeps of tile running all the way into the front hallways of the house. Or small areas of tile at the front door can make entry areas look larger. Whether they are mosaic, terra cotta, or slick contemporary styles, tiled entryways are usually made of a different material than the rest of the nearby flooring, setting entryways apart from the rest of the house. They're great for catching the elements from the outdoors—dirt, rain, grass—because they are easy to clean.

Tiled stairways in homes reflect a history of public staircases that rise with tile. In a public plaza in Spain, hundreds of steps are framed in tile, going up in a glory of yellow, blue, and green glazes. In hotels, palaces, and public buildings throughout Europe, no one would think of neglecting the stairs

BELOW: *Designer Catherine Gerry made Griffoul's leaf tiles seem as if they blew in the door onto a ground of slate squares.*

NEAR RIGHT: *Original Malibu tiles climb the steps of the Adamson House. The tiles were specially made for the 1929 mansion.*

CENTER RIGHT: *A San Diego staircase by Urban Jungle Art & Design is an evolution in tile, with water and fish portrayed at the bottom, land animals in the middle, and birds and the sun at top.*

FAR RIGHT: *A Los Angeles stairway features original Malibu tiles.*

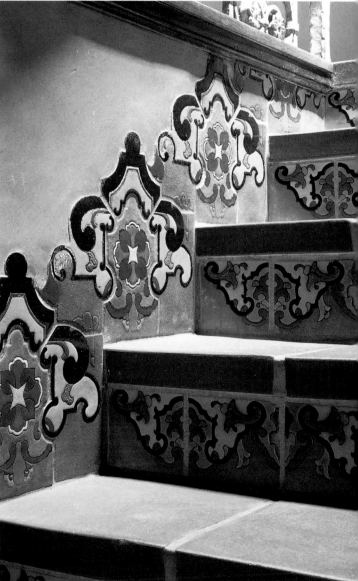

and leaving them bare of tile. At El Gran Convento Hotel in Old San Juan, Puerto

Rico, a hotel that was transformed from a convent, grand tile staircases rise to the

top floors of the historic building, but the most charming staircase is a smaller one at

the back of the hotel. Each riser contains rows of tiles showing figures doing differ-

ent things with their days — fishing, working, falling in love. The little people, in their

places on the risers, escort you as you climb up the stairs.

So it is with tile for staircases in the home; the tile goes with you as you

climb step by step. A wonderful effect is achieved when each riser contains a dif-

ferent design, just as in outdoor steps throughout Europe, California, and Florida.

As long as you stay with classic designs or keep the designs in the same color

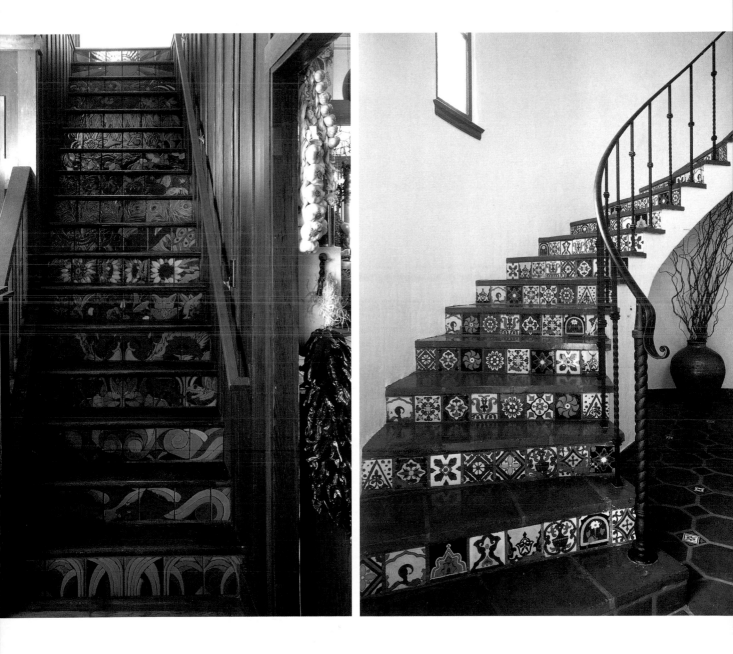

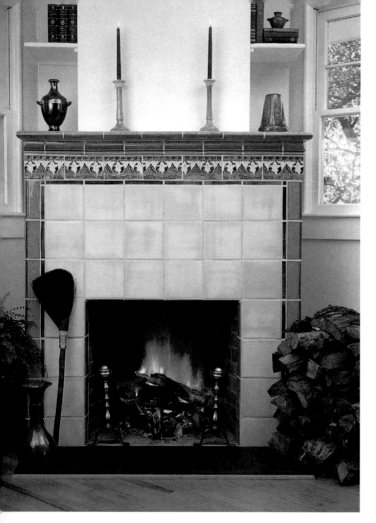

schemes, the mixture should work. Otherwise, it could be too chaotic. You can also tile each riser with many different-colored tiles in a row. The colors need to bounce around in just the right way as they rise up the stairs, however, for the look to work, so plan the design carefully before the tile is installed.

Putting tile on the walls of rooms other than the kitchen or bath may seem to take a lot of courage, but actually it is quite natural since the tile on these walls can follow the architectural elements of the room. While tile can be placed dramatically halfway up walls of entryways, dining rooms, and halls, as one homeowner did with terra cotta, usually smaller borders of tile work better on walls. They are wonderful for framing arches, doors, and windows of homes, either in simple contemporary designs, or in more elaborate trims or glittery mosaics. Just as in European country homes, you can use a border of decorative tile in place of a chair rail in the dining room, or a ceiling molding in the living room or bedroom. A baseboard can be replaced with a charming tile trim. This single band of tile can transform a space when it is run all the way around the room or, as in the case of a loft in Milan, the entire home. In old Italian villas, borders of tile run near the floor throughout the home, and when they turn corners, their patterns change. Even with changing patterns, the border unifies the space, catching the eye at various points throughout the room. And tile floor borders, unlike baseboards, never have to be painted.

ABOVE: *The fireplace, a focal point in a room, is an opportunity to show off beautiful glaze designs. "Flowing" glazes taken from their antique pottery finishes are created by Fulper Tile. Here tiles in "flowing ivory" glaze meet with a Victorian lily border of "Chinese blue" glaze.*

RIGHT: *The entire first floor of a house in Miami is enveloped in tile, with the mosaic floors of the dining room, sleeping porch, and living room leading up to the fantastic fireplace. The Cuban tile dates to 1938 and features the Miami flower, bird of paradise.*

In colonial America, in places like Williamsburg, tile was wrapped around fireplaces to keep the heat contained and provide resistance to ash and soot. But it was also an ornamental statement, showing the importance of the fireplace in a colonial home. With charming designs showing detailed scenes of people in everyday life, the fireplace became a focal point in the room.

Today, tile is available in reproductions of those historic Williamsburg designs that harken back to the days when the fireplace was the center of the home. But since most wall tile is appropriate for fireplaces, the striking array of designs available presents the opportunity to introduce all sorts of styles into the room, from deco to southwestern to sleekly contemporary. You can have a gold or platinum surround, or a mosaic design — elegant or funky — created by an artist. Fireplace surrounds offer a great opportunity to show off any kind of art tile, since the fireplace is the focal point of the living area. There are also hearth sets available in murals that surround the fireplace. L'Esperance Tile Works sells a hearth set that is a recreation of those used during the aesthetic movement, with tile grasses swaying in urns on either side of the fireplace and a tile sunrise above it. And Moravian Tileworks is recreating their historic hearth sets that run around the fireplace to tell the story, tile by tile, of Columbus coming to the New World, for example, or the legend of Rip Van Winkle. These sets of handmade tile cost about $1,000.

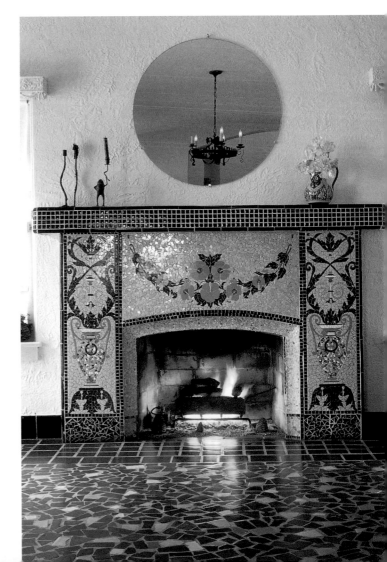

The energy of tile becomes apparent in its ability to add color, design, and style to a fireplace. That energy shows in rooms throughout the house, where tile has lit them up, made them surprising, and transformed them.

*Handmade tile from Fulper Pottery
is glossed with "leopardskin" glaze,
a formula that varies in color from
greenish-blue to olive to brown and
shimmers with changing colors as it
glows in the firelight. Antique Fulper
pots sit on the mantle.*

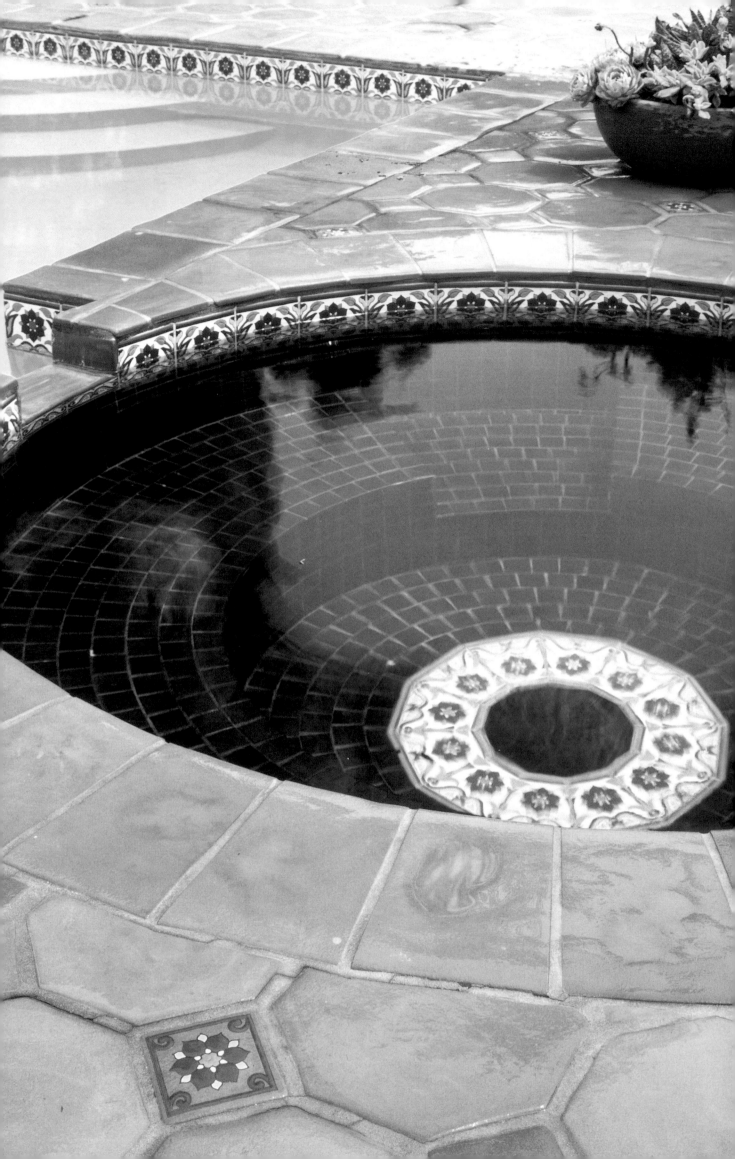

In colonial America, in places like Williamsburg, tile was wrapped around fireplaces to keep the heat contained and provide resistance to ash and soot. But it was also an ornamental statement, showing the importance of the fireplace in a colonial home. With charming designs showing detailed scenes of people in everyday life, the fireplace became a focal point in the room.

Today, tile is available in reproductions of those historic Williamsburg designs that harken back to the days when the fireplace was the center of the home. But since most wall tile is appropriate for fireplaces, the striking array of designs available presents the opportunity to introduce all sorts of styles into the room, from deco to southwestern to sleekly contemporary. You can have a gold or platinum surround, or a mosaic design—elegant or funky—created by an artist. Fireplace surrounds offer a great opportunity to show off any kind of art tile, since the fireplace is the focal point of the living area. There are also hearth sets available in murals that surround the fireplace. L'Esperance Tile Works sells a hearth set that is a recreation of those used during the aesthetic movement, with tile grasses swaying in urns on either side of the fireplace and a tile sunrise above it. And Moravian Tileworks is

recreating their historic hearth sets that run around the fireplace to tell the story, tile by tile, of Columbus coming to the New World, for example, or the legend of Rip Van Winkle. These sets of hand-made tile cost about $1,000.

The energy of tile becomes apparent in its ability to add color, design, and style to a fireplace. That energy shows in rooms throughout the house, where tile has lit them up, made them surprising, and trans-formed them.

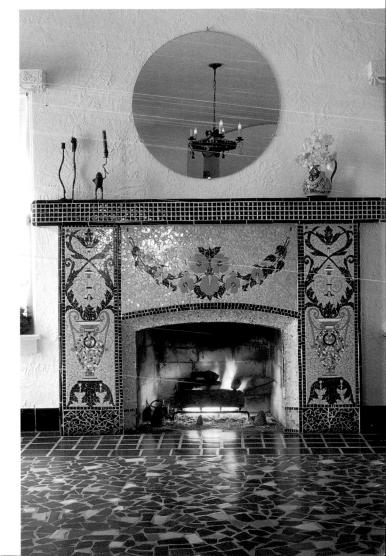

Handmade tile from Fulper Pottery is glossed with "leopardskin" glaze, a formula that varies in color from greenish-blue to olive to brown and shimmers with changing colors as it glows in the firelight. Antique Fulper pots sit on the mantle.

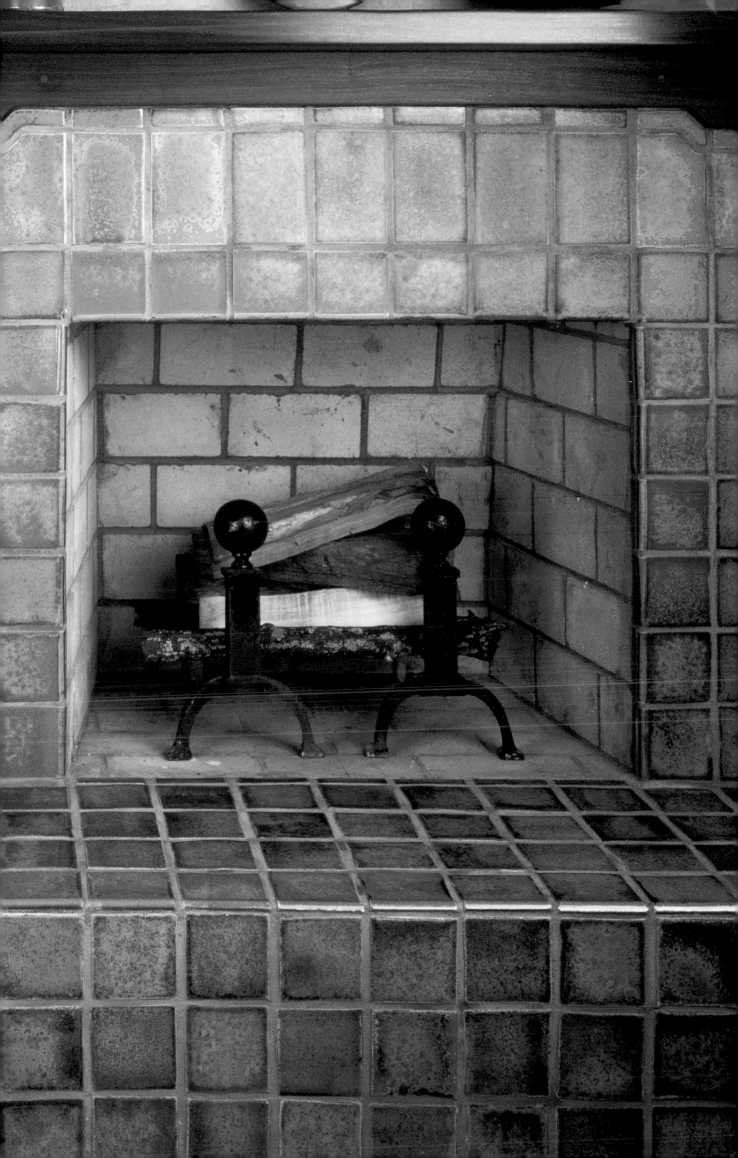

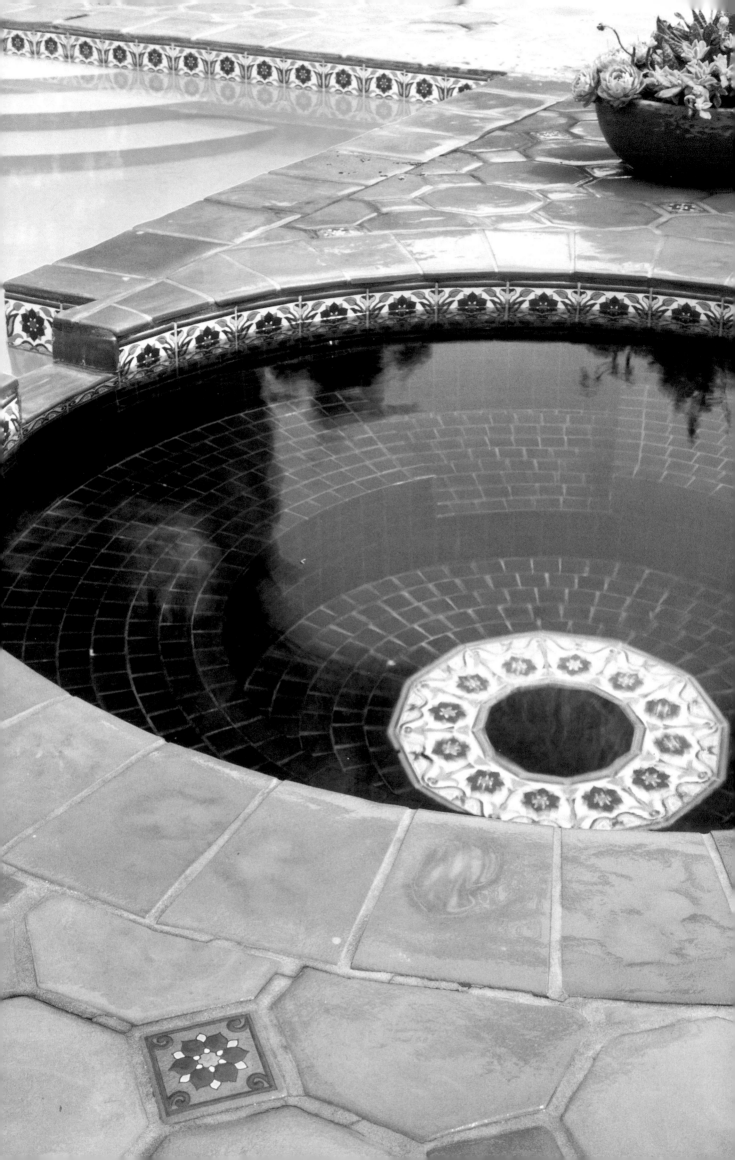

Outdoor Ceramics

They could not understand what they were doing so far from their youth on a terrace with checkerboard tiles in a house that belonged to no one and was still redolent of cemetery flowers.

—GABRIEL GARCÍA MÁRQUEZ, *LOVE IN THE TIME OF CHOLERA*

Many people would be happy sitting outside a house belonging to no one and smelling of cemetery flowers only to be on a tile terrace. People love the idea of tile outdoors—on patios and porches, on terraces and balconies, in pools and fountains. Perhaps this is because tile was in many ways meant to live outdoors, in what seems like its natural habitat. Tile is made from the four elements—composed of earth and water, baked by fire in a kiln, and cooled in the air. So it seems right for it to exist outside among those elements—running across the ground, flowing through water in pools and fountains and standing up to rain storms, being heated by the sun, and not deteriorating in the constantly changing air of the outdoors.

This is why for centuries across the world it has done so, making art out of the pavements of San Marcos in Italy, spreading underwater in the elaborate pools and ponds of mansions in Portugal, covering the floors of outdoor rooms at the Alhambra in Spain, reaching into the air on domes of mosques in the blue skies of Iran, and living on benches, columns, and steps of plazas in old California and Florida.

So when tile leaves the bounds of the house, the kitchen counters and bathroom walls and entryway floors, and spills into the garden or yard, it seems natural. It is almost as if it grew there, like a lovely flowering vine. Tile is charmingly integrated into today's backyards on steps, benches, garden walls, patios, terraces, porches, fountains, archways around doors and windows, pools, ponds, whirlpools, and outdoor bars.

Flowered Malibu tile resembles blossoms that have fallen in the jacuzzi and ground cover that blooms on the terra cotta pavers.

The significant addition of tile can have a huge effect on outdoor space, transforming it more—and more permanently—than a garden or landscape design, lawn design, or any other single change to the outdoors could. In fact, big garden-wall murals become part of the landscape, both complementing and being enhanced by it. Even the small presence of tile, however, such as rows of tile on entryway steps or a tile design covering a patio, will appear to create a real change in the outdoors. This is because tile draws the eye, becoming, at the most, a focal point and, at the least, a wonderful little discovery. It is like a permanent garden.

Columns of tile give the outdoors a lush look that is reminiscent of European gardens. A contemporary interpretation in a Miami garden designed by Dennis Jenkins and showroom owner Sunny McLean (ABOVE) *draws on deep historical precedents. The eighteenth-century school garden at the Colegio Manuel Bernardes outside Lisbon* (RIGHT) *is one of the quietest places on earth but is vibrantly alive with the designs and stories being told in tile on its columns and walls. At the cloister gardens of Santa Chiara convent in Naples* (FOLLOWING PAGES), *monks and cats that inhabit the convent wander among the columns and benches made entirely by local tile artisans in 1742.*

These gardens of tile are often "grown" from broken-tile mosaics created by artists or homeowners because the freedom, artistry, and informality of mosaic lends itself to the outdoors. Although mosaics appear in many places in American yards today, they are particularly beloved underfoot. Using regular, unbroken tile on the ground can also evoke a wonderful sense of abandon, with ceramic spreading across the yard in expanses that might never be attempted in the house because of space or design limitations. Whether broken or in squares, tile is such an architectural material that covering the ground with it gives the outdoors a sense of grandeur and importance that is usually associated with the indoors. To spread tile across the ground is to literally create an outdoor floor. At the same time, outdoor floors have everything to do with the earth.

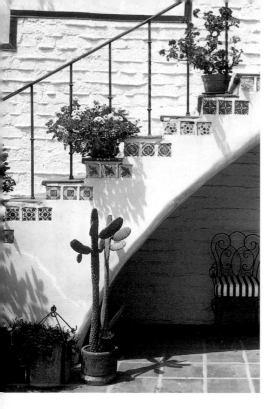

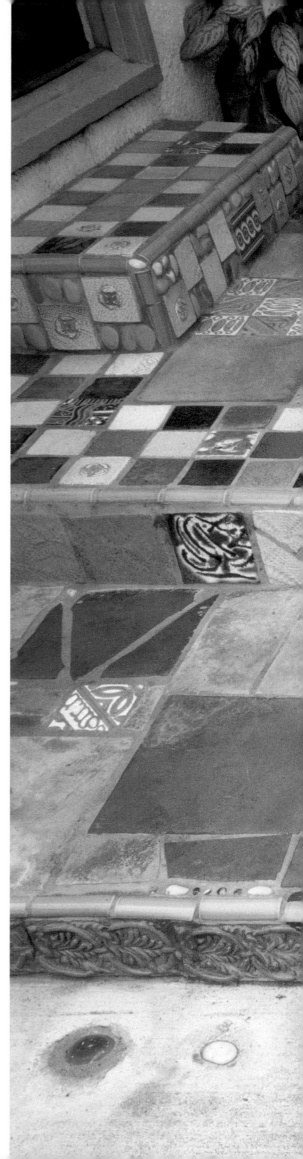

LEFT: *In the courtyard of a Los Angeles home, the rise of each step is announced by a charming row of Mexican-style tiles made in California. Plants and tiles, both of which are natural and earthy, always work together.*
RIGHT: *Designer Nancy Kintisch used dozens of different ceramics to transform a small outdoor entryway in Los Angeles into a landscape of tile. Many mosaic artists preserve pieces of the past by using original tile taken from the home in their designs.*

New breeds of commercially available tile for outdoor floors that are more varied, more sophisticated in design, and more advanced in technology than ever before are helping to revolutionize the use of tile outside. Their greater durability in heat and cold, and changes between the two, is causing them to appear more frequently in northern climates, and their new stylishness is letting them be seen as a real design element for outdoor spaces.

Tile for outdoor floors is still being imported from places like Spain, Mexico, and Italy, where this kind of tile has been made for centuries. But American companies are also now carefully developing outdoor tile that is strong but stylish, combining classic themes with contemporary technology.

Outdoor floor tile is not only more durable than it used to be, but some companies now claim that it is more durable than steel. At the same time, it often resembles the finer, thinner tiles of the indoors, instead of the heavy, clunky patio tile of the past,

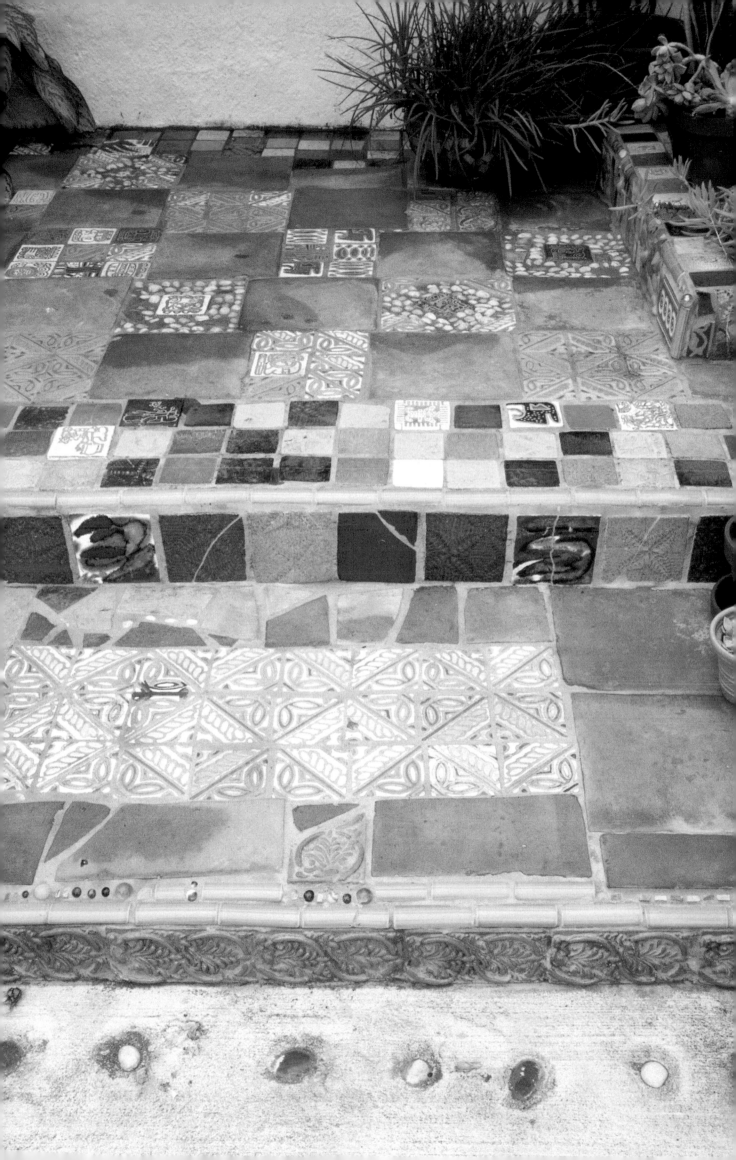

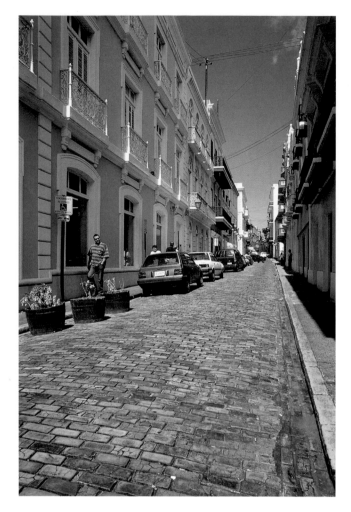

Outdoor floors made from tile are as natural as those made from the earth. In Old San Juan (LEFT), the streets are blue tile bricks brought by the Spanish as ballast for their ships when they settled Puerto Rico. Upon arrival, they used the unneeded ceramic bricks to make the floors of the city. In an only slightly less ambitious project, artist Miriam Wosk surrounded her Los Angeles penthouse in a balcony of tile (RIGHT, ABOVE AND BELOW). The floors, which run around the entire building, change patterns every few feet, creating different environments along the balcony. Outdoor rugs created from a mixture of Malibu tile and other California ceramics appear in one area, while in another, freeform mosaic patterns, tile edging on the balcony, and the red tile roof beyond combine with ceramic pots to create a tile garden.

because today's technology allows it to be made stronger with less material. The colors and designs can be remarkably subtle and the surface shadings interestingly varied, bringing unexpected elegance to outdoor floors. There are tiles made to look like beautiful rare marble, stone, or granite. Endless patterns can be created from among the variety of colors, sizes, and shapes now available, and by using the small accent dots and squares designed to coordinate with the larger tiles. Even while getting stronger, some commercial tiles are carefully made to look aged and handcrafted, with the nicks and texture and imperfections of the floors of an Italian piazza that has been worn by lovers' feet and marketplace carts and bicycles. Imported English patio and entrance walk tiles that draw on original Victorian pattern books for their designs harken back to the days of William Morris but come in twice as many colors and geometric combinations as they did in the late 1800s.

Most standard floor tiles are unglazed or have a dull matte, rather than glossy, coating so that they will not be slippery when it rains. But newly developed floor tiles have sand thrown onto the glaze during firing to give them a slightly rough texture so they are not only slip-resistant, but look rustic, almost like part of nature. All outdoor tiles should be immune to frost, and most to staining. Pavers are large-sized unglazed tiles used for any outdoor flooring area; quarry tiles are heavier, made from clays that render them especially durable for high-traffic areas like patios and entrance walks.

Using tile to create outdoor floors, you can take lessons from the Mediterraneans and spread tile freely, the way most Americans spread lawn seeds. A deck outside a house may be floored in terra cotta tile, say, instead of wood. Other elements surrounding the deck, such as a barbecue or grill, an outdoor bar or cooking island, or planters and pots, can be covered in brightly flowered decorative tile, creating the effect of flowering plants and trees blooming across the space. If you use that same decorative tile in accents across the terra cotta floor, standing out with color and lifelike blossoms that have fallen to the ground, you will have created a delightful motif that unifies the space.

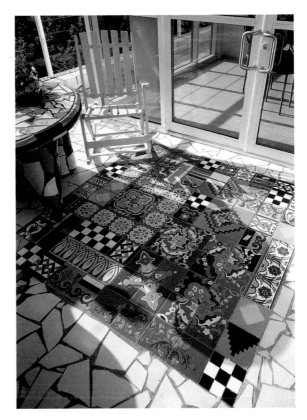

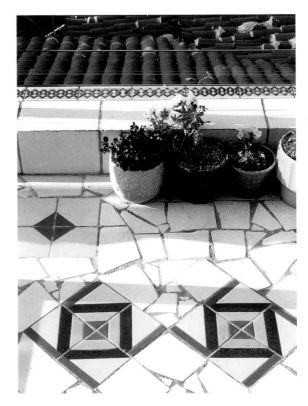

A TILED TOWN

In the town of Vietri on the southern coast of Italy, tile seems to grow on the rough Mediterranean buildings like ivy on the façades of colleges. It covers the village's small groceries, depicting scenes in ceramic behind and around and above the bunches of bananas, crates of oranges, and cloves of garlic that are sold outside. It appears as a recurring theme inside cafés—lining walls, covering counters, and running across tables in blue and yellow blooms of flowers—making having a coffee like stepping into a garden of tile. It spills candidly across floors of unlikely buildings like garages, where cars drive across bright glazed donkeys, grape-stomping women, and bands of village musicians. Because of the miracle of tile's strength and endurance, the lovely peasant scenes from the town's past are not diminished by the exhaust of today's cars. Tile shows up in hidden corners, as if it had been put there solely for the delight of that person who comes upon it. The tile appears to have sprouted on its own, like a flower.

But though the tile in this village looks so natural it seems to have just bloomed, the care taken in its creation is extraordinary. It can be seen in the details of tiled exteriors—a vine winding exquisitely all the way up a building; and in major tile murals—the power with which a wave curves to meet the ceramic boat above it. Most of all, it shows in the pure earnestness of the stories told throughout the town in tile—their eagerness to convey the life of a fishing village in Italy, with nets cast across rows of blue and green tile oceans and oars that dip to meet seas of glazed fish. There are also gleeful and graphic tiled accounts, from the vine to the glass, of the making of wine in an Italian village.

Vietri lives with ceramics because it lives by ceramics, having made them since the Middle Ages for export to places as near as Rome and as far as North Africa. But they can all be bought in a stroll through the main square of the town, where shop after shop is covered with tile on the outside and lined with it and other ceramics to buy on the inside—in stacks, on shelves, hanging on walls, lying on floors. Though the naive style used to portray peasant life in simple bright blue, greens, and yellows against a white background is the hallmark of Vietri's tile all over the world, there is also a striking diversity of styles and subjects. Suns and stars, sunflowers and glowing moons innocently light up single tiles in one corner of a shop, while more daring tiles make up murals of Bacchus and mischievous fauns displaying at least half of the deadly sins in another. Nearby, a passionate crucifixion scene is on display, glazed in vivid detail, while tiled animals gather on another mural in a sweet nativity scene.

It is possible to watch the tile being made in shop windows and on potters' wheels throughout the village. The vibrancy of Vietri tiles results technically from the fact that they are fired twice, with the painting taking place in between the two firings. Watching Gian Cappetti, a master craftsman, paint tiles in his studio is just as inspirational as viewing the centuries-old church floors that he copies. He custom-makes floor tiles for purchase based on famous historic buildings or can create original, more contemporary designs.

American importers have discovered Vietri, and tiles from there are widely available in showrooms and home stores. The tiles sold throughout the town, however, begin at about $10 each and run up from there. But the experience of wandering through the landscape of tile in this small village—its continuous joy, life, expression, and forthright sense of place—is invaluable.

You can further draw on Mediterranean cultures that make little distinction between the outdoors and in. The same kind of tile, for example, can flow from the indoors outside for a sense of space and unity. It may continue outdoors from an entryway floor at the front door or a kitchen one at the back. Designer William Diamond suggests going all the way with the idea in warmer climates, tiling the driveway, the pool terrace, and the living room floors with a material like Italian terra cotta.

You can also bring the style of the house outdoors with the kind of tile you use. Classic terra cotta can evoke a country feeling, for example; sleek and subtle-colored tiles will result in a contemporary look; and cool greens and blues can give the hip, seaside feeling of places like South Beach in Miami and Santa Monica in Los Angeles. Or you can continue the color themes you've used indoors outside.

Just as you may have indoors, of course, you can create borders and patterns with tiles of different colors and sizes. This is particularly successful when used to make pathways that lead people through gardens and landscapes, among the natural groundcovers of flowers, lawns, and herbs.

The element of water is celebrated outdoors in tile with fountains, swimming pools, whirlpools, and goldfish and flower ponds. Tiles for pools have been reinvented with both the visual and physical effects of water in mind, using high-gloss glazes that reflect the light from the sparkling water, whether they are lining pools, marking water depths, or measuring lap lanes. Art tiles feature impressionistic water lilies blooming at the edges of pools and ceramic fish diving into them, with vivid relief portraits of ladybugs, lizards, dragonflies, fallen leaves,

The cold-climate alternative to bright mosaic outdoor floors are the muted colors and frost-resistant styles copied from Victorian walkways. Recreated today by Original Style in England, the tile spreads across porches like rugs in designs that change as different colors are used.

and pine needles inserted in pool surrounds.

Real water lily ponds can be created with tile. Dark tile linings will make a pond seem natural, whereas a bright tile or a mosaic bottom will make it stand out as a little piece of art.

Fountains catch the eye quickly, so artist Debra Yates, who creates mosaics that often have water running down them in

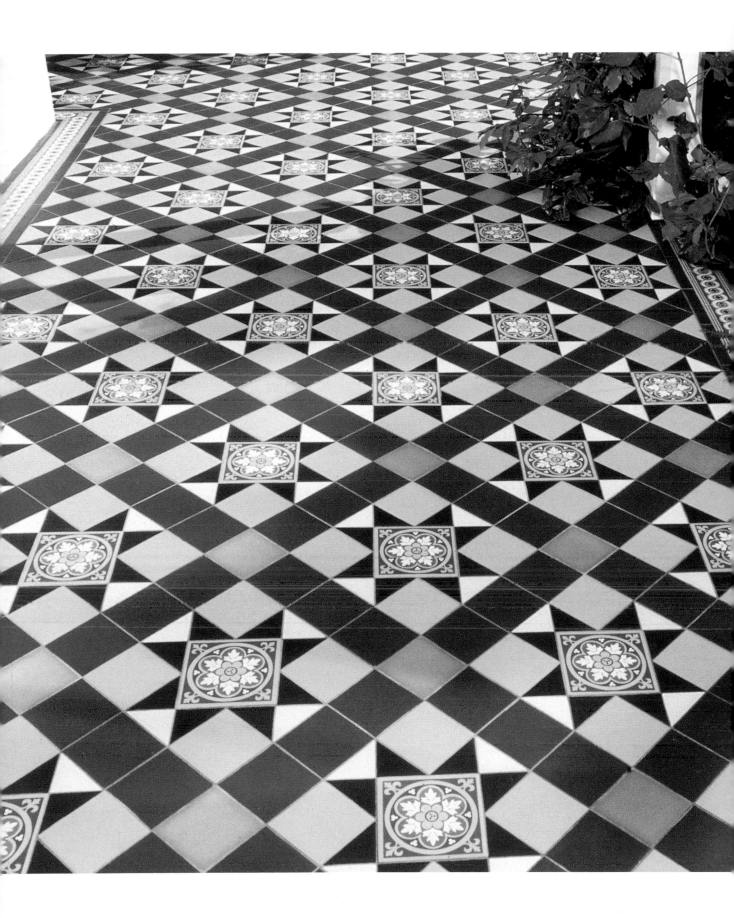

Water and tile are destined to be together, with water flowing beautifully over the ceramic, brightening but not bothering it. In a pool at the Casa de la Torre in Mexico (ABOVE), 1930s or 1940s Sunburst tiles by Talavera make two suns—one in the tile and one in the reflection of the water. A contemporary fountain in Los Angeles (RIGHT) was created by the owner in the tradition of Antonio Gaudi; instead of the ceramics of Spain, however, inexpensive, commercial Dal Tile was broken up and used in a more American approach. The Plaza de Espana in Seville (FOLLOWING PAGES) is the original inspiration for combining water and ceramic; its bridges have remained fresh and vibrant since 1929 due to the bright tile that covers them and spans the river below.

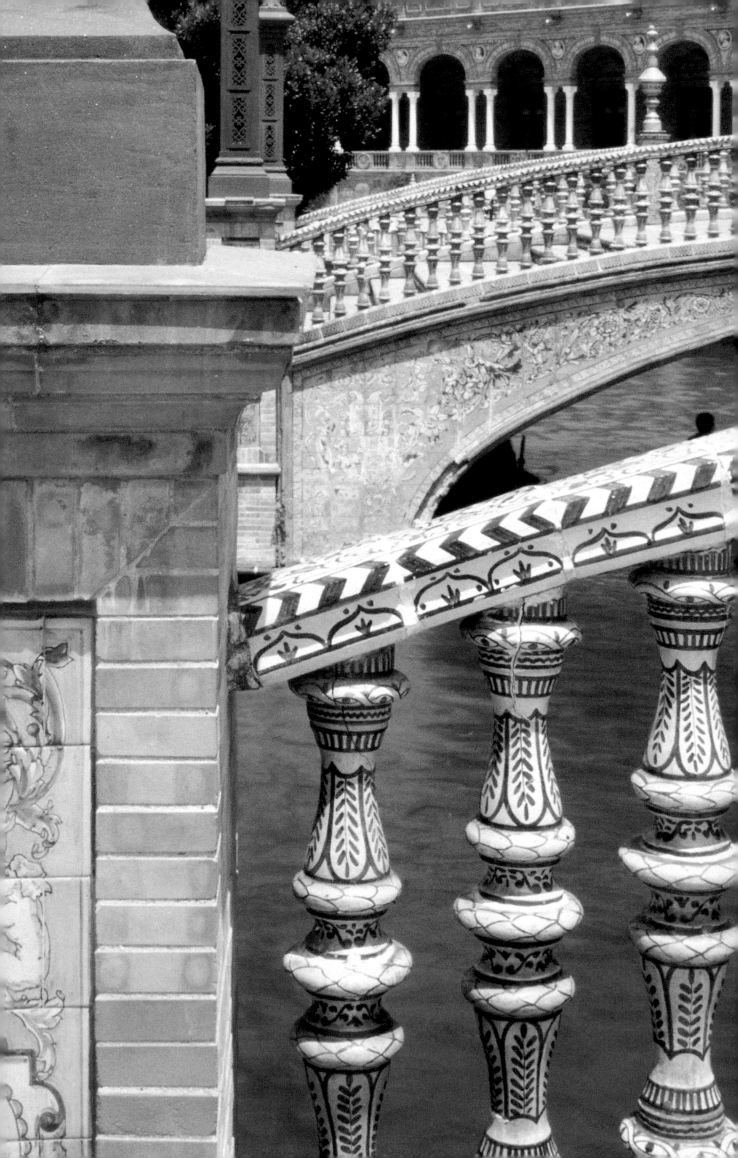

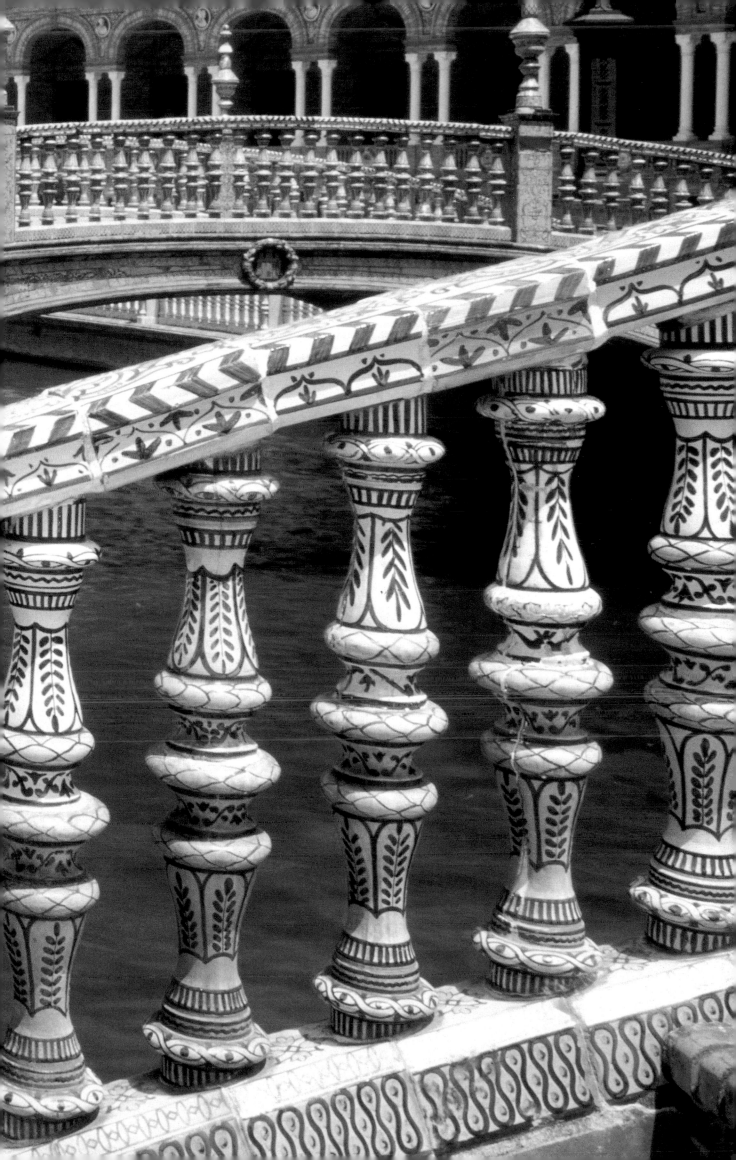

Walls of tile may seem extravagant, but in fact they are quite natural, since tile is an architectural material. The sweep of ceramic across a building, whether it is the facade of a palace or the back of a house, is beautiful and allows for patterns that are more largely conceived than in other spaces. In Lisbon (RIGHT), the exteriors of nearly all the buildings are covered in tile. Here the tile imitates architectural panels and friezes above the windows. In a similar, though smaller, fashion, designer Nancy Kintisch created a mosaic archway above the exterior window of a house in Los Angeles (ABOVE), giving the window presence and highlighting it as an architectural element. Artist Debra Yates regularly splashes mosaics onto the walls of houses (BELOW), such as this one in her backyard in Miami. Her murals, which can be as large as 60 feet long, are as much a part of the landscape as the surrounding plants, flowers, and trees.

sheets, suggests carefully choosing a focal point for one before having it made or tiled. A fountain is a big element, so consider the view from several different places, both indoors and out.

Tile may be spread around other parts of the outdoors in the sun and air. Wall murals and tile that runs around the edges and arches of windows and doors take their cues from both ancient and contemporary buildings covered in tile. Murals can open up space or transform an unwanted wall. Benches and columns covered with tile are special focal points. Garden walls become charmed when touched by ceramic, providing an interesting backdrop for flowers, plants, and greenery. Raised flower beds can be edged in stone and delightfully detailed in tile. Huge urns may be blooming with tile and large pots can be lined with it.

All of these outdoor effects can be created with art or commercial tile or mosaics. A mixture of the two can be particularly striking, with an ordered grid of squares next to a freeform design. Whichever way you create them, use tile in colors and designs that complement the surroundings and landscape — your garden flowers, your trees,

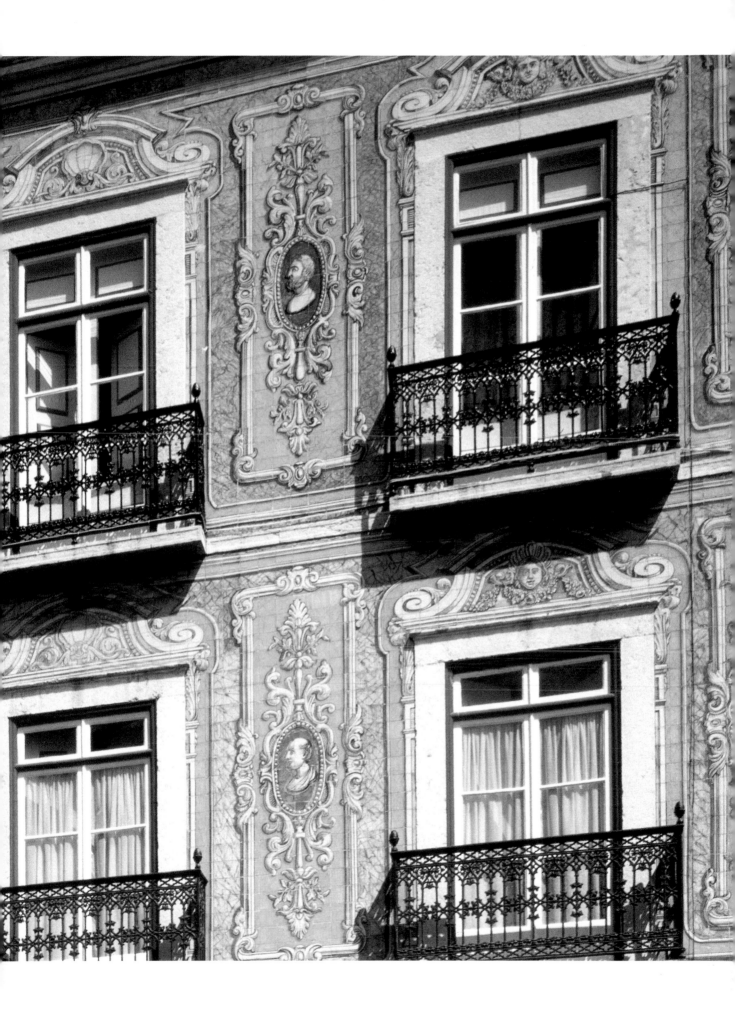

HEARST CASTLE TILE

When William Randolph Hearst commissioned architect Julia Morgan to build him a mansion on a hill overlooking the Pacific Ocean with swirling staircases, towering ceilings, and pools that look like entire rooms partially filled with water, she knew that tile would give it the sense of grandeur and detail that great mansions must possess. So she designed tile just for Hearst Castle—lotus, papyrus, and Victorian buttercup designs in bright California blues, reds, and yellows; regal dragons; stately castles—and spilled it across the staircases, made it climb to the great ceilings, and created the most memorable pools in American architecture.

Now the tile that distinguishes the publishing magnate's famous mansion at San Simeon is showing up around backyard pools, in showers, and on countertops in today's homes. The original tile is being replicated so that the designs that were once accessible only to those living in castles are now sold in stores and showrooms in major cities throughout the country. Rob Kellenbeck, a ceramicist in Grass Valley, California, recognized an opportunity for revival when he came upon the original molds for the tile in a factory where they had been sitting unused for almost sixty years; he bought them for nearly nothing, and is now making the relief tile in vibrant glazes under the name of his pottery, Deer Creek.

The lovely and lively motifs of jumping tritons, realistic rabbits, stained glass, floral vines, opening gardenias, and the arts and crafts–style arrows, woven garlands, and chains of ivy that made art out of the walls of the 1920s and '30s are best shown off today when set into larger fields of solid-colored tile, as shown at right. They can splash across outdoor spaces, run around rooms, climb stair risers, or surround fireplaces in an array of color combinations, darks and lights, rough terra cotta and shiny glazed textures.

With Julia Morgan's tile available, there may be no need to hire an architect. It is possible to incorporate the designs of one of the best architects of the century, and an outdoor bar or a sink countertop can bring to life the beauty, artfulness, and detail of an entire era. But the decisions for today should be much easier—Hearst Castle, after all, has sixty-one bathrooms, forty-one fireplaces, and two pools.

Deer Creek tile is available at many stores throughout the country, among them Concept Studios in California; Beaver Distributors in Michigan; Waterworks in Connecticut; Sunny McLean & Company in Florida; and Ann Sacks Tile and Stone, and Walker Zanger with branches in major cities.

Benches made of tile have existed for centuries, making an event out of sitting outdoors. A contemporary mosaic bench (ABOVE) *makes a corner of a Miami backyard as ceremonious as a Spanish plaza. Long rows of tiled benches* (RIGHT) *at the Biltmore Hotel in Coral Gables highlight the Mediterranean-style architecture and give a sense of grandeur to the courtyard. Built in 1926, the hotel was home to such guests as the Duke and Duchess of Windsor, the Roosevelts, and Al Capone. The tile, though Spanish-style, was made in America.*

your paths and walks. You may want subtle colors that appear natural and don't overwhelm the landscape, or vibrant ones that complement and interact with it.

These elements in tile are outdoor art, one of the few places where art and nature exist together. Even in the rain, they will continually brighten and transform the space, bringing joy to your outdoors. Creating this joy can be simple or complex. Projects involving architectural elements like fountains, benches, and mosaic murals may require architects and artists and, where the entire site has to be considered, a landscape architect.

Though "planting" tile in the outdoors is like designing a landscape, the results don't come and go with the seasons like gardens and plants. Tile is there to stay, so take your time planning it, being sure what you choose will last in style as long as it will in substance, knowing it is what you like and can live with.

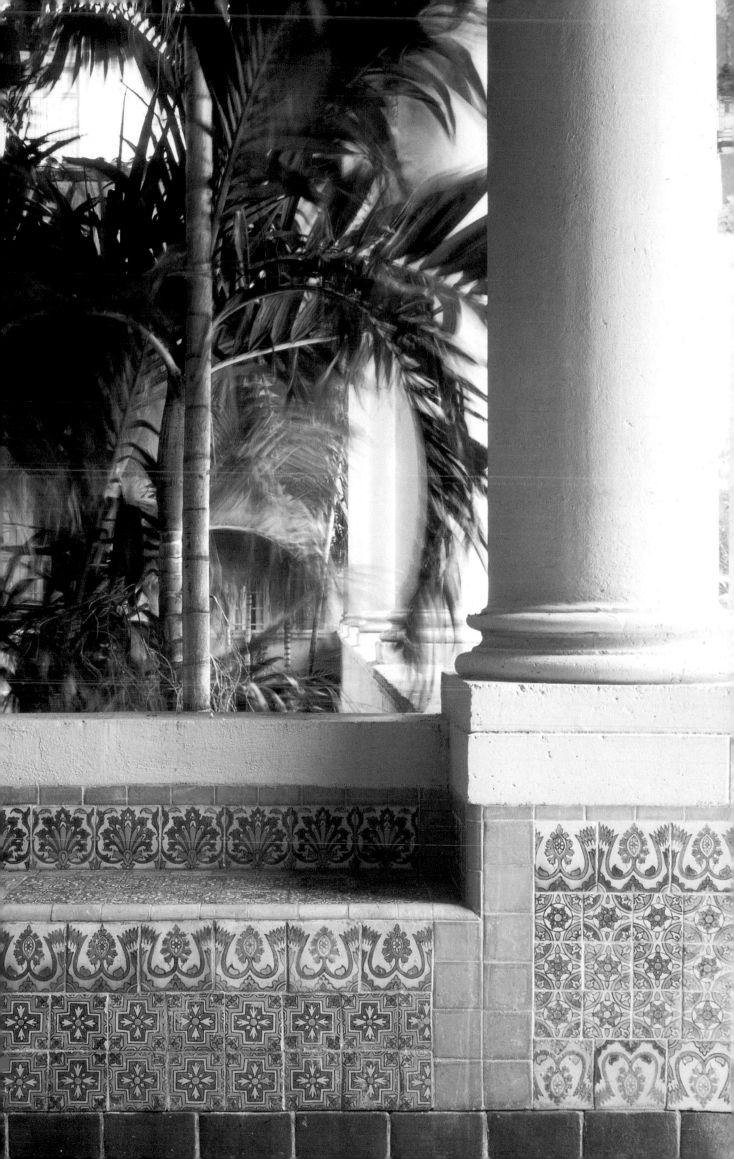

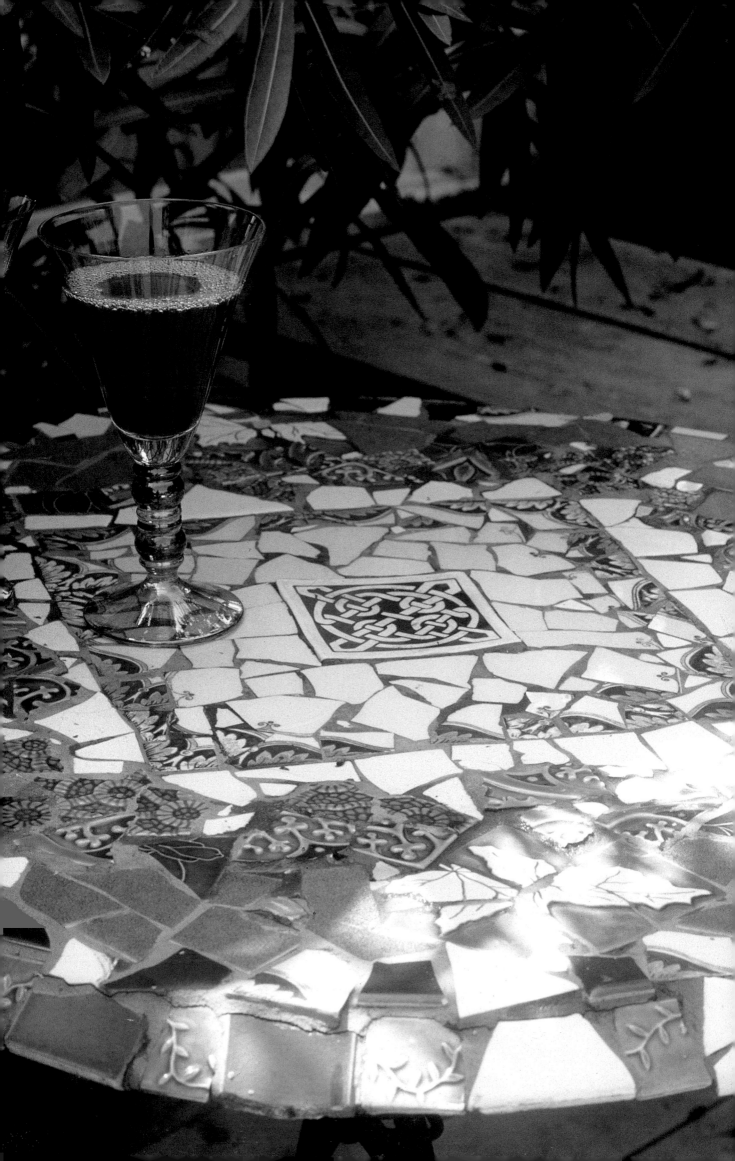

Tile Off the Wall

Yet suddenly across the shiny tiled surface of the bar table I felt
something—nothing so extreme as love . . .

—Graham Greene, *The End of the Affair*

There are many ways to live with tile other than putting it on the walls or floors. In smaller, easier, more intimate, and less expensive ways you can celebrate its history and artistry, bringing tile out of its standard context to be appreciated as art. These are ways of living with tile that are totally different from chopping vegetables on it in the kitchen or showering surrounded by it in the bath.

Bringing tile into your life can be as simple as buying a dining table in Pier One, for example, charmingly topped with rows of tile reminiscent of those that shine in bars; or as studied as cultivating and arranging a collection of antique tiles that you have fallen in love with in a special corner of a room; or as creative as treating today's art tiles like little paintings, hanging them on the wall or displaying them on shelves. You may have an actual work of art made from ceramic above your couch or a favorite tile from Morocco or California under your coffee cup or a sign spelling out your address in bright tile in front of your house. Tile is beautiful, useful, and versatile, so it travels well, fitting into many rooms and roles throughout — and outside — the house.

Liberated from walls and floors, seen beyond the shower stall and the kitchen backsplash, tile is allowed to take on a different character. It can be richer, more adventurous, surprising. And it becomes a focal point, set in the middle of a room rather than serving as a backdrop, where it can be especially appreciated, admired at closer range, touched, and used every day.

On a practical note, these small canvases of tile can make the experience of tile possible without the trouble, cost, and commitment of installing it. Or they can offer a way of getting to know

The classic look of artist Holly Leuders' tables derives from the pavements of San Marcos and the Byzantine mosaics of Greece, which influence her work. She will also custom design patterns and colors for specific settings, matching them to rooms.

tile slowly, before you renovate, so that when you do you'll be comfortable with it and know what colors, forms, and designs you like. If you've already covered your walls and floors with striking tile, small tile pieces within the rooms can resonate and complete the house while making it spirited, charming, and alive.

Because of the popularity of tile today, it is easier than ever to introduce it into your life. From tiled furniture and objects to functional art to collectors' pieces, tile is out there, everywhere. You just have to go find what you like.

TILED FURNITURE AND OBJECTS

Anything that can be sold for the home today, it seems, can be tiled—and is. Walk into a home design store and it appears as if tile has grown joyfully across everything like a wandering vine. It covers tabletops, sweeps across benches and chairs, lines the insides of bowls, wraps around the bases of lamps, runs around the edges of mirrors and picture frames, enlivens flowerpots and planters, and makes art out of everyday objects like switchplates and cabinet pulls. There are

tiled armoires, cabinets, shelves, clocks, medicine chests, urns, birdhouses, and ornaments for the garden; bathroom accessories such as soap dishes, tissue boxes, trash cans, toilet lids, and toothbrush holders; and even tiled phones and televisions.

Some of these are made from traditionally shaped tiles, like coffee, dining, and end tables topped in glossy white or colored squares or geometric designs created from different sizes, combinations, and patterns of tile. There are also wood trays lined with pretty tiled squares depicting thyme, bay, or ivy, for example.

Many more tiled objects and furniture are made by artists from pieces of broken tile, which can turn the corners and round the curves of pieces that are not flat, and can form expressive patterns and designs. These paintings in tile have engendered an artistry in furniture and object design that is striking, as mosaic patterns have come off of the pavements of San Marcos and the walls of Pompeii and ended up on tabletops in living rooms and planters on windowsills.

Three generations of clocks tell time in tile. The face of a contemporary mantel clock from Levy-Larocque (ABOVE) *is a single handpainted tile with hands attached to the front and an architectural roof and columns surrounding it. Though much smaller, it follows in the tradition of a two-story-high clock in Madrid* (BELOW), *which has been showing the hours of the day in huge ceramic numbers since 1899 at the old ABC/Blanco & Negro newspaper building. At the Adamson House in Malibu* (LEFT), *the kitchen clock was built into the wall in 1929. The former home of Malibu Potteries' owner is covered in the famously bright ceramics whose glazes were so high in metal content that the inventor died developing them.*

BELOW: *Artist Judy Robertson mixed tile with broken pottery, bits of mirror, marbles, flowers and heads from figurines, and assorted angels to create a three-dimensional mosaic mirror. Open flowers hold odds and ends like toothpaste caps, and a ceramic basket carries small vials of perfume.*

RIGHT: *Even the birds are favoring tile roofs today, with a mosaic of broken pottery to cover the rest of the house. Mozayiks offers this and other whimsical but useful objects.*

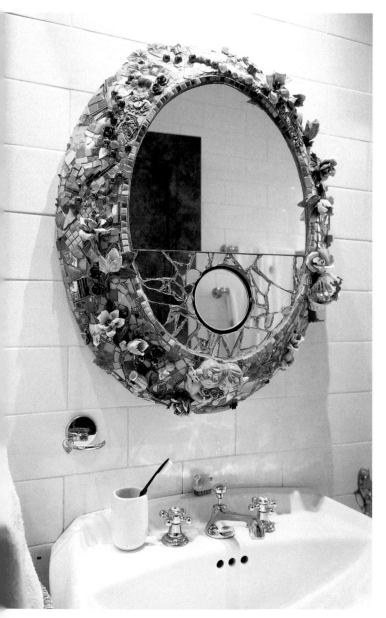

The artists who create these objects also tend to mix other materials with the tile, using the historic European technique of *pique assiette,* which literally translates as "stolen dish" and involves the use of broken pottery and china. The shards may have a story that goes with them — they could be from favorite dishes that were accidentally dropped but were full of memories and so are saved in another way in a mosaic design — or they may come from objects chosen for their beauty alone and then actually broken on purpose to transform a pot or picture frame. Bits of broken mirror may also be used, which do not bring bad luck to the objects but simply add some shine and a sense of mystery, along with colored glass, small pieces of veined stone and marble, and shells.

Though these mosaic objects are created by individual artists, the range of stores offering them is striking. As personal as they are, the objects are not elitist — at least not in character, if sometimes in price. (Some large tables may sell for as much as $4,000 or $5,000, but small tables may be as little as a few hundred dollars, and the smallest objects — a vase or picture frame — may be only $35 or $50.) Specialty stores sell handmade artists' items, but so do large home design shops such as Domain and ABC Carpet and Home. And mass-produced objects are available across the country at chain design stores such as Pier One, Crate & Barrel, and Williams-Sonoma.

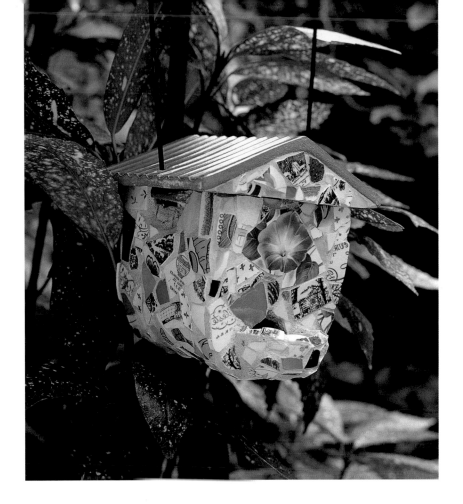

Because artists make the mosaic items by hand, they can usually be custom-designed. Most artists offer a group of standard designs through stores, but they are usually happy to work with the store to create tables with special designs for individuals, such as the dining table that comes complete with a setting of plates, silverware, and even a bowl of fruit all created of mosaic tile. A mosaic table on which a backgammon board is laid out in tile offers both beautiful patterns and great games to its owners. But most custom work is on a simpler scale, sticking with a preconceived design but adjusting it to the colors in a room, perhaps picking them up from the fabric, paint, upholstery, or even a dominant work of art there.

Besides being striking and unique accents in a room, tiled furniture and objects seem to be so popular today because they introduce a very human element into a space. The broken pieces of tile in a mosaic that invite touch by their very nature spill across, wrap around, or frame the kinds of things in a home that you touch every day — tabletops, vases, cabinet doors. The individual pieces of tile slick on their surface from their original glaze, rough around the edges where they

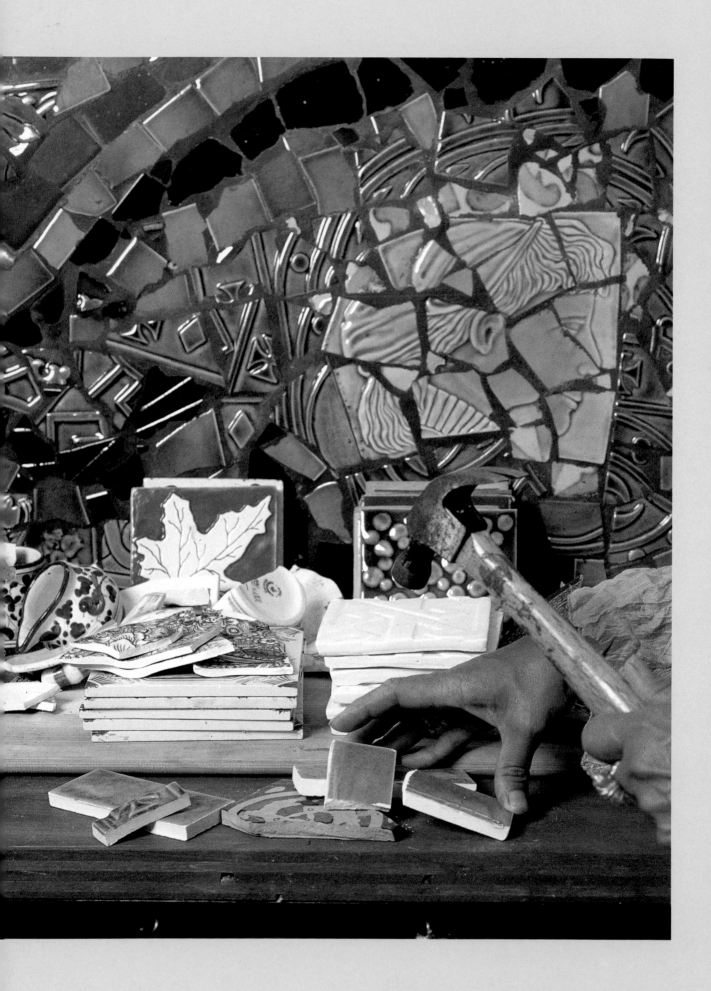

MAKING MOSAICS

OPPOSITE: It may seem odd that artist Holly Leuders takes tiles that she has had specially and carefully handmade and hits them with a hammer. But she is breaking the custom-colored tiles into pieces to create the centuries-old look of mosaic. The character of the pieces is not predictable—part of the fun of mosaics is that you never know what you're going to get when you bring a hammer to a tile. There are different shapes, different sizes, different elements of broken tile every time, so each piece—and in turn each project that it goes into—is distinctive.

TOP RIGHT: Leuders sketches out general designs on paper first and then transfers them with a marker to the tabletop itself. The surface she uses for the tabletop is Wonderboard, which will not warp. She finds that basic geometric shapes such as circles, squares, and rectangles work best in an overall pattern. Although they will look different in the larger mosaic, they are a good basis for a design.

CENTER RIGHT: Here Leuders makes decisions about the colors, textures, and surface designs of the broken

tiles, figuring out what should go next to what. She lays out each piece that could possibly fit on the board so that she can see the design clearly and make any changes before gluing all the pieces down with ready-mix cement or tile adhesive. Leuders goes back and fits in smaller pieces wherever there is space until the surface is covered as entirely as possible because grout, which will cement the entire design later, doesn't adhere well in spaces larger than one-quarter inch. Standard edging tiles are glued onto the sides of the table.

BOTTOM RIGHT: Grout is spread on with a rubber spatula like frosting on a cake, filling in between the tiles. The grout, which can be any color, is either bought pre-mixed or mixed with a powdered pigment or combination of pigments to get a desired color. Since the grout covers a good deal of the surface, its color is as important to the overall design as the tile colors. Leuders removes grout from the top surfaces of the tiles and polishes them with terry cloth. Now she can see what the mosaic really looks like, since the grout has made it come to life. The finished tabletops are ready to be placed on stands and used.

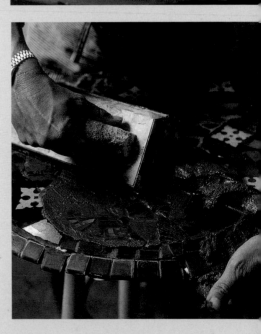

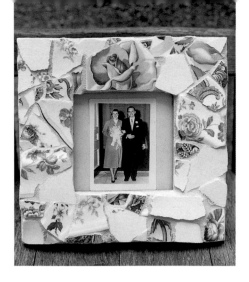

ABOVE: *To create old-fashioned picture frames, artisans—like those from Mozayiks—collect eighteenth-century china from flea markets and antique stores and place the broken pieces into a new form. The European technique of assembling shards of tile, glass, and other materials into a design is called* pique assiette, *which literally translates to "stolen dish." In this case, it is particularly appropriate.*

BELOW: *A watercooler was made into a seaside scene composed of tile and shells by artist Judy Robertson, transforming its impersonal nature.*

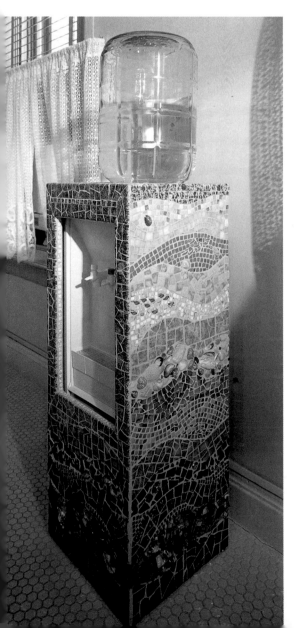

were broken, and then textured with grout—make a table, chair, or cabinet not just a piece of furniture but an experience. Artist Judy Robertson has covered everything from microwave ovens and watercoolers to computer stands with tile. It humanizes the high-tech character of these objects, making them "high touch" instead.

Tiled furniture and objects are also popular because they have a classic look and impart a sense of history. How could they not, when mosaics derived from the Byzantine Empire thousands of years ago? Mosaic tiled objects also give a sense of energy and motion when you look at them, gazing down at or across their patterns made from dozens or hundreds of pieces of tile joining to portray a picture or design. And they are suited to optimistic, colorful, joyful themes; some of the names of tile accessories for sale from a company called Smashing Tiles are "Vase in Bloom," "Frame in Bloom," and "Lamp in Summer" because of their bright, flowering designs.

Because these items are so rich in texture, historical reference, and design, they are probably best placed in areas of the house where few other busy patterns and colors will compete with them. This way, they will not overwhelm anything else and will be in a position to be shown off themselves. Mosaic-tiled furniture and objects, even with all their historical background, probably fit best in contemporary-style homes, in which the backgrounds are likely to be white walls and wood or plain-colored floors.

FUNCTIONAL ART

Many of the tiles you'll encounter today — old or new — are so stunning in pattern, color, glaze, or design that they are at their best when set apart, standing alone as nothing less than little works of art.

If you are shopping for tile during a renovation, you will doubtless come across some that you want to have around you but that don't fit into your design. Or you may run into individual tiles while traveling in Italy or France or Santa Fe that you can't imagine going home without. Or you may be given a special tile as a gift. Luckily, tile is a democratic material and, like books, everyone can afford a few — if not a wall — of them.

Giving them a home is an art in itself. With tiled furniture and accessories, the artist has created the object for you. But if you begin to use some of the breathtakingly beautiful individual imported and art tiles in singular ways, you are the artist, putting them in the right environments throughout the home. Isolated from walls and floors, they stand out and their beauty can really show. Seen on this small scale, they become personal and intimate, something to be lived with yet admired. So the intricate detail that gives a delft tile its charm can be appreciated when it is hung in a special place. The rich glaze of a tile handmade by an artisan can glimmer up at you from beneath your coffee cup where it sits.

Shops that sell single tiles salvaged from historic buildings are common on the streets of Lisbon and many other cities throughout Europe. Bringing a few back and using them throughout the house provides another way to live with tile.

You can put tiles on the wall like small paintings. Some even have ceramic surrounds that frame them like pictures, ready for hanging. Or you can display them on shelves like antiques. And like antiques and Oriental rugs and all classic elements in design, fine tiles go with almost everything while standing out as something extraordinary. They can also

RIGHT: *Tiles backed with cork are sold as trivets by Crate & Barrel.*

TOP: *Embossed tiles with intricate scenes, like those from Warwick Pottery Works, come with their own ceramic frames so they can be hung on the wall.*

CENTER: *Any beautiful tile, such as this one made by artist Laura Shprentz, can be a creative alternative to candle holders.*

BOTTOM: *The glazes of Russian tiles from Amsterdam Corp. are so unusual they should be displayed as art.*

be used at the front of your house for an address sign, or on doors within the house to decorate or designate them.

But the great thing about art tiles is that they are durable as well as beautiful and can be used at the same time that they are revered. Like beautiful vases, they are centerpieces that also serve a purpose. They are functional art.

Home design stores such as Crate & Barrel and Williams-Sonoma have realized this, selling handmade or imported tiles backed with cork or felt to use as trivets. Whether you buy theirs or use your own, you'll find yourself reaching for them all the time.

Anything that you don't want to set on a table you can set on a tile. Small tiles are great for mugs of coffee, and bigger ones for holding teapots or hot pans at the table. Even if they are some of your favorites, you don't have to worry about using them. If tiles can survive centuries of the dust of Tunisia and the winds of Morocco, they can take scalding pots and spilling coffee.

A tile can hold a vase of flowers, keeping the table dry and becoming part of a centerpiece. Tiles live beautifully under flowerpots and planters, not bothered by moisture and soil when plants are watered. You can keep candles burning on tiles, sealing the bottom of the candle to the tile by dripping hot wax on it and placing the candle on top. Several of them make an atmospheric scene at a dinner table, freeing the candles from holders and causing light to shimmer across the glaze and show off the design of the tile. Wax drips onto the glazed tile, but it is simple to remove later and doesn't hurt the tile.

If you don't want to make your own art out of tile, there are artists who work in ceramic that do, and you can buy

their expressive works to hang above your couch or place in a special corner of your home. This is another, very different, way of putting tile on the wall.

The ceramic has a way of drawing you into the story of the picture, sometimes reaching out in relief or through words written on the tile. Put aside as an individual expression in a frame, it is art distinct from the tile that lives on the walls and floors of a house, with the same effect as a painting or sculpture, but with the vitality, humanity, and immediacy of ceramic.

COLLECTING

Collecting tiles is an extraordinary way to experience them because it allows you to live with art and history together. Aside from the value of their extreme beauty, these tiles are literally pieces of other countries and eras that survived to tell the story of architecture and design. Whether you love the brilliant blue and red stylized tiles of Turkish palaces or the purely California look of bright original Malibu tiles or the gloss and elegance of turn-of-the-century English majolica, every tile tells something about a culture in its designs and the spirit of its patterns, even in its glazes.

OPPOSITE: *Any railing in a house makes a charming place to display antique tile. From left, these are: two 1920s English Art Deco tiles with inlaid glazes; a Minton tile from England made with a decal in about 1910; a rare handpainted ruby tile by William De Morgan; an English Victorian tile; an Art Nouveau tile from the 1910s; a Malibu border from the early 1930s; a "high Nouveau" tile from England; and two Victorian wallpaper-style tiles.*

RIGHT: *A mural from Taylor Tilery that dates to the 1930s and is entitled "Tango," was found at a flea market and now lives in an outdoor courtyard.*

BELOW: *A custom-made Grueby tile was once the source of water for a turn-of-the-century fountain.*

With each American tile, you see a different part of art, design, and life—the luminous metallic glazes that died years ago with their inventors; the lovely, lyrical scenes of pre-war artisans anxious to put their idealism down in ceramic; the daring lines and forms of the deco era; the pretty and pristine images of Victoriana.

These tiles are all visually striking and can live comfortably almost anywhere in a house, from walls and shelves to baseboard runners and chair rails. They can be framed individually and hung like art. Or, if you expect to remain in a house long-term, the tiles can actually be used—installed side-by-side in a special corner of the kitchen, or incorporated into a fountain, or placed outdoors as the centerpiece of a garden wall.

Sometimes collectible tile is part of a house, rather than on display within it. In an arts and crafts-style house in Los Angeles that originally belonged to Will Rogers, historic tile has remained in place since 1912, when the house was built. An original Batchelder tile (BELOW) *graces a brick column in the back-yard. The fireplace surround* (RIGHT) *glows with the variegated glazes of handmade tile. It was made by the historic Los Angeles Tile Company, one of many manufacturers that disappeared with the Depression. Luckily, appreciation for the tile is back.*

The monetary value of tiles is higher than it has ever been because of today's intense interest in them. You will definitely find fewer good deals at flea markets, antique stores, and urban artifacts markets than you could have five or ten years ago. People now know the value of those old fireplace tiles that were torn out of 1930s houses. But because of the increased interest in ceramic, more is being saved and is becoming available.

Two organizations in particular are vital for anyone thinking of collecting tile seriously, because they are integral to keeping its history and heritage alive: The Tile Heritage Foundation of California and the Friends of Terra Cotta in New York (see the Sources section for details).

By collecting tile, you are individually preserving a piece of the past. Of course, you are also decorating and transforming the rooms of your home. Plus, the new tile you install today, during this renaissance, could very well become a valuable collector's item someday in the future.

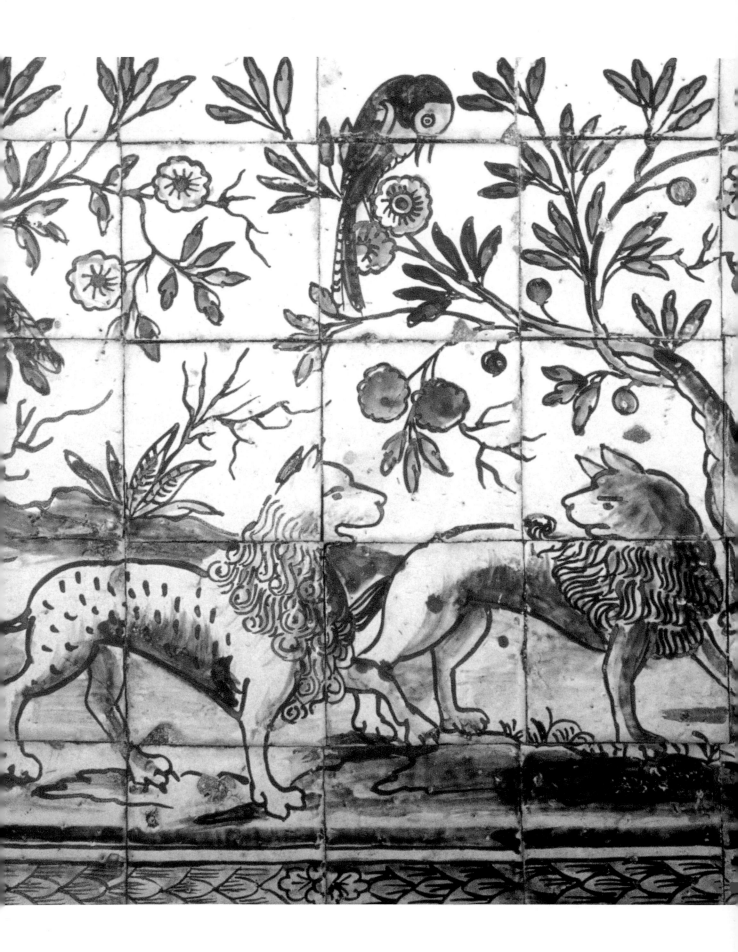

Sources

SHOWROOMS

This is a selection of showrooms that carry, along with many other types of tile, the newest art and imported ceramics. There are many more fine tile stores than could possibly be listed here.

Alabama

Ceramic Harmony
11317 S. Memorial Pkwy.
Huntsville, AL 35803
256-883-1204

Design Tile & Stone
665 N. Eastern Blvd.
Montgomery, AL 36109
334-270-2054

Design Tile & Stone
4524 Southlake Pkwy.
Birmingham, AL 35244
205-733-8453

Design Tile & Stone
437 University Blvd.
Birmingham, AL 35205
205-324-8473

Arizona

Ceramica
7039 E. Main St.
Scottsdale, AZ 85251
480-970-7074

Craftsman Court Ceramics
4169 N. Craftsman Ct.
Scottsdale, AZ 85251
480-970-6611

Fractured Earth
3150 N. Estrella
Tucson, AZ 85705
520-620-6219

Waterworks
2574 E. Camelback Rd., #101
Phoenix, AZ 85106
602-912-9214
www.waterworks.com

California

Ann Sacks Tile & Stone
103 S. Robertson Blvd.
Los Angeles, CA 90048
310-285-9801

Ann Sacks Tile & Stone
2 Henry Adams St., Suite 125
San Francisco, CA 94103
415-252-5889

Arizona Tile
1065 W. Morena Blvd.
San Diego, CA 92110
619-276-3915
www.arizonatile.com

California Art Tile
8687 Melrose Ave., Suite M70
West Hollywood, CA 90069
310-659-2614
www.californiaarttile.com

Concept Studio
2720 E. Coast Hwy.
Corona Del Mar, CA 92625
949-759-0606

Country Floors
8735 Melrose Ave.
Los Angeles, CA 90069
310-657-0510
www.countryfloors.com

Country Floors
San Francisco Design Center
2 Henry Adams St., Suite 110
San Francisco, CA 94103
415-241-0500

Decorative Tile & Bath
18416 Ventura Blvd.
Tarzana, CA 91356
818-344-3536

Eurobath & Tile
2915 Red Hill Ave., Suite F102
Costa Mesa, CA 92626
714-545-2284
www.eurobathtile.com

European Bath, Kitchen, Tile, & Stone
143 S. Pegros Ave., Suites F & G
Solana Beach, CA 92075
858-792-1542
www.kellyspipe.com

European Tile Art
6440 Lusk Blvd., #D107
San Diego, CA 92121
858-452-5090

From the Ground Up
7462 Girard Ave.
La Jolla, CA 92037
858-551-9902

International Bath & Tile
7177 Convoy Ct.
San Diego, CA 92111
858-268-3723
IBTSDiego@aol.com

International Bath & Tile
158 S. Solana Hills Dr.
Solana Beach, CA 92075
858-481-4984

Materials Marketing
55 E. Huntington Dr., #150
Arcadia, CA 91006
626-462-1890
www.materials-marketing.com

Mission Tile West
853 Mission St.
South Pasadena, CA 91030
626-799-4595
www.missiontilewest.com

Mission Tile West
1207 4th St., #100
Santa Monica, CA 90401
310-434-9795

Natural Stone Design
5691-A Power Inn Rd.
Sacramento, CA 95824
916-387-6366

NS Ceramic
401 E. Carillo St., #A-1
Santa Barbara, CA 93101
805-962-1422
www.nsceramic.com

Paris Ceramics
8373 Melrose Ave.
West Hollywood, CA 90048
323-658-8570
www.parisceramics.com

Paris Ceramics
San Francisco Design Center
101 Henry Adams St., #408
San Francisco, CA 94103
415-490-5430

Plain and Fancy Tile
25 N. Catalina Ave.
Pasadena, CA 91106
626-577-2830

Rhomboid Sax
8902 Beverly Blvd.
Los Angeles, CA 90048
310-550-0170
www.styleforliving.com

Tile Collection
518 E. Haley St.
Santa Barbara, CA 93103
805-963-8638

Tile Source
949 Industrial Ave.
Palo Alto, CA 94303
650-424-8672

Villeroy & Boch
1701 S. State College Blvd.
Anaheim, CA 92806
714-634-4300
www.villeroy-boch-usa.com

Walker Zanger
8750 Melrose Ave.
West Hollywood, CA 90069
310-659-1234
www.walkerzanger.com

Walker Zanger
350 Clinton St.
Costa Mesa, CA 92626
714-546-3671

Walker Zanger
8901 Bradley Ave.
Sun Valley, CA 91352
818-504-0235

Walker Zanger
23002 Foley St.
Hayward, CA 94545
510-670-0800

Walker Zanger
101 Henry Adams St., #412
San Francisco, CA 94103
415-487-2130

Waterworks
7631 Girard Ave.
La Jolla, CA 92037
858-454-0446
www.waterworks.com

Waterworks
8715 Melrose Ave.
West Hollywood, CA 90069
310-289-5211

Waterworks
984 Avocado Ave.
Newport Beach, CA 92660
949-717-6525

Waterworks
201 Hamilton Ave.
Palo Alto, CA 94301
650-322-8445

Waterworks
35 N. Fair Oaks
Pasadena, CA 91103
626-568-3301

Waterworks
235 Kansas St.
San Francisco, CA 94103
415-431-7160

Waterworks
55 Geary St.
San Francisco, CA 94108
415-982-1970

Colorado

Eurobath & Tile
475 S. Broadway
Denver, CO 80209
303-298-8453
www.eurobath-tile.com

Materials Marketing
775 S. Jason St.
Denver, CO 80223
303-777-0007
www.materialsmarketing.com

Waterworks
185 Steele St.
Denver, CO 80206
303-394-2940
www.waterworks.com

Connecticut

Amsterdam Corporation
P.O. Box 397
Litchfield, CT 06759
860-567-1350
www.homeportfolio.com/amsterdam

Paris Ceramics
37 E. Elm St.
Greenwich, CT 06830
203-862-9538
www.parisceramics.com

Tiles, A Refined Selection
345 Post Rd. W.
Westport, CT 06880
203-227-4004
www.tiles-arefined.com

Waterworks
23 W. Putnam Ave.
Greenwich, CT 06830
203-869-7766
www.waterworks.com

Waterworks
29 Park Ave.
Danbury, CT 06810
203-792-9979

Waterworks
181 Main St.
Westport, CT 06880
203-227-5008

Westport Tile & Design
175 Post Rd. W.
Westport, CT 06880
203-454-0032
www.westporttile.com

Florida

Atelier Elsner
11812 143rd St. N.
Largo, FL 33774
727-596-3038
www.elsnertile.com

Country Floors
94 N.E. 40th St.
Miami, FL 33137
305-576-0421
www.countryfloors.com

Country Floors
1855 Griffin Rd., Suite B-458
Dania, FL 33004
954-925-4004

Design Tile & Stone
4641 Gulfstarr Dr., #108
Destin, FL 32541
850-650-3406

Forms & Surfaces
3801 N.E. Second Ave.
Miami, FL 33137
305-576-1880
www.formsandsurfaces.com

Iberia Tiles
2975 N.W. 77th Ave.
Miami, FL 33122
305-591-3880

Iberia Tiles
4221 Ponce de Leon Blvd.
Coral Gables, FL 33146
305-446-0222

Iberia Tiles
6590 W. Rogers Circle, #A3
Boca Raton, FL 33487
407-241-8453

Paris Ceramics
204 Seaview Ave.
Palm Beach, FL 33480
561-835-8875
www.parisceramics.com

Southwest Tile & Design
4034 N. Washington Blvd.
Sarasota, FL 34234
941-355-8373

Tile Market
834 Orange Ave.
Winter Park, FL 32789
407-628-4322

Tile Market
1221 1st St.
Sarasota, FL 34236
941-365-2356

Tile Market
1170 3rd St. S., #B110
Naples, FL 34102
941-261-9008

Tile Market
320 S. Federal Hwy.
Stuart, FL 34994
561-283-2125

Traditions in Tile
7660 Phillips Hwy., #8
Jacksonville, FL 32256
904-739-7386
www.traditionsintile.com

Villeroy & Boch
704 Park Central Blvd., Suite A
Pompano, FL 33064
954-978-8888
www.villeroy-boch-usa.com

Waterworks
191 N.E. 40th St., #101
Miami, FL 33137
305-573-5943
www.waterworks.com

Waterworks
244 S. County Rd.
Palm Beach, FL 33480
561-659-4450

Georgia

Renaissance Tile & Bath
349 Peachtree Hills Ave., N.E.
Atlanta, GA 30305
404-231-9203

Specialty Tile
1700 Oakbrook Dr.
Norcross, GA 30093
770-246-9224
www.specialtytile.com

Traditions in Tile
3210 Roswell Rd., Suite C
Atlanta, GA 30305
404-239-9186
www.traditionsintile.com

Traditions in Tile
3065 Trotters Pkwy.
Alpharetta, GA 30004
770-569-5232

Traditions in Tile
305 Shawnee N. Dr., #950
Suwanee, GA 30024
770-831-1353

Traditions in Tile
369 McDonough Pkwy.
McDonough, GA 30253
678-583-8731

Traditions in Tile
201 Woodfield Ct.
Macon, GA 31201
478-477-8881

Traditions in Tile
200 Cleveland Rd.
Bogart, GA 30622
706-543-0500

Traditions in Tile
692 N. Glynn St.
Fayetteville, GA 30214
770-461-8141

Traditions in Tile
4041-B Kingston Ct.
Marietta, GA 30067
770-951-1545

Traditions in Tile
4520 Palazzo Way, Suite B
Douglasville, GA 30134
770-489-5502

Traditions in Tile
11350 Old Roswell Rd., #400
Roswell, GA 30076
770-343-9104

Walker Zanger
791 Miami Circle, N.E.
Atlanta, GA 30324
404-365-9991
www.walkerzanger.com

Waterworks
1 W. Paces Ferry Rd.
Atlanta, GA 30305
404-266-1080
www.waterworks.com

Idaho

Sun Valley Kitchen & Bath
221 Northwood Way, #400
Ketchum, ID 83340
208-726-7546

Illinois

Ann Sacks Tile & Stone
501 N. Wells St.
Chicago, IL 60610
312-923-0919

The Fine Line
209 W. Illinois St.
Chicago, IL 60610
312-670-0300
www.finelinetile.com

Hispanic Designe
6125 N. Cicero Ave.
Chicago, IL 60646
773-725-3100
www.hispanicdesigne.com

Materials Marketing
1234 W. Fulton Ave.
Chicago, IL 60035
312-226-0222
www.materials-marketing.com

Materials Marketing
1661 Old Skokie
Highland Park, IL 60607
847-831-1611

Paris Ceramics
The Merchandise Mart, Suite 1373
Chicago, IL 60651
312-467-9830
www.parisceramics.com

Prestige Bath & Tile
11 John St.
North Aurora, IL 60542
630-801-8600

Waterworks
503 N. Wells St.
Chicago, IL 60610
312-527-4668
www.waterworks.com

Waterworks
907 Greenbay Rd.
Winnetka, IL 60093
847-784-1662

Indiana

Architectural Brick & Tile
7760 E. 89th St.
Indianapolis, IN 46256
317-842-2888
www.architecturalbricktile.com

Louisville Tile
1417 N. Cullen Ave.
Evansville, IN 47715
812-473-0137
www.louisville-tile.com

Louisville Tile
915 Kincaid Dr., #800
Fishers, IN 46038
317-570-8453

Iowa

R.B.C. Tile & Stone
2001 N.W. 92nd Ct.
Des Moines, IA 50325
515-224-1200
www.rbctile.com

Kansas

International Materials
4691 Indian Creek Pkwy.
Overland Park, KS 66207
913-383-3383

Kentucky

Louisville Tile
4520 Bishop Lane
Louisville, KY 40218
502-452-2037
www.louisville-tile.com

Louisville Tile
2495 Palumbo Dr.
Lexington, KY 40509
606-268-8373

Unique Tile
414 Baxter Ave.
Louisville, KY 40204
502-589-1987

Maine

Coastal Decorating Center
Plaza One, Route 1 N.
Kennebunk, ME 04043
207-985-3317
www.coastaldecorating.com

Harbor Farm
Route 15
Little Deer Isle, ME 04650
207-348-7788
www.harborfarm.com

Keniston's Tile Bangor
728 Stillwater Ave.
Bangor, ME 04401
207-945-0742
800-639-4603

Maryland

Charles Tiles
801 Light St.
Baltimore, MD 21230
410-332-1500

Massachusetts

DiscoverTile LLC
1 Design Center Place, #647
Boston, MA 02210
617-330-7900
www.discovertile.com

Paris Ceramics
1 Design Center Place, #551
Boston, MA 02210
617-261-9736
www.parisceramics.com

Roma Tile
400 Arsenal St.
Watertown, MA 02472
617-926-7662
www.romatile.com

The Tile Gallery
10 West St.
West Hatfield, MA 01088
413-247-7655
www.tilegallery.com

The Tile Room
16 Macy Ln.
Nantucket, MA 02554
508-325-4732

Tile Showcase
1 Design Center Place, Suite 639
Boston, MA 02110
617-426-6515
www.tileshowcase.com

Tile Showcase
291 Arsenal St.
Watertown, MA 02172
617-926-1100

Tile Showcase
255 Turnpike Rd.
Route 9
Southboro, MA 01772
508-229-4480

Tiles, A Refined Selection
1 Design Center Place, #632
Boston, MA 02210
617-357-5522
www.tiles-arefined.com

Waterworks
1 Design Center Place, #147
Boston, MA 02210
617-951-2496
www.waterworks.com

Waterworks
103 Newbury St.
Boston, MA 02210
617-267-2519

Michigan

Virginia Tile
24404 Indoplex Circle
Farmington Hills, MI 48335
248-476-7850
www.virginiatile.com

Virginia Tile
1700 Stutz St., Suite 100
Troy, MI 48084
248-649-4422

Virginia Tile
7689 19 Mile Rd.
Sterling Heights, MI 48314
810-254-4960

Virginia Tile
3440 Broadmoor Ave., S.E.
Grand Rapids, MI 49512
616-942-6200

Waterworks
241 Merrill St.
Birmingham, MI 48009
248-593-9485
www.waterworks.com

Minnesota

Fantasia Showroom
275 Market St., #102
Minneapolis, MN 55405
612-338-5811

Rubble Tile Distributors
6001 Culligan Way
Mennetonka, MN 55345
952-938-2599
www.rubbletile.com

Rubble Tile Distributors
1830 Woodale Dr.
Woodbury, MN 55125
651-735-3883

Rubble Tile Distributors
3220 W. County Rd., #42
Burnsville, MN 55337
952-882-8909

Missouri

Ceramic Tile Services
1610 Hampton
St. Louis, MO 63139
314-647-5132

Classic Kitchen & Bath
8642 Pardee Ln.
Crestwood, MO 63126
314-843-4466
www.tallman.com

Nebraska

RBC Tile & Stone
9333 H. Court
Omaha, NE 68127
402-331-0665

Nevada

European Bath, Kitchen, Tile, & Stone
4050 S. Decatur
Las Vegas, NV 89103
702-873-8600
www.kellyspipe.com

Materials Marketing
5415 S. Cameron St., #118
Las Vegas, NV 89118
702-227-4000
www.materials-marketing.com

Walker Zanger
4701 Cameron St., Suite P
Las Vegas, NV 89103
702-248-1550
www.walkerzanger.com

New Jersey

Artistic Tile
727 Route 17 S.
Paramus, NJ 07652
201-670-6100
www.artistictile.com

Artistic Tile
777 Broad St.
Shrewsbury, NJ 07702
732-212-1616

Charles Tiles
760 County Rt. 523
Stockton, NJ 08559
609-397-0330
www.charlestiles.com

Ideal Tile
2232 Route 9 S.
Howell, NJ 07731
908-780-3004
www.idealtileimporting.com

Ideal Tile
Route 1, Wick Plaza
Edison, NJ 08817
908-819-8000

Ideal Tile
4345 Hwy. 9, #77
Freehold, NJ 07728
908-462-0315

Ideal Tile
319A Sansone Plaza, Hwy. 22 E.
Green Brook, NJ 08812
908-752-4700

Ideal Tile
Route 1 Plaza
2901 Brunswick Pike
Lawrenceville, NJ 08648
609-771-1124

Ideal Tile
1316 Route 73
Mt. Laurel, NJ 08054
609-772-9393

Ideal Tile
2001 Hwy. 35
Ocean Township, NJ 07712
908-517-0111

Ideal Tile
499 Route 17
Paramus, NJ 07652
201-262-2220

Ideal Tile
224 Route 37 E.
Toms River, NJ 08753
908-349-2262

Ideal Tile
562 Route 46 E.
Totowa, NJ 07512
201-890-4644

Ideal Tile
566 S. Delsea Dr.
Vineland, NJ 08360
609-696-2188

Mediterranean Tile & Marble
461 Route 46 W.
Fairfield, NJ 07004
973-808-1267
www.medtile.com

Short Hills Marble & Tile
658 Morris Tnpk.
Short Hills, NJ 07078
201-376-1330

Waterworks
171 E. Ridgewood Ave.
Ridgewood, NJ 07450
201-689-7500
www.waterworks.com

New Mexico

Architectural Surfaces
5801 Midway, N.E.
Albuquerque, NM 87107
505-889-0124

Counterpoint Tile
320 Sandoval
Sante Fe, NM 87501
505-982-1247
www.counterpointtile.com

Tiles de Santa Fe
1719 5th St., N.W.
Albuquerque, NM 87102
505-242-9351
www.tilesdesantafe.com

Tiles de Sante Fe
901 W. San Mateo
Sante Fe, NM 87505
505-455-7466

New York

Alan Court & Associates
34 Park Place
East Hampton, NY 11937
631-324-7497
www.alancourtassociates.com

Amsterdam Corporation
150 E. 58th St.
New York, NY 10155
212-644-1350

Ann Sacks Tile & Stone
5 E. 16th St.
New York, NY 10003
212-463-8400

Artistic Tile
79 Fifth Ave.
New York, NY 10003
212-727-9331
www.artistictile.com

Artistic Tile
150 E. 58th St.
New York, NY 10022

Artistic Tile
65 Tarrytown Rd.
White Plains, NY 10607
914-422-0041

Best Plumbing, Tile, and Stone
3333-1 Crompond Rd.
Yorktown Heights, NY 10598
914-736-2468

Catskills Kitchen & Bath
1094 Morton Blvd.
Kingston, NY 12401
845-336-4880

Ceramica Arnon
134 W. 20th St.
New York, NY 10011
212-807-0876
www.ceramicaarnon.com

Country Floors
15 E. 16th St.
New York, NY 10003
212-627-8300
www.countryfloors.com

Elon Inc.
153 Main St.
Mt. Kisco, NY 10546
914-242-8434

Elon Inc.
Saw Mill River Rd.
Millwood, NY 10546
914-941-7788
elon@bestweb.net

EX
155 E. 56th St.
New York, NY 10022
212-758-2593
www.exinc.org

Hastings Tile
230 Park Ave. S.
New York, NY 10003
212-674-9700

Ideal Tile
2048 Broadway
New York, NY 10023
212-799-3148
www.idealtileimporting.com

Ideal Tile
405 E. 51st St.
New York, NY 10022
212-759-2339

Ideal Tile
1937 Central Park Ave.
Yonkers, NY 10710
914-736-2468
914-779-9552

Kitchen Dimensions
2 Franklin Sq.
Saratoga Springs, NY 12866
518-583-0081

Nemo Tile
48 E. 21st St.
New York, NY 10010
212-505-0009
www.nemotile.com

Nemo Tile
177-02 Jamaica Ave.
Jamaica, NY 11432
718-291-5696

Nemo Tile
277 Old Country Rd.
Hicksville, NY 11802
516-935-5300

Paris Ceramics
150 E. 58th St.
New York, NY 10155
212-644-2782
www.parisceramics.com

Quarry Tile, Marble, and Granite
192 Lexington Ave.
New York, NY 10016
212-679-8889

Shelly Tile Ltd.
979 Third Ave.
New York, NY 10022
212-832-2255

Shoreline Ceramic Tile
649 Route 25A
Rocky Point, NY 11778
516-744-5653

Stone Source
215 Park Ave. S.
New York, NY 10003
212-979-6400
www.stonesource.com

Tile Depot
2091 Jericho Tnpk.
E. Northport, NY 117331
516-499-8453
www.idealtileimporting.com

The Tile Room
1349 University Ave.
Rochester, NY 14607
716-473-1020

Tiles, A Refined Selection
42 W. 15th St.
New York, NY 10011
212-255-4450
www.tiles-arefined.com

Tiles, A Refined Selection
227 E. 59th St.
New York, NY 10022
212-308-1177

Urban Archeology
143 Franklin St.
New York, NY 10013
212-431-4646
www.urbanarcheology.com

Urban Archeology
239 E. 58th St.
New York, NY 10022
212-371-4646

Villeroy & Boch
901 Broadway
New York, NY 10003
212-677-1151
www.villeroy-boch-usa.com

Walker Zanger
37 E. 20th St.
New York, NY 10003
www.walkerzanger.com

Waterworks
469 Broome St.
New York, NY 10013
212-966-0605
www.waterworks.com

Waterworks
225 E. 57th St.
New York, NY 10022
212-371-9266

Waterworks
40 E. Parkway
Scarsdale, NY 10583
914-472-3991

Waterworks
87 Newtown Ln.
East Hampton, NY 11937
631-329-8201

Waterworks
1468 Northern Blvd.
Manhasset, NY 11030
516-365-2632

North Carolina

Adriano Tile
113-B Main St.
Carrboro, NC 27510
919-967-0946

Laufen Ceramic Tile
3402 South Blvd.
Charlotte, NC 28209
704-527-1355
www.laufenusa.com

McCullough Ceramic Tile
5272 Germanton Rd.
Winston-Salem, NC 27105
336-744-0660

Renaissance Tile & Bath
2041 South Blvd., Suite A
Charlotte, NC 28203
704-372-1575

Walker Zanger
11435 Granite St., Suite M
Charlotte, NC 28273
704-588-6140
www.walkerzanger.com

Ohio

Classico Tile
1196 W. Third Ave.
Columbus, OH 43212
614-291-5909

Hamilton Parker
1865 Leonard Ave.
Columbus, OH 43219
614-358-7800
info@hamiltonparker.com

Hamilton Parker
188 E. William St.
Delaware, OH 43105
740-363-1196

Kemper Design Center
3200 E. Kemper Rd.
Cincinnati, OH 45241
513-772-8900
www.kemperdesign.com

Kemper Design Center
3160 S. Tech Blvd.
Dayton, OH 45342
937-885-1177

Louisville Tile
11083 Kenwood Rd.
Cincinnati, OH 45242
513-936-8453
www.louisville-tile.com

Stoneworks Ltd.
5194 Richmond Rd.
Bedrod Heights, OH 44146
216-595-9675
www.stoneworksltd.com

Surface Style
6650 Bush Blvd.
Columbus, OH 43215
614-781-6990
surfacestyle@yahoo.com

The Thomas Brick Company
27750 Chagrin Blvd.
Cleveland, OH 44122
216-831-9116

The Thomas Brick Company
975 Crocker Rd.
Westlake, OH 44145
440-892-9400

Toledo Tile
2121 N. Reynolds Rd.
Toledo, OH 43615
419-536-9321
www.toledotile.com

Virginia Tile
800 Resource Dr.
Brooklyn Heights, OH 44131
216-749-4540
www.virginiatile.com

Oklahoma

Tile Stone Distributors, Inc.
2309 E. 69th St.
Tulsa, OK 74136
918-492-5434
www.tilestone-distributors.com

Oregon

Ann Sacks Tile & Stone
500 N.W. 23rd Ave.
Portland, OR 97210
503-222-7125

Ideal Tile
655 Wallace Dr., N.W.
Salem, OR 97304
503-362-9861
www.idealtileimporting.com

Pratt & Larson Tile
1201 S.E. Third Ave.
Portland, OR 97214
503-231-9464
www.prattandlarson.com

United Tile
3401 S.E. 17th Ave.
Portland, OR 97202
503-231-4958
www.unitedtile.com

Pennsylvania

Charles Tiles
4401 Main St.
Philadelphia, PA 19127
215-482-8440
www.charles-tiles.com

Country Floors
1706 Locust St.
Philadelphia, PA 19103
215-545-1040
www.countryfloors.com

Joanne Hudson Associates
2400 Market St., Suite 310
Philadelphia, PA 19103
215-568-5501
www.joannehudson.com

Splash
1237 Freedom Rd.
Cranberry Township, PA 16066
724-772-1060

Tile Collection
4031 Bigelow Blvd.
Pittsburgh, PA 15213
412-621-1051

Tile & Designs
229 Spahr St.
Pittsburgh, PA 15232
412-362-8453
www.tileanddesigns.com

Waterworks
1525 Walnut St.
Philadelphia, PA 19102
215-568-0151
www.waterworks.com

Rhode Island

Professional Tile Designs
105 Franklin St.
Westerly, RI 02891
401-348-1004

Professional Tile Designs
155 Jefferson Blvd.
Warwick, RI 02888
401-732-8585

Tennessee

Ceramic Tile Supply
1601 E. 27th St.
Chattanooga, TN 46038
423-698-1512
www.louisville-tile.com

Gray's Creek Natural Stone & Tile
10545 Hwy. 64 E.
Memphis, TN 38002
901-213-3422
www.rlstone.com

Louisville Tile
650 Melrose Ave.
Nashville, TN 37211
615-248-8453
www.louisville-tile.com

Monarch Tile
4072 Senator
Memphis, TN 38118
901-363-5880
www.monarchceramictile.com

Traditions in Tile
2548 Bransford Ave.
Nashville, TN 37204
615-269-9669
www.traditionsintile.com

Texas

Antique Floors
1221 Dragon St.
Dallas, TX 75207
214-760-9330

Architectural Design Resource
5120 Woodway, Suite 115
Houston, TX 77056
713-877-8366
www.houstonadr.com

Architectural Tile & Stone
5605 Burnet Rd.
Austin, TX 78756
512-420-9989

Custom Accessories
4211 Richmond
Houston, TX 77027
713-961-1324

Elon
15421 Capital Port Dr.
San Antonio, TX 78249
210-493-3566

French-Brown Floors
7007 Greenville Ave.
Dallas, TX 75231
214-363-4341
www.french-brown.com

Materials Marketing
120 W. Josephine St.
San Antonio, TX 78212
210-371-8453
www.materials-marketing.com

Materials Marketing
3433 W. Alabama, Suite A
Houston, TX 77027
713-960-8601

Materials Marketing
115 Wild Basin Rd., #105
Austin, TX 78746
512-328-7682

Materials Marketing
1626 Hi Line Dr., Suite A
Dallas, TX 75207
214-752-4226

Palmer Todd, Inc.
203 W. Rhapsody
San Antonio, TX 78216
210-341-3396
www.palmertodd.com

Walker Zanger
7055 Old Katy Rd.
Houston, TX 77024
713-880-9292
www.walkerzanger.com

Walker Zanger
11550 Newberry, #300
Dallas, TX 75229
972-481-3900

Waterworks
4524 Cole Ave.
Dallas, TX 75205
214-559-4155
www.waterworks.com

Utah

Contempo Tile
3699 South 300 W.
Salt Lake City, UT 84115
801-262-1717
www.contempo.com

Contempo Tile
1300 W. Center St.
Orem, UT 84057
801-426-8686

Contempo Tile
440 W. 200 N.
St. George, UT 84770
435-628-3700

Vermont

North Country Tile
800 Marshall Ave.
Williston, VT 05495
802-660-8668

Virginia

Ideal Tile
4425 Brookfield Corp. Dr.
Chantilly, VA 22031
703-968-0550
www.idealtileimporting.com

Ideal Tile
216 Maple Ave. W.
Vienna, VA 22180
703-938-3500

La Galleria
993 Laskin Rd.
Virginia Beach, VA 23451
757-428-5909

Washington

Ann Sacks Tile & Stone
115 Stewart Ave.
Seattle, WA 98101
206-441-8917

Spokane Tile & Design
1319 W. First Ave., Suite 100
Spokane, WA 99202
509-624-0339

United Tile
3001 E. Valley Rd.
Renton, WA 98055
425-251-5290
www.unitedtile.com

Waterworks
10223 N.E. 10th St.
Bellevue, WA 98004
425-990-8640
www.waterworks.com

Washington, D.C.

Además
816 N. Fairfax St.
Alexandria, VA 22314
703-549-7806

Architectural Ceramics
692 Losstrand Ln.
Rockville, MD 20850
301-762-4140
www.aci.baweb.com

Artistic Tile
300 D St., S.W.
Washington, D.C.
202-554-8719
www.artistictile.com

Bartley Tile Concepts
6931 Arlington Rd., Suite C-2
Bethesda, MD 20814
301-913-9113

Design Tile
8455-B Tyco Rd.
Tysons Corner, VA 22182
703-734-8211

French Country Living
10205 Colvin Run Rd.
Great Falls, VA 22066
703-759-2245
www.frenchcountry.com

Ideal Tile
1109 W. Broad St.
Falls Church, VA 22046
703-237-8400
www.idealtileimporting.com

Ideal Tile
1596B Rockville Pike
Rockville, MD 20852
301-984-3200

Waterworks
1519 Wisconsin Ave.
Washington, D.C. 20007
202-333-7180
www.waterworks.com

West Virginia

Davis Tile & Stone Gallery
167 Greenbag Rd.
Morgantown, WV 26505
304-296-3243
www.daviskitchenandtile.com

Showcase Kitchen & Bath
926 Fourth Ave.
Huntington, WV 25701
304-522-4492

Wisconsin

Ann Sacks Tile & Stone
7654 Woodlake Rd.
Kohler, WI 53044
414-452-7250

Childcrest
W135 N5511 Campbell Dr.
Menomonee Falls, WI 53051
262-781-2551
www.rbctile.com

Lexco Tile & Supply
1616 S. 108th St.
West Allis, WI 53214
800-242-2249
www.lexcotile.com

Lexco Tile & Supply
5915 52nd St.
Kenosha, WI 53144
888-864-8255

Lexco Tile & Supply
2580 Todd Dr.
Madison, WI 53713
888-865-8255

Wyoming

Teton Tile & Design
455 W. Broadway
Jackson, WY 83001
307-733-0003
tetontile@wyoming.com

Canada

Artisan Tile & Stone
10453 170th St.
Edmonton, Alberta T5P 4S7
403-944-9146

Country Floors
321 Davenport Rd.
Toronto, Ontario M5R 1K5
416-922-9214
www.countryfloors.com

Country Floors
5337 Rue Ferrier
Montreal, Quebec H4P 1L9
514-733-7596

Empire Kitchen & Bath
5911 Third St., S.E.
Calgary, Alberta T2H 1K3
403-253-0655

World Mosaic
767 Bank St.
Ottawa, Ontario K1S 3V3
613-232-5341

STORES FOR TILED FURNISHINGS AND OBJECTS

ABC Carpet and Home
888 Broadway
New York, NY 10003
212-473-3000

Le Fanion
299 W. Fourth St.
New York, NY 10014
212-463-8760

Maison et Cafe
148 S. La Brea Ave.
Los Angeles, CA 90036
213-935-3157

Santa Barbara Ceramic Design
428 E. Haley St.
Santa Barbara, CA 93101
805-966-3883

Soho Galleries
29 E. 21st St.
New York, NY 10010
212-674-7721

Solar
Rua D. Pedro V, 68-70
1250 Lisboa PORTUGAL
351-1-346-55-22

COMPANIES (FACTORY-MADE TILE)

American Marazzi Tile
359 Clay Rd.
Sunnyvale, TX 75182
972-226-0110
www.am-marazzi.com

American Olean
7834 Hawn Freeway
Dallas, TX 75217
800-933-TILE
www.americanolean.com

Buchtal Corporation USA
1018 Windward Ridge Pkwy.
Alpharetta, GA 30005
770-442-5500
www.buchtalusa.com

Crossville Ceramics
P.O. Box 1168
Crossville, TN 38557
931-484-2110

Dal-Tile
7834 Hawn Freeway
Dallas, TX 75217
800-933-TILE
www.daltile.com

Emaux de Briare
86 Tec St.
Hicksville, NY 11801
516-931-6924
www.emauxdebriare.com

Florida Tile
P.O. Box 447
Lakeland, FL 33802
863-687-7171

Laufen Ceramic Tile
P.O. Box 570
Tulsa, OK 74101
918-428-3851
www.laufenusa.com

Original Style
Falcon Rd., Sowton Industrial Estate
Exeter, Devon ENGLAND EX2 7LF
44-13-92-474-011

Sannini
Via Provinciale Chiantigiana, 135
50023 Impruneta, Firenze ITALY
39-055-207-076

Summitville Tiles
State Rd. 644
Summitville, OH 43962
330-223-1511
www.summitville.com

The Tileworks
4140 Grand Ave.
Des Moines, IA 50312
515-246-8304

POTTERIES (HANDMADE AND REPRODUCTION TILE)

Deer Creek Tile
305 Richardson St.
Grass Valley, CA 95945
530-272-3373

Epro Tile
156 E. Broadway
Westerville, OH 43081
614-882-6990

Fulper Tile
P.O. Box 373
Yardley, PA 19067
215-736-8512

L'Esperance Tile Works
1118 Rock City Rd.
Rock City Falls, NY 12863
518-884-2814
lestilewk@aol.com

Malibu Ceramic Works
P.O. Box 1406
Topanga, CA 90290
310-455-2485

McIntyre Tile
P.O. Box 14
Healdsburg, CA 95448
707-433-8866

M.E. Tile
6463 Waveland Ave.
Hammond, IN 46320
219-554-1877
www.metile.com

Meredith Tile
1201 Millerton Rd., S.E.
Canton, OH 44711
330-484-1656
www.meredithtile.com

Moravian Pottery & Tile Works
130 Swamp Rd.
Doylestown, PA 18901
215-345-6722
http://go.to/mptw

Peace Valley Tile
64 Beulah Rd.
New Britain, PA 18901
215-340-0888

Pewabic Pottery
10125 E. Jefferson
Detroit, MI 48214
313-822-0954
www.pewabic.com

Pratt & Larson Tile
12200 Northup Way
Bellevue, WA 98005
425-882-0707
www.seattlesidewalk.com

David Rago
333 N. Main St.
Lambertville, NJ 08530
609-397-9374
www.ragoarts.com

Richard Keit Studios
206 Canada St.
Ojai, CA 93023
805-640-9360
www.rtkstudios.com

Sonoma Tilemakers
7750 Bell Rd.
Windsor, CA 95492
707-837-8177

Terra Designs
241 E. Blackwell St.
Dover, NJ 07801
973-539-2999

Tile Restoration Center
Marie Glass Tapp
3511 Interlake Ave. N.
Seattle, WA 98103
206-633-4866
www.tilerestorationcenter.com

Trikeenan Tileworks
P.O. Box 22
Keene, NH 03431
603-352-4299
www.trikeenan.com

Venice Tile, LLC
24160-F Avenida Rancheros
Diamond Bar, CA 91765
909-860-9494

ARTISTS AND STUDIOS (CUSTOM, HANDPAINTED, OR ARTISTIC EXPRESSIONS IN CERAMIC)

Sophie Acheson
6 Post Office Ln.
Greens Farms, CT 06436
203-255-1349

Cristina Acosta
P.O. Box 923
Bend, OR 97709
541-388-5157
www.cristina-acosta.com

Benedikt Strebel Ceramics
978 Guerrero St.
San Francisco, CA 94110
415-824-7949
b.strebel@worldnet.att.net

Blue Slide Art Tile
c/o California Art Tile
8687 Melrose Ave., Suite B447
Los Angeles, CA 90069
800-646-8453

Lynda Curtis
983 Old Post Rd.
New Paltz, NY 12561

Decoratta
115 E. Main St.
Silverdale, PA 18962
215-453-0820
decoratta@enter.net

Designs in Tile
P.O. Box 358
Mount Shasta, CA 96067
530-926-2629
www.designsintile.com

Dunis Studios
23645 North Hwy. 281
San Antonio, TX 78258
210-497-5787
www.dunisstudios.com

Firebird
335 Snyder Ave.
Berkeley Heights, NJ 07922
908-464-4613
www.firebirdtiles.com

Frank Giorgini
4425 Route 67
Freehold, NY 12431
618-634-3559
www.udu.com

Gooseneck Designs
2020 Hughes Shop Rd.
Westminster, MD 21158
410-848-5663
www.gooseneckdesigns.com

Imagine Design
1515 Broad St.
Bloomfield, NJ 07003
800-680-TILE
www.imaginetile.com

La Luz Canyon Studio
P.O. Box 10627
Alameda, NM 87184
505-899-9977
www.laluz-studio.com

Levy Larocque
One Cottage St.
Easthampton, MA 01027
413-527-5040

Ted Lowitz
4401 N. Ravenswood Ave.
Chicago, IL 60640
773-784-2628
www.lowitzandcompany.com

Laura Shprentz
168 Irving Ave., #400E
Port Chester, NY 10573
914-939-6639
www.erols.com/lshprentz

Surving Studios
17 Millsburg Rd.
Middletown, NY 10940
800-768-4954
www.surving.com

Table Tiles Inc.
P.O. Box 5013
Glen Arm, MD 21057
410-592-9158

Susan Tunick
771 West End Ave., #10E
New York, NY 10025
212-962-1864

Urban Jungle Art & Design
244 W. Brookes Ave.
San Diego, CA 92103
619-299-1644
deirdrelee@usa.net

Martine Vermeulen
N. Anson Rd.
RR2, Box 92A
Stanfordville, NY 12581
845-868-7054

Warwick Pottery Works
P.O. Box 123
Elverson, PA 19520
610-286-9764
www.warwickpotteryworks.com

Wirth-Salander Studios
43 N. Main St.
South Norwalk, CT 06854
203-852-9449
wirth-salander@snet.net

Nina Yankowitz
106 Spring St.
New York, NY 10012
212-226-4375
www.yankowitzandholden.com

MOSAICS

Carlos Alves
1043 Lincoln Rd.
Miami Beach, FL 33139

Lia Catalano
200 Tan Hollow Rd.
Westerlo, NY 12193
800-464-4394
www.hannacroismosaics.com

George Fishman
103 N.E. 99th
Miami Shores, FL 33138
305-758-1141
www.georgefishmanmosaics.com

Nancy Kintisch
3636 Brunswick Ave.
Los Angeles, CA 90039
323-663-3930

Mozayiks
612 E. 9th St.
New York, NY 10019
212-677-7834

New Ravenna
P.O. Box 265
Belle Haven, VA 23306
757-442-3379

Kim Rizio
7551 S.W. Ludlam Rd.
South Miami, FL 33143
305-665-2768

SerpenTile
332 E. 90th St.
New York, NY 10128
212-427-4232

Smashing Tiles (mail order)
502-241-1790
www.smashingtiles.com

Robert Stout
808 Wellesley N.E.
Albuquerque, NM 87106
505-266-2675

Miriam Wosk
440 S. Roxbury Dr.
Beverly Hills, CA 90212
310-553-8244

Debra Yates
7291 S.W. 52 Ct.
Miami, FL 33143
305-666-6180

Mountaintop Mosaics
www.mountaintopmosaics.com
(materials for making mosaics)

Wit's End Mosaic
www.mosaic-witsend.com
(materials and classes)

IMPORTERS

Cepac Tile (Japanese tile)
16825 Saticoy St.
Van Nuys, CA 91406
818-781-1888

Ceramic Tile Trends (Brazilian tile)
3251 Oradell Ln.
Dallas, TX 75220
214-358-5557

Cuban Tropic Tile (Cuban tile)
3632 N.W. 37th Ave.
Miami, FL 33142
305-633-8941

Solar Antique Tiles (European and
 Islamic antique tile)
306 E. 61st St.
New York, NY 10021
212-755-2403
www.solarantiquetile.com

Souli Tile (Moroccan and Tunisian tile)
8113 Germantown Ave.
Philadelphia, PA 19118
215-753-1904

Ticsa America (Spanish tile)
386 Cliffwood Park St.
Brea, CA 92621
714-671-7939

Wholesale Tile & Accessories, Inc. (Guatemalan, Mexican, and Portuguese tile)
1902 Flagler St.
Tampa, FL 33605
813-248-0455

ARCHITECTS AND DESIGNERS

Arthur Cotton Moore, Architect
3050 K St., N.W., Suite 125
Washington, D.C. 20007
202-337-9081

Arquitectonica
550 Brickell Ave., #200
Miami, FL 33131
305-372-1812
www.drgintl.com

Vivien Baraban, Designer
1044 Stony Ln.
Gladwyne, PA 19035
610-519-9660

Michael Berzak, Designer
121 W. 19th St., Suite 1001
New York, NY 10011
212-243-2639

Beyer Blinder Belle Architects
41 E. 11th St.
New York, NY 10003
212-777-7800

Scott Bromley, Architect
242 W. 27th St.
New York, NY 10001
212-620-4250
www.bromleycaldari.com

Centerbrook Architects
P.O. Box 955
Centerbrook, CT 06409
860-767-0175
www.centerbrook.com

Steve Chase Design
70-005 Mirage Cove Dr.
Rancho Mirage, CA 92270
760-324-4602

Cosas Inc., Designers
419 16th St.
Brooklyn, NY 11245
718-768-7013

Carl D'Aquino, Designer
180 Varick St.
New York, NY 10014
212-929-9787

Denning-Fourcade Design
111 E. 56th St.
New York, NY 10022
212-759-1969

Kate Dundes, Designer
192 Lexington Ave.
New York, NY 10016
212-251-0212

Melvin Dwork, Designer
196 Ave. of the Americas
New York, NY 10013
212-966-9600

Lori Erenberg, Designer
16060 Temecula
Pacific Palisades, CA 90272
310-459-1515

Catherine Gerry, Designer
302 W. 98th St., Suite 2
New York, NY 10025
212-663-5466

Michael Golden, Tile Designer
37 W. 20th St., Suite 303
New York, NY 10011
212-645-3001

Steven Harris, Architect
50 Warren St.
New York, NY 10007
212-587-1108

Barbara Hauben-Ross, Designer
226 E. 54th St.
New York, NY 10022
212-832-6640

Hunton Brady Pryor Maso Architects
135 W. Central Blvd., Suite 400
Orlando, FL 32801
407-839-0886
www.hbpm.com

Dennis Jenkins, Designer
5813 S.W. 68th St.
South Miami, FL 33143
305-665-6960

Laura Kaehler, Architect
One Fawcett Pl.
Greenwich, CT 06830
203-629-2212

Julie Kalberer, Architect
462 Broadway
New York, NY 10013
212-219-3007
www.lhparch.com

James Lumsden, Designer
1329 Sierra Alta Way
Los Angeles, CA 90069
310-276-5640
www.jameslumsden.com

Susan Lyle, Designer
255 E. 72nd St.
New York, NY 10021
212-288-2729

Helfand Myerberg Guggenheimer, Architects
428 Broadway
New York, NY 10013
212-925-2900
www.hmga.com

Jordan Mozer, Architect
228 W. Illinois St.
Chicago, IL 60610
312-661-0060

Mullman Seidman Architects
443 Greenwich St.
New York, NY 10013
212-431-0770

Barton Myers, Architect
1025 Westwood Blvd.
Los Angeles, CA 90024
310-208-2227

Florence Perchuk, Designer
60 E. 42nd St., #1166
New York, NY 10165
212-932-0441

Robert Orr & Associates Architects
441 Chapel St.
New Haven, CT 06511
203-777-3387
www.robertorr.com

Raul Rodriguez, Architect
2100 Ponce de Leon Blvd.
Coral Gables, FL 33146
305-448-7417
www.rodriguezquiroga.com

Dennis Rolland, Designer
405 E. 54th St.
New York, NY 10022
212-644-0537
dennisrolland@aol.com

Aldo Rossi, Architect
45 E. 20th St.
New York, NY 10003
212-982-4700

Donato Savoie, Architect
247 Centre St.
New York, NY 10013
212-226-4324

Anita Solow, Designer
167 E. 67th St.
New York, NY 10021
212-772-7915

Janet Sperber, Designer
2754 Calhoun St.
San Diego, CA 92110
619-298-1141
www.bazaardelmundo.com

Skip Sroka, Designer
7307 MacArthur Blvd., #214
Bethesda, MD 20816
301-263-9100
www.srokadesign.com

Sarah Susanka, Architect
2600 Salisbury Plain
Raleigh, NC 27613
612-338-3900
www.notsobighouse.com

Tigerman-McCurry
444 N. Wells, Suite 206
Chicago, IL 60610
312-644-5880
www.tigerman-mccurry.com

Venturi, Scott Brown & Associates, Architects
4236 Main St.
Philadelphia, PA 19127
215-487-0400
www.vsba.com

Alan Wanzenberg, Architect
211 W. 61st St.
New York, NY 10023
212-489-7840

TILE INSTALLERS

A good installation is vital to a successful
tile project; a bad one can ruin it. Showrooms
will be able to recommend installers, but check
references to be sure you know who you're getting.
These are a few recommendations for installers in
major cities.

David Garbo
New York, NY
212-223-2653

Innovative Tile & Supply
Santa Monica, CA
310-453-4696

T. Pedell
New York, NY
212-873-9687

Carol Terranova
New York, NY
212-228-2140

ASSOCIATIONS AND SOCIETIES

These organizations can provide historic information or contemporary sources for tile you are having trouble locating.

Friends of Terra Cotta
771 West End Ave., #10E
New York, NY 10025
212-932-1750
www.preserve.org/fotc

Tile Council of America
100 Clemson Research Blvd.
Anderson, SC 29625
864-646-8453
www.tilesusa.com

Tile Heritage Foundation
P.O. Box 1850
Healdsburg, CA 95448
707-431-TILE
www.tiles.org

The Society of American Mosaic Artists
P.O. Box 428
Orangeburg, SC 29116
www.scsuedu/sama

TILE EXPERIENCES

Tile can be found everywhere, no matter where you are, and part of its joy is in its discovery. Here, however, are a few recommendations of some particularly outstanding tile locations to visit.

Adamson House (Estate)
23200 Pacific Coast Hwy.
Malibu, CA 90265
310-456-8432

Art en Route (New York City Subway)
Write for guidebook:
Arts for Transit
347 Madison Ave.
New York, NY 10017

A-R-T Tour (Los Angeles Metro)
Call for information:
213-244-6408

Arlington Hotel (Mineral water baths)
239 Central Ave.
Hot Springs, AR 71901
501-623-7771

Biltmore Hotel
1200 Anastasia Ave.
Coral Gables, Fl 33134
305-445-1926

Catalina Island
(Tile-covered island off the coast of Los Angeles)
Call for information:
310-510-1520

Fonthill (Estate)
E. Court St. & Swamp Rd.
Doylestown, PA 18901
215-348-9461

Gallery Ratton (Contemporary tile gallery)
Rua Academia das Ciencias, 2C 1200
Lisboa, PORTUGAL
351-1-346-0948

Garth Clark Gallery (Ceramic art gallery)
24 W. 57th St.
New York, NY 10019
212-246-2205

Gran Hotel El Convento (Hotel)
100 Cristo St.
Old San Juan, Puerto Rico 00902
809-723-9020

Hotel Alfonso XIII
San Fernando, 2
41004 Sevilla, SPAIN
34-54-95-422-2850

KunstHausWien (Museum)
Untere Weisgerberstraise 13
1030 Wien, AUSTRIA
43-1-01-712-0491

McNay Art Museum
6000 N. New Braunsels Ave.
San Antonio, TX 78209
210-824-5368

Museu Nacional do Azulejo (Tile museum)
Rua da Madre de Deus, 41900
Lisboa, PORTUGAUL
351-1-814-7747

Palacio Fronteira (Palace)
Largo Sao Domingos de Bemfica, 11500
Lisboa, PORTUGAL
351-1-778-2023

Union Station (Train Station)
800 N. Alameda St.
Los Angeles, CA 90012
213-683-6873

Watts Towers (107-foot-tall tile sculpture)
1765 E. 107th St.
Los Angeles, CA 90002

YMCA (Pools)
5 W. 63rd St.
New York, NY 10023
212-875-4131

Photo Credits

All photographs are by Roy Wright, except for the following:

Sophie Acheson, 39

Daniel Aubry, 6–7, 21 (top), 63

Laurie Black, 122 (left)

Thomas Brummett, 124, 126–127

Randall J. Corcoran, 9, 56 (top)

Crate & Barrel, 163

Franco Di Lecce, 132–133, 138, 139

Michael R. Golden Design, 74 (illustration),
111 (both photos)

Mick Hales, 18

John M. Hall, 37 (both photos), 49, 51, 104, 110,
120–121, 152, 155 (top), 157, 158 (top),
160 (bottom), 162, 163 (all photos)

Stephen Harris, 80 (top)

Jill Herbers, 32

Jean Kallina ©, 100 (top)

David Livingston, 93, 98 (top)

Original Style, 141

Fred Maroon, 19 (top)

Peter Mauss © Esto, 14

Terri Ocana, 61

Paris Ceramics, 87 (right); 89

Pewabic Pottery, 88 (bottom)

Lanny Provo, 65, 130, 146 (bottom)

Pull Cart Tile, 45 (illustration)

Rebuild Dubrovnik Fund, 31

Eric Roth, 75

Nancy Stout, 10–11

Tim Street-Porter, 66–67, 77, 78–79, 142 (left)

Matt Wargo, 29 (bottom)

Jerry Wellman, 98 (bottom)

Bryan Whitney, 22, 23

Michael Yurgeles, 40